Launching the Imagination

Two-Dimensional Design

Launching the Imagination

Two-Dimensional Design

first edition

Mary Stewart

McGraw-Hill Higher Education ⊗

*A Division of The **McGraw-Hill** Companies*

LAUNCHING THE IMAGINATION: VOLUME 1: TWO-DIMENSIONAL DESIGN
Published by McGraw-Hill, an imprint of The McGraw-Hill Companies, Inc. 1221 Avenue of the Americas, New York, NY, 10020.

This book is printed on acid-free paper.

2 3 4 5 6 7 8 9 0 KGP/KGP 0 9 8 7 6 5 4 3 2

ISBN 0-07-248283-4

Editorial director: *Phillip A. Butcher*
Sponsoring editor: *Joe Hanson*
Developmental editor: *Cynthia Ward*
Senior marketing manager: *David Patterson*
Lead project manager: *Mary Conzachi*
Production supervisor: *Susanne Riedell*
Senior designer: *Pam Verros*
Media producer: *Shannon Rider*
Lead supplement producer: *Cathy L. Tepper*
Photo research coordinator: *Ira C. Roberts*
Photo researchers: *Elsa Peterson Ltd. and Photosearch, Inc.*
Cover design: *Jenny El-Shamy*
Interior design: *Pam Verros*
Typeface: *10.5/14 Palatino*
Compositor: *GTS Graphics, Inc.*
Printer: *Quebecor World Kingsport*
Cover Image Credits:
[1] Victor Vasarely. *Vega Per.* 1969. Oil on canvas, 64 × 64" (162.6 × 162.6 cm). Honolulu Academy of Arts, gift of the Honorable Clare Booth Luce, 1984 (5311.1). © 2002 Victor Vasarely/Artists Rights Society (ARS), NY/ADAGP, Paris. Photo: Tibor Franyo.
[2] Käthe Kollwitz. *Self-Portrait in Profile, Facing Left, I.* 1889. Lithograph, 5-7\8 × 5-7/8" (15 × 15 cm). Unsigned. Staatliche Kunstsammlungen der DDR. Kupferstichkabinett Dresden.
[3] Poster: *"Master Harold" ... and the Boys.* Poster. The Department of Theater Arts, California State University, Los Angeles, David McNutt, 1985.
[4] Bart Forbes. *Landmark.* 1999. Oil on canvas, 14" w × 19" d (35.6 × 48.3 cm). From Frogfolio 10, Dellas Graphics, Syracuse, NY. © Bart Forbes, 2001.
[5] Nancy Crow. *Double Mexican Wedding Rings 1.* © 1988. Hand quilted by Marie Moore. 72 × 720 (183 × 183 cm). Photo: J. Kevin Fitzsimons.

Library of Congress Control Number: 2001097904

www.mhhe.com

Launching the Imagination:
Two-Dimensional Design
is dedicated to
Ruth Asbury Stewart.

Mary Stewart is currently an Associate Professor and the Foundation Coordinator in the Northern Illinois University School of Art. She also serves as the Regional Coordinator Advisor for Foundations in Art: Theory and Education, a professional organization devoted to excellence in college-level teaching. A long-time member of the Syracuse University Foundation Program, she has taught Two-Dimensional Design, Three-Dimensional Design, and Drawing for over twenty-five years. As an artist, Stewart uses the dialogs of Plato as a beginning point for visual narratives using drawing, visual books, and computer graphics.

about the author

The Design Continuum

My fascination with design dates back to 1980, the year I taught my first two-dimensional design course. As a graduate student at Indiana University, I had been teaching drawing since 1977. The transformation of perceptual reality into effective illusion was the main concern in basic drawing, and I knew many ways to accomplish this goal. It was far more difficult to determine either the form or the content for a course in design. In researching the subject, I discovered a dizzying array of skills to master and concepts to explore.

Auditing the courses of two master teachers raised even more questions. The first, taught by Professor William Itter, was derived from the approach developed by his teacher, Joseph Albers. Professor Itter's course was methodical, systematic, and highly analytical. The second course, taught by Professor David Hornung, offered a thorough investigation of unity and variety through an exploration of patterns in art and life. His approach was exuberant, synthetic, and often irreverent. Despite significant differences in their assignments, both teachers presented substantial design information effectively.

In developing my own course, I concluded that a comprehensive approach to design required exuberance as well as analysis and that rambunctiousness was the natural partner to rigor. Design is equally a noun and a verb. It offers a problem-solving process as well as a well-crafted product. Because the ideas and approaches to design are ever-changing, the educational possibilities are infinite. Thus, when McGraw-Hill invited me to write a new design book, I was determined to present substantial information in the liveliest possible way.

A Flexible Framework

Launching the Imagination: Two-Dimensional Design offers a clear, concise, and comprehensive overview of the elements, principles, and problem-solving processes of two-dimensional design. The book covers all the topics common to two-dimensional foundations courses and found in other textbooks; however, I have attempted to refine, distill, and update the presentation of this core material. Over two hundred and fifty images from a wide variety of sources illustrate these points in a clear and engaging manner. A special effort has been made to include a broad range of

images, including examples from film, advertising, and graphic design, as well as traditional fine arts. *Launching the Imagination* showcases contemporary art, so that first-year students (many of whom are concurrently studying art history) have a fuller view of the art world they will be entering. The stylistic range is broad and the examples are drawn from many cultures.

Since the basic elements and principles of design are presented concisely, *Launching* includes many unique features:

- Launching the Imagination is the only foundations text that includes an extensive discussion of concept development and creativity, including specific critical thinking and problem-solving strategies, time-management techniques, and a thorough discussion of critiques.

- Each chapter ends with a point-by-point summary, a list of key words, a brief list of recommended readings, and at least five key questions. These questions are designed to help students analyze their studio works in progress, rather than solely relying on a final critique for input.

- Profiles are special two-page spreads, found in every chapter, which highlight interviews with living artists and designers. Through these interviews, students learn about the working processes, career choices, obstacles overcome, and criteria for excellence of a remarkable group of masters in the field. These interviews help students see connections between basic design and professional practice while providing an introduction to potential careers.

A glossary, extensive bibliography, and comprehensive index provide further information and help readers access sections of the book of particular interest.

Launching the Imagination: Two-Dimensional Design is composed of the first six chapters from a larger book titled *Launching the Imagination: A Comprehensive Guide to Basic Design.* The comprehensive text includes three chapters on three-dimensional design and three chapters on four-dimensional design. A third book, *Launching the Imagination: Three-Dimensional Design*, provides a concise introduction to three-dimensional design. With three options available, teachers and students can use the book best suited to their curricular needs.

A Pedagogical Support System

In addition to the integrated pedagogy highlighted above, each copy of *Launching the Imagination* is packaged with Launching the Imagination's *Core Concepts in Art* CD-ROM, which features over 70 interactive exercises illustrating such fundamental elements as line, shape, and color; narrated video segments on a wide range of media; study resources correlated to each chapter; a research and Internet guide; and a study skills section offering practical advice on succeeding in college.

Instead of providing extensive exercises in the text, *Launching the Imagination* is accompanied by an extensive Instructor's Manual. Advice on course construction, critique skills, and technical resources is included, along with over fifty terrific assignments.

Finally, *Launching the Imagination* is supported by a dynamic Website featuring additional studio exercises, Web-based resources for students and teachers, and interactive problems for further study.

Acknowledgments

It has been quite a job and I've received a lot of help from my colleagues. At Northern Illinois University, School of Art Chair Adrian Tió has been relentlessly optimistic and highly supportive. From Syracuse University, I would like to thank Paul Nielsen and Sarah McCoubrey, who chaired the Art Foundation Department during this project, and were consistently helpful. Peter Forbes, Jude Lewis, Stephen Carlson, and Stan Rickel offered their encouragement and lots of help, and librarians Randall Bond and Terence Keenan provided prompt, gracious, and insightful advice on my many research questions. Mat Kelly, Ben Marra, and Akiyo Okura acted as my assistants at various points—each contributed ideas as well as energy to the book. I would particularly like to thank Jason Chin for commenting at length on many chapters, and Trisha Tripp and Cally Iden, whose critiques appear in chapter six.

Colorado College, where I worked as a scholar-in-residence in January 2000, also provided valuable support. I would especially like to thank Kate Leonard, who arranged my visit, librarian Leroy Smith, who created a storyboard Website for my students, and Carl Reed, whose advice substantially improved this book.

I would also like to thank the following artists and designers who contributed so generously to the Profiles which accompany each chapter:

Phillia Yi	*Printmaker*
Ann Baddeley Keister	*Weaver*
Ken Botnick	*Graphic Designer*
Ken Stout	*Painter*
Nancy Callahan	*Artist*
Diane Gallo	*Writer*
Heidi Lasher-Oakes	*Sculptor*
Bob Dacey	*Illustrator*

I am also grateful for the advice of the following reviewers, who responded thoughtfully to the project in various stages of development. Their opinions, suggestions, criticisms, and encouragement helped shape the book:

Scott Betz	*Weber State University*
Jeff Boshart	*Eastern Illinois University*
Peter Brown	*Ringling School of Art and Design*
Michael Croft	*University of Arizona*
Albert Grivetti	*Clarke College*
Ann Baddeley Keister	*Grand Valley State University*
Margaret Keller	*St. Louis Community College*
Karen Schory	*Johnson County Community College*

Finally, the McGraw-Hill team has been knowledgeable, supportive, and unfailingly enthusiastic. Sponsoring Editor Joe Hanson was wonderfully encouraging, and strongly committed to the design of this book as well as its content. Development Editor Cynthia Ward, Editorial Director Phil Butcher, Designers Keith McPherson and Pam Verros, Production Manager Mary Conzachi, and Marketing Manager David Patterson were highly accessible and wonderfully supportive throughout. Christine Baker, Editorial Project Manager for GTS Publishing Services,

preface

preface

offered clear production guidelines and kept the whole
project on track. And, Picture Researchers Elsa Peterson and
Judy Brody of Elsa Peterson Ltd. did a great job with my
many requests and obscure sources: without their detective
work, I could never have included such a wide range of
images in this book.

brief table of contents

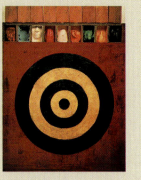

Introduction
Beginner's Mind, Open Mind

You are ready to embark on a marvelous journey. New technologies and exhibition venues offer dazzling new ways to produce, perform, and publicize visual ideas. Contemporary sculpture has expanded to include performance art and installations (i.1), and metalsmiths now use everything from plastics to precious metals to create inventive small-scale sculptures (i.2). Graphic designers develop many forms of visual communication, from shopping bags and exhibitions (i.3) to Websites, logos, and brochures. Film and video, the most popular forms of public storytelling worldwide, are becoming increasingly integrated with the Internet, which promises to extend visual communication even further (i.4). And, as a result of the extensive experimentation

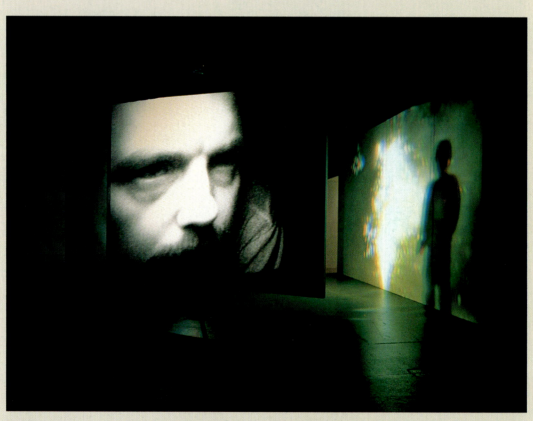

i.1 **Bill Viola, *Slowly Turning Narrative*, 1992.** Bill Viola's *Slowly Turning Narrative* consists of a large, rotating screen onto which moving images are projected. One side of the screen is a mirror, which reflects distorted images back into the room.

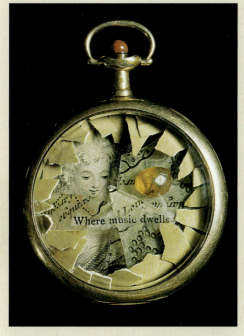

i.2 Keith E. LoBue, *Where the Music Dwells,* 1993. A broken pocket watch can become an evocative artwork when images and words are added.

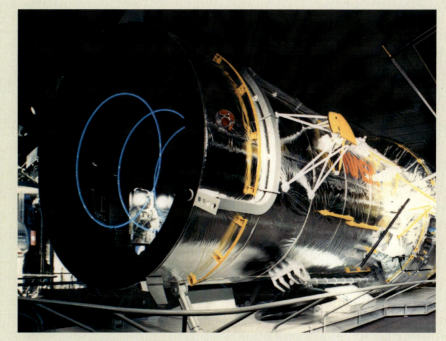

i.3 Bill Cannan & Co., NASA's Participating Exhibit at the 1989 Paris Air Show. To suggest the mystery of space travel and highlight individual displays, this NASA exhibition used dramatic pools of light within a mysterious dark setting.

i.4 Hans-Jürgen Syberberg, *Parsifal,* 1982. Syberberg combined live actors with oversized projections of dreamlike landscapes in his filmic interpretation of Richard Wagner's opera.

i.5 Christian Marclay, *Amplification,* 1995. The photographic images in this installation shift, fuse, and divide, depending on the position of the viewer.

with expression and abstraction in the twentieth century, the traditional arts of painting, printmaking, and photography (i.5) now offer expanded opportunities for introspective thinking and the development of a personal vision. The opportunities for exploration are endless. It is a great time to be studying art and design!

A journey of a thousand miles begins with one step. As a beginner, your first steps are especially important. Free of the preconceptions or habitual patterns that often paralyze more advanced students, beginners enter the learning experience with an open mind and an intense desire to learn. With no reputation to defend, they can more easily make the mistakes that are so essential to learning. Having taught students at all levels (from freshmen to graduate students and beyond), I have found that beginners of any age are the most courageous students by far. The open, unencumbered "beginner's mind" is wonderfully receptive and resilient. As a result, remarkable changes occur during the first year of study.

Defining the Basics

Launching the Imagination is designed to supplement and support a variety of introductory courses. These courses provide a general overview of studio art and often serve as prerequisites for many specific majors, ranging from advertising design to sculpture and video. Because it is impossible to teach the specific skills required for all these majors in one year, first-year courses focus on general knowledge and essential skills. These **foundation** classes are designed to provide the base on which more advanced study can be built.

Most schools divide this essential information into a variety of drawing and design courses. Drawing helps us develop a heightened awareness of the visual world and gives us many ways to translate our observations into images. At the foundation level, "design" refers to all other types of visual organization, from photography and collage to cardboard constructions and simple Websites. *Launching the Imagination* is devoted to all aspects of basic design.

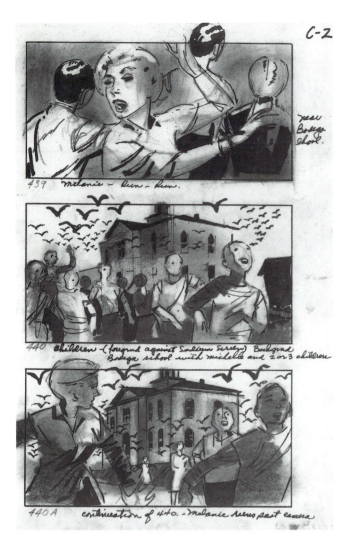

i.6 **Harold Michelson, Storyboard for Alfred Hitchcock's** *The Birds.* Storyboards are used to plan the sequence of events and compose the specific shots in a film. Alfred Hitchcock, who began his career as an artist, preplanned his films with exacting care.

Defining Design

The ideas and implications of basic design are extensive and complex. The compositions created by fine artists and the designs used in the applied arts are all derived from the same raw material. As a verb, design can be defined four ways:

- To plan, delineate, or define, as in designing a building.

- To create a deliberate sequence of images or events, as in developing a film storyboard (i.6).

- To create a functional object, as in product design (i.7).

- To organize disparate parts into a coherent whole, as in composing a brochure (i.8).

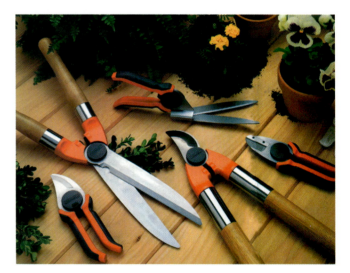

i.7 **Designworks/USA, Home Pro Garden Tool Line.** These five gardening tools are all based on the same basic combination of handle, blades, and simple pivot. Variations in proportion determine their use.

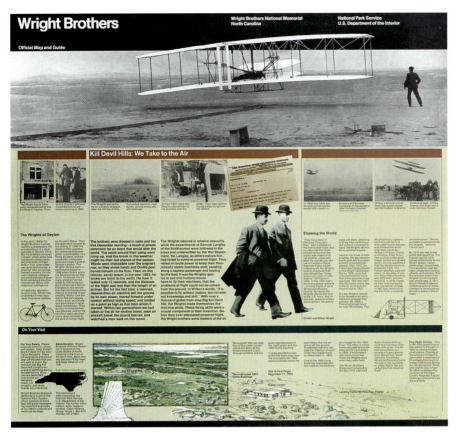

i.8 **Bruce Geyman, Brochure for the National Park Service.** Graphic designers often work with words and images equally. Blocks of text are carefully integrated into the visual composition.

i.9 Garden Design. An extensive layout is generally used for planning a garden. Matching the plants to the soil conditions, setting, climate, and overall intent saves money and improves results. In this case, the design is not an artwork in itself, but rather a plan of action.

As a noun, design may be defined as

- A plan or pattern, such as the layout for a garden (i.9).

- An arrangement of lines, shapes, colors, and textures into an artistic whole, as in the composition of a painting or sculpture (i.10).

Design is deliberate. Rather than hope for the best and accept the result, artists and designers explore a wide range of solutions to every problem, then choose the most promising option for further development. Even when chance is used to generate ideas, choices are often made before the results are shown. Design creates a bridge between artistic intention and compositional conclusion. As painter Joseph Albers noted, "To design is to plan and to organize, to order, to relate and to control."

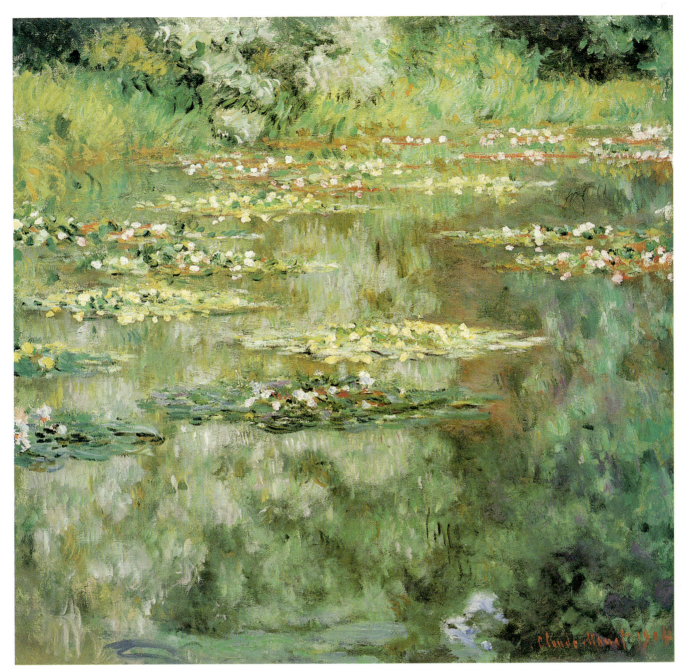

i.10 Claude Monet, *Waterlily Pond (Le Bassin des Nymphéas),* **1904.** Impressionist Claude Monet moved to the village of Giverny in 1883 and built an extensive water garden. The waterlilies he grew there inspired his last major series of paintings. Monet combined lines, shapes, textures, and colors to create a compelling illusion of a shimmering space.

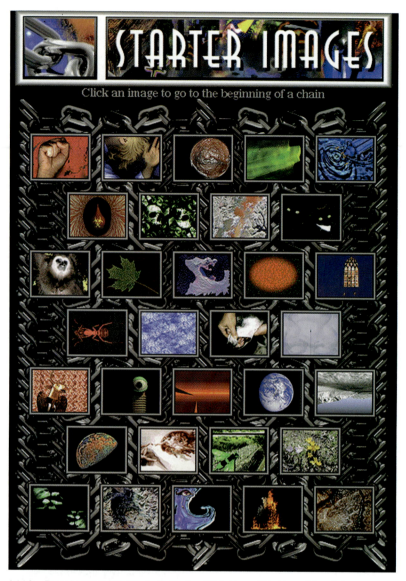

i.11A **Bonnie Mitchell, *Chain Art* Index Web Page.** Working with collaborators from around the world, Mitchell explores communication, cultural influences, and creativity in her projects.

Design Fundamentals

The title of this book defines its purpose. Painter Ken Stout has described the purpose of a foundation program clearly and simply. He says:

Imagine that each of your students is a rocket sitting on a launching pad. Each one has plenty of fuel and is ready to fly. As a foundation teacher, it is your job to fire them up, to get them off the ground. It is their job to keep the process going and to fly to the furthest reaches of their imagination.

The first year is indeed a launching pad. To help ignite your imagination, I have woven the following four themes into every chapter in this book.

Visual Communication Is Fundamental

Through the study of art, we can learn about ourselves and the world around us. For computer graphics master Bonnie Mitchell, the Web provides endless opportunities for innovation and expression. It all began with *Chain Art* (i.11) in 1992, at the very beginning of the Internet explosion. Mitchell sent an e-mail to six people, inviting their participation. They forwarded the message to many others, all around the globe. The respondents were then divided into 22 groups, and each received an incomplete starter image. One team member completed the image, which was then sent to another team member for further elaboration. This process continued until each team member completed a variation, producing a total of 136 images. All were shown on Mitchell's Website. Through this project, Mitchell and her collaborators explored their own ideas about creativity and learned about the creative processes of others. Using a new technology, they transformed personal expression into global communication.

Indeed, mastering the basics of visual communication is another reason to study art. The traditional Western emphasis on verbal communication is rapidly expanding. New technologies encourage us to integrate words, and images in Websites, books, and magazines. Some ideas are best expressed in words, while others can only be conveyed through images. This creates new applications for art and design in every field of knowledge, from anthropology to zoology.

Concepts Feed Communication

A concept may be defined as a well-developed thought. By developing rich concepts, we set the stage for the development of inventive objects and images. Dull concepts, on the other hand, generally result in dull images. In any foundation course, we often see predictable solutions to predictable problems. These include the use of a jagged red line to convey anger, or a skull and a pool of blood to suggest death. Each of these choices is usually effective—but rarely inspiring. We've seen it all before. By developing new approaches and new ideas, we can personalize our communication and make our messages memorable.

Developing concepts is just as much work as developing technical skills. As is the case with any new task, your first efforts at concept development may be frustrating. Initially, your ideas may seem foolish or inadequate. A willingness to explore and experiment is essential. With a combination of hard work and a sense of adventure, your ideas will improve rapidly. To help in this process, Chapter Five provides two major problem-solving strategies and many examples of concept development.

Concept + Composition = Communication

Developing a great idea is only half the battle. To reach an audience, the idea must be communicated visually, through composition. Composition may be defined as "the combination of multiple parts into a harmonious whole." For example, a simple musical composition consists of an arrangement of multiple notes to create melodies and harmonies that are sung or played in a particular rhythm.

i.11B *Chain Art*, details.

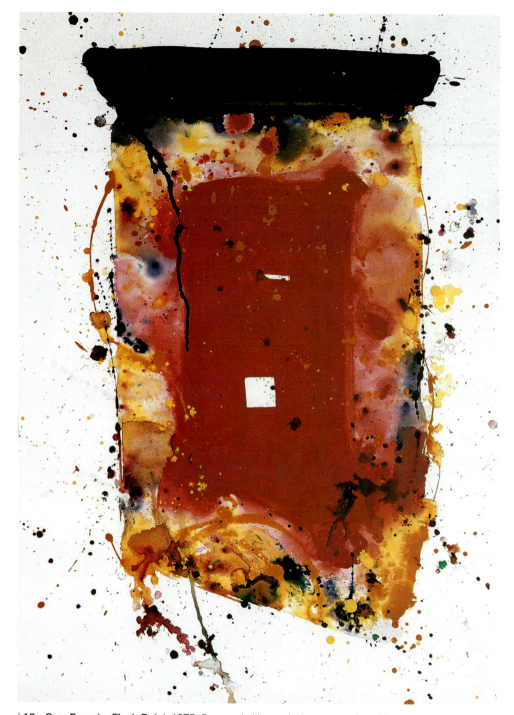

i.12 Sam Francis, *Flash Point,* 1975. Surrounded by explosive energy, the white square in the center of this painting provides a unifying focal point.

Two-dimensional compositions are constructed from lines, shapes, textures, values, and colors that have been arranged to create a unified whole (i.12). Lines, planes, volumes, masses, and space are the most basic components of a three-dimensional composition (i.13). Time design, including video, photography, performance, kinetic sculpture (i.14),

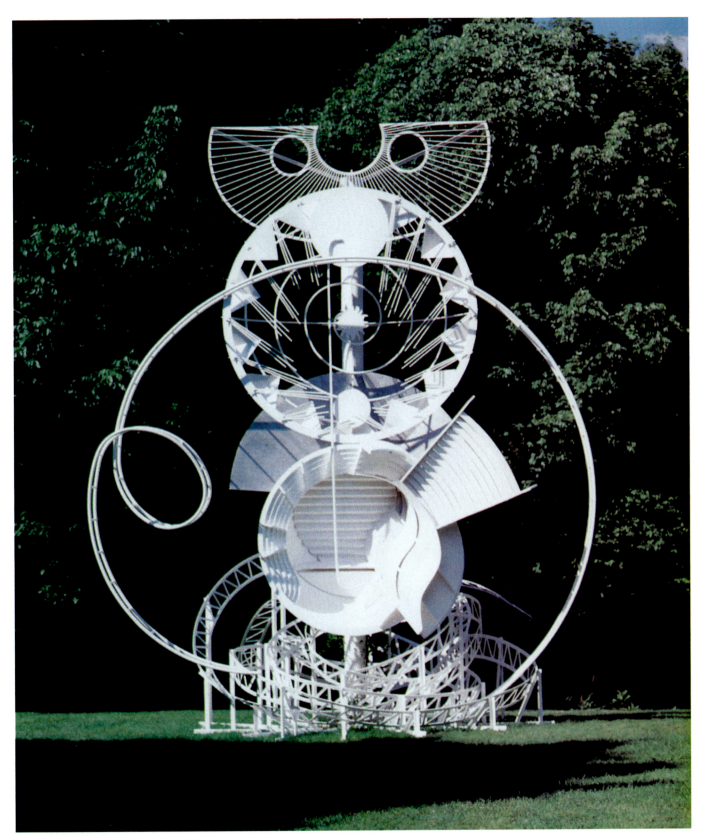

i.13 Alice Aycock, *Tree of Life Fantasy: Synopsis of the Book of Questions Concerning the World Order and/or the Order of Worlds,* **1990–92.** Inspired by the double-helix structure of DNA and by medieval illustrations representing the entrance to paradise as a spinning hole in the sky, Aycock has combined a linear structure with a series of circular planes and a lot of open space. The resulting sculpture is as open and playful as a roller coaster.

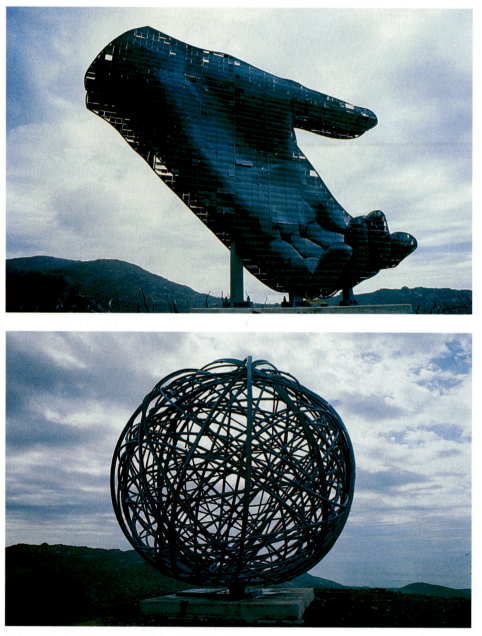

i.14 Todd Slaughter, *Mano y Balo* (details), 1997. Constructed using over one thousand movable panels, the monumental hand appears and disappears as the wind blows.

and the book arts (i.15), is based on the juxtaposition of images and events. A great idea never saved a bad painting. Art and design are visual forms of communication: without careful composition, a great idea may be lost.

Developing a wide range of solutions to every problem is the quickest way to master composition. Small, quick studies are often used to explore the

i.15 Paul Jenkins and Jae Lee, from *Inhumans*: "First Contact," March 1999.
Comic books, like films, rely on development of characters, use of "camera" angles, and the organization of multiple images.

possibilities. By translating a mental image into a rough sketch, you can immediately see whether the idea has potential. Furthermore, the best way to have a good idea is to have a lot of ideas. If you explore only one idea, you are far less likely to produce an inventive image. By selecting the best rough composition from 20 sketches, you will have a good beginning point for your final design.

While the compositions created by experienced artists and designers may convey all sorts of complex ideas, at the foundation level composition is often distilled down to **pure form.** Form may be defined as the physical manifestation of an idea. For example, Sam Francis' painting in Figure i.12 is formed by a small square surrounded by an irregular rectangular shape. A series of circles and curving lines creates the sculptural form of *Tree of Life Fantasy* (i.13) by Alice Aycock. Form is created whenever the elements of design are combined.

Translating elusive ideas and emotions into tangible form is one of the greatest challenges for any artist or designer. Simply inventing various ways to balance a circle, cross, and line provides a heightened understanding of basic visual relationships (i.16). When we tackle composition at such a fundamental level, we have only the elements and principles of design as companions. We cannot rely on our brilliant ideas or eloquent explanations to get us out of a compositional jam.

Critical Judgment Supports Creative Thinking

Imagine yourself ruby mining in North Carolina. It is a sunny day and you are surrounded by rolling hills. To your right is a series of pits, half full of mud. To your left, a stream has been directed into a wooden trough. Benches and open trays with wire mesh on the bottom face the trough. You start by shoveling mud into two buckets, then head to the trough to wash it out in the flowing water. When the mud is removed, small bits of gravel remain in the washing tray. If you are lucky, you may find rubies, sapphires, or garnets in this gravel.

However, you will only find these treasures if you know where to look. Except for its six-sided shape, an uncut ruby looks like any other stone. Likewise, determining which ideas and images have the most potential requires a trained eye. You must be able to spot the compositional gems while

i.16 Mary Stewart, *Formal Relationships* **(Exercise), 2001.** The relationships between the parts and the whole determine the visual quality of a design. To explore a wide range of relationships, artists and designers often complete many small studies before developing more elaborate work.

discarding the compositional gravel. Critiques, or group discussions of artwork, are the most common means by which such visual thinking is developed. By describing an image, comparing it to the other artworks on display, identifying its greatest strengths, or proposing alternative solutions, you can learn a great deal about composition and communication.

Putting It All Together

In the pages that follow, the ideas presented in this introduction are explored in depth. Over 600 images supply visual examples from many cultures and in all areas of art and design. Fourteen interviews with living artists provide insight into the creative process.

Reading this book, however, is just the first step. True understanding comes through your own efforts combined with the direction your teachers can provide. Remember that basic drawing and design courses provide the foundation on which all subsequent courses are built. You are only a beginner once in your entire life: this is not a rehearsal. By using your time well, you really *can* get the rocket off the launching pad.

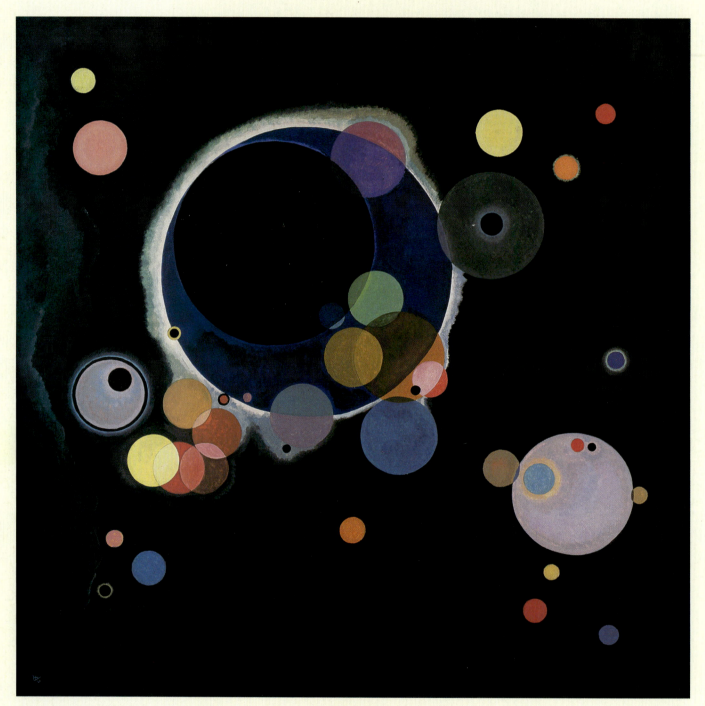

Wassily Kandinsky, *Several Circles,* **1926.** Oil on canvas, 55¼ × 55⅜ in. (140.3 × 140.7 cm).

Two-Dimensional Design

The careful observation required for drawing, the understanding of color required for watercolor painting, and the craftsmanship required for metalsmithing can increase awareness of ourselves and our world. On a personal level, making art heightens our attention, engages our emotions, and provides a sense of accomplishment. Creating objects and images is engrossing and exhilarating. These personal rewards make art one of the most popular hobbies.

The professional artist or designer must translate these personal insights into public communication. No one will pay for the production of meaningless images. The ideas and emotions a professional wishes to express must engage an audience, whether the communication occurs in the silence of a museum or in the chaos of a city street.

This ability to communicate visually is developed through years of study plus relentless practice. Artists and designers must develop their visual awareness, develop engaging ideas, and master various techniques. Fully committed to their work, they spend hours in the studio, refining ideas and inventing alternative solutions to visual problems.

A journey of one thousand miles begins with one step. In the chapters that follow, we will begin by defining several basic elements and principles of design and explore their expressive qualities. Chapter One focuses on the basic elements of two-dimensional design. Chapter Two is devoted to the characteristics and compositional impact of color. Chapter Three is devoted to the organization of all the elements of design into increasingly complex compositions. These readings, combined with studio assignments, can help you build the base of visual knowledge needed for art and design at a personal as well as a professional level.

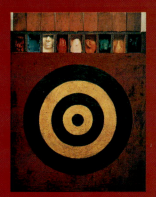

Two-Dimensional Design:
Elements

Line, shape, texture, value, and color are the building blocks from which two-dimensional designs are made. Just as oxygen and hydrogen are powerful both individually and when combined as H_2O, so the visual elements are powerful both individually and in combination. In this chapter we explore the unique characteristics of line, shape, texture, and value, and then analyze their uses in art and design. Color, the most complex visual element, is discussed in Chapter Two. In Chapter Three, the design elements are combined to create complex compositions.

Line

Defining Line

Line is one of the simplest and most versatile elements of design. Line may be defined as

- A point in motion (1.1A).

- A series of adjacent points (1.1B).

- A connection between points (1.1C).

- An implied connection between points (1.1D).

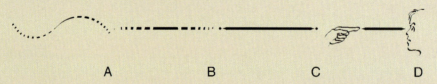

| | | | |
| A | B | C | D |

1.1 Despite its apparent simplicity, line can be created in many ways and can play many roles in a design.

The inherent dynamism of line is embodied in the first definition. Lighter and more fluid than any of the other visual elements, line can add a special energy to a design. To retain this enegy, the line must be substantially longer than it is wide. The remaining three definitions emphasize the connective power of line. Simply by drawing a line, we can create a bridge between separate visual elements.

Types of Line

Actual Lines

As shown in Figure 1.2, a wide variety of lines can be produced using graphite, markers, or brushes. Many drawings are entirely composed from lines. In Figure 1.3, Eleanor Dickinson used **contour lines** to describe both the inner and outer edges of a woman's hands. In Figure 1.4, Rembrandt used a chalk line to define the spheres and cylindrical volumes from which the moving figures are made. Because it uses such basic forms to communicate visual information, this type of drawing is often called a **volume summary.** Rico Lebrun's **gesture drawing** of a hand (1.5) combines contour, volume, and movement. More concerned with action than anatomical detail, this drawing captures the movement of the muscular hand.

1.2 Every tool produces a distinctive line.

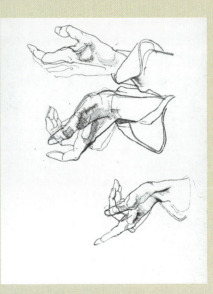

1.3 Eleanor Dickinson, *Study of Hands,* **1964.** Pen and ink, 13⅛ × 10⅛ in. (34 × 26 cm).

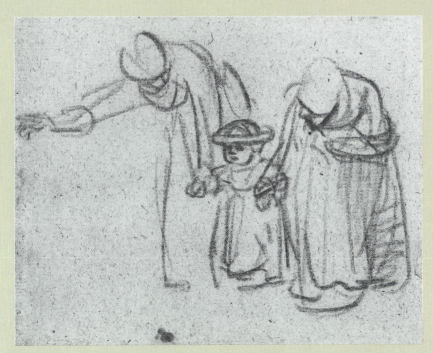

1.4 Rembrandt van Rijn, *Two Women Helping a Child to Walk,* **c. 1635–37.** Black chalk.

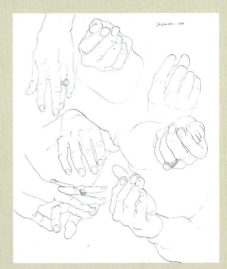

1.5 Rico Lebrun, *Hand,* **1964.** Pen and ink.

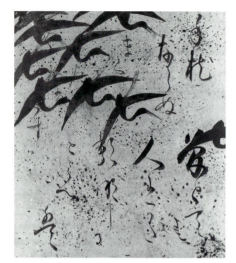

1.6 Attributed to Tawaraya Sôtatsu, calligraphy by Hon'ami Koetsu, *Flying Cranes and Poetry,* Edo period **(1615–1868).** Ink on gray-blue paper, gold flecked, 7⅝ × 6⅜ in. (19 × 16 cm).

1.7 Wu Guanzhong, *Pine Spirit,* **1984.** Chinese ink, color on paper, 2 ft 3⅝ in. × 5 ft 3½ in. (70 × 140 cm).

Calligraphic lines can add even more energy to a drawing or a design. The word *calligraphy* is derived from two Greek words: *kalus,* meaning "beautiful," and *graphein,* meaning "to write." Like handwriting, the calligraphic line is personal, eloquent, and highly expressive. In Figure 1.6, words and images are combined in a celebration of flight. In this image, painter Tawaraya Sôtatsu and calligrapher Hon'ami Koetsu used variations in line weight and velocity to suggest the graceful motion of birds. This exploration of movement is pushed even further in *Pine Spirit,* by Wu Guanzhong (1.7) Fluid ink lines record the movement of the artist's hand while simultaneously creating an abstract landscape. There is a wonderful economy in each

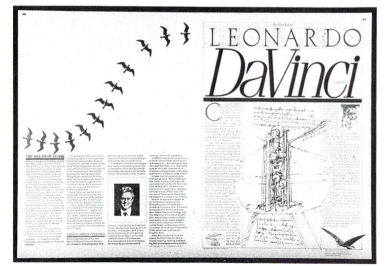

1.8 B. Martin Pedersen, Page Layout: Leonardo da Vinci, March 1982.

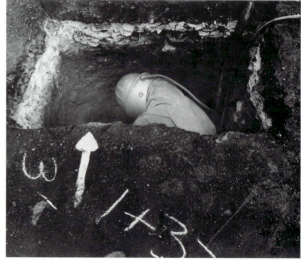

1.9 Minor White, *Sandblaster,* San Francisco, 1949. Gelatin silver print, 10⁷⁄₁₆ × 11⁷⁄₁₆ in.

of these drawings: like poetry, the story is fully told using minimal means.

Implied Lines

Given enough clues, the human mind will combine separate visual parts by filling in the missing pieces. This inclination for **closure** is so strong that connections will be made even when lines are **implied,** rather than drawn. Broken lines become continuous. In B. Martin Pedersen's Leonardo da Vinci layout (1.8), closure creates an elegant curve while breaks in the line emphasize the energy of flying birds. Visual bridges are built. The actual arrow in Minor White's photograph (1.9) extends by implication to connect the worker's helmet to the numbers in the foreground. Compositional structure may be revealed. In Alfred Leslie's *The Killing Cycle* (1.10), the single woman in the lower left corner is connected to the four figures in the upper right by the dead man on the diagonal board. Bent arms and legs create even more diagonal lines.

In *Design Basics,* David Lauer describes an especially elegant form of closure as "lost and found" contours.[1] Some paintings can easily be reduced to a clear, concise line drawing. In other paintings, the edges of volumes are less clearly defined, causing figure and ground to merge. Both approaches are used in *The Killing Cycle,* as the top four figures are clearly delineated while the lower two figures begin to merge with the surrounding space. This effect is even more pronounced in Caravaggio's *The Deposition* (1.11A), from which Leslie derived his inspiration. A line drawing of this image has many gaps, as details are lost in the shadows (1.11B). Used skillfully, this loss of definition becomes a strength rather than a weakness. Connections made through closure can stimulate the viewer's imagination and increase visual impact.

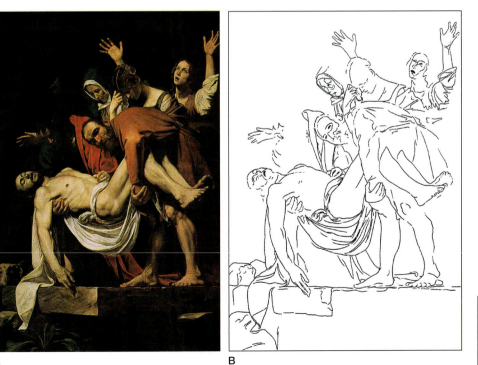

1.10 Alfred Leslie, *The Killing Cycle (#5): Loading Pier,* 1975. Oil on canvas, 9 × 6 ft (2.7 × 1.8 m).

A **B**

1.11 Caravaggio, *The Deposition,* 1604. Oil on canvas, 9 ft 10⅛ in. × 6 ft 7⅞ in. (3 × 2.03 m).

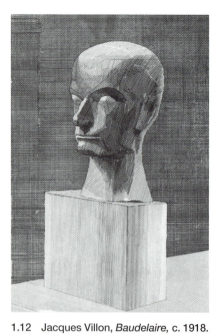

1.12 Jacques Villon, *Baudelaire*, c. 1918. Etching, printed in black, plate 16⁵/₁₆ × 11 in. (41.4 × 28 cm).

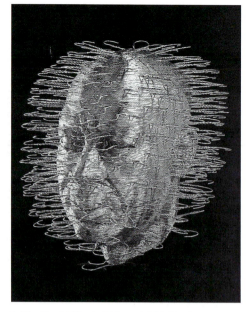

1.13 David Mach, *Eckow*, 1997. Coathangers, 2 ft 2¼ in. × 1 ft 11½ in. × 2 ft 5½ in. (67 × 60 × 75 cm).

Line Networks

When grouped together, multiple lines and line networks can further describe volume and suggest space. **Hatching,** a technique often used in printmaking and drawing, produces a range of grays through straight parallel lines. Even a wider range of grays can be produced through **cross-hatching,** which creates networks of lines. Jacques Villon's portrait of the poet Charles Baudelaire (1.12) is divided into faceted planes, with layers of lines providing both the structure and the shadows. Each set of lines emphasizes the angularity of the plane it defines, and each plane adds to the illusion of the three-dimensional head. **Cross contours,** created through curving parallel lines, can create an even more powerful illusion of dimensionality. By bending coat hangers into the curves and depressions defining the head (1.13), David Mach has created a type of topographic map. These lines form an actual sculpture, which has been photographically reduced to create the two-dimensional image shown here. By combining hatching, cross-hatching, and cross contour in *Head of a Satyr* (1.14), Michelangelo carved out an image that clearly describes the curves and planes of the head while retaining the energy of the liveliest gesture drawing.

Expressive Uses of Line

Lines can contain, define, dissect, or combine elements within a composition. Each aspect of line is equally important. Two lines dominate Barnett Newman's *Stations of the Cross: Lema Sabachthani, The First Station* (1.15). The hard black line is as emphatic as a mathematical equation. Despite its great height, this line gains stability through its position along the left edge of the painting. In contrast, the line on the right is agitated and exposed, surrounded by open space rather than being supported by a firm edge. In this painting, Newman sought to convey both

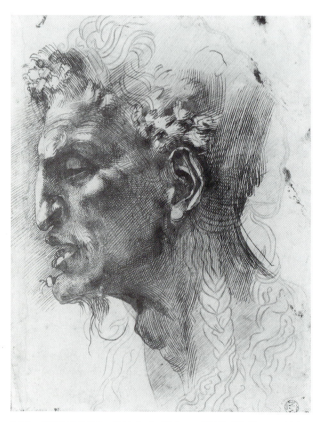

1.14 Michelangelo, *Head of a Satyr*, c.1620–30. Pen and ink over chalk, 10⁵/₈ × 7⁷/₈ in. (27 × 20 cm).

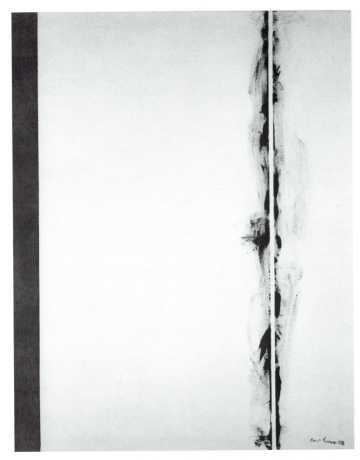

1.15 Barnett Newman, *Stations of the Cross: Lema Sabachthani, The First Station,* **1958.** Magna on canvas, 6 ft 5⅞ in. × 5 ft ½ in. (1.98 × 1.54 cm).

1.16 Ad by Citizens Against Cocaine Abuse: "**The average high induced by cocaine lasts thirty minutes. The average death induced by cocaine lasts slightly longer.**" Art Director & Designer: Gary Goldsmith, Copywriter: Neal Gomberg, Agency: Goldsmith/Jeffrey, Client: Citizens Against Cocaine Abuse.

1.17 Crispin Prebys, Cover of *Paleoanthropology,* 2nd ed., by Milford H. Wolpoff, 1999. Drawing of a skull.

1.18 In this drawing, the edges of the format create a strong boundary.

spiritual strength and human suffering using the most minimal means possible.

In an ad for an antidrug campaign, Gary Goldsmith used a similar economy of line (1.16). When combined with a sentence describing the brevity of a cocaine high and a sentence suggesting the finality of death, the boundary between the narrow white line and the large black rectangle becomes the boundary between life and death.

Lines also can be used to expand or compress an image. The bold horizontal line in Crispin Prebys's textbook cover design (1.17) provides an anchor for the title while visually expanding the design. Like a time line, the cover image seems to continue right into the book. On the other hand, a compressive force at the edge of the composition is opposed by the explosive force of the basketball players in Figure 1.18. Asymmetrical balance and spatial exaggeration add to the effect and convey the message that these players are really pushing the limits.

1.19 **John Baldessari,** *Heel,* **1986.** Black-and-white photographs with oil tint, oil stick and acrylic, mounted on board, 8 ft 10½ in. × 7 ft 3 in. (2.7 × 2.2 m).

1.20 Brochure from an American Institute of Graphic Arts conference "Design 2 Business, October 5–6 '96 NYC."

Lines can serve many purposes at once. In John Baldessari's *Heel* (1.19), a curving red line near the center of the painting connects the people on the plaza, while the vertical and horizontal black lines simultaneously contain and connect nine different images of heels. In an advertisement for the American Institute of Graphic Artists (1.20), two vertical dotted lines highlight the speaker's schedule, while a horizontal line dissects the "design to business" logo. Inside the brochure, an arrow line connects the D, 2, and B, reinforcing the same theme. Even the columns of text can be read as lines. Despite their apparent simplicity, lines bring both power and grace to these two compositions.

Shape

Defining Shape

A **shape** is created when

A B C D

1.21 Any form of enclosure can create a shape.

- A line connects to enclose an area (1.21A).

- An area of color or texture is defined by a clear boundary (1.21B, 1.21C).

- An area is surrounded (1.21D).

In two-dimensional design, a shape that seems three dimensional is called a **volume.** This illusion of space is generally created using lighting.

1.22 Variations in lighting can transform a shape into an illusory volume.

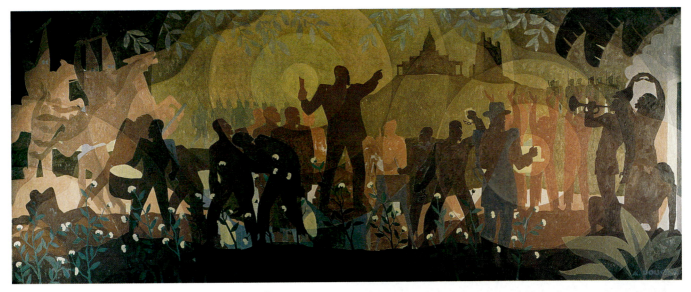

1.23 Aaron Douglas, *Aspects of Negro Life: From Slavery Through Reconstruction,* **1934.** Oil on canvas, 5 ft × 11 ft 7 in. (1.52 × 3.5 m).

Through lighting, a three-dimensional solid can be defined on a flat surface using a series of **values,** or gray tones. In drawing, continuous values are used to create **shading,** or **gradation.** For example, in Figure 1.22, an angular shape becomes a faceted polyhedron through variations in lighting.

Both shape and volume can be used to create a compelling composition. In Aaron Douglas' *From Slavery Through Reconstruction* (1.23), overlapping shapes and transparent targets create an energetic panorama. We can almost hear the speaker in the center and feel the movement of the crowd.

In Rivera's *Detroit Industry* (1.24), shading and perspective have been added to increase the illusion of space. The overlapping shapes have been methodically organized in a structure known as one-point perspective (which is discussed at length in Chapter Three). The use of shading gives the men and machinery a three-dimensional look.

Graphic designers are equally aware of the unique power of both flat shapes and dimensional volumes. In a cover for *Ulysses* (1.25), Carin Goldberg used crisp, simple shapes to create a dramatic design. The primary colors of red, yellow, and blue combined with the tilted text block immediately attract attention. Krystyna Skalski and John Jinks used a very different approach in their cover for a mystery novel (1.26). Every shape is gradated to suggest a light

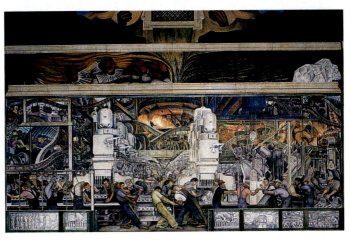

1.24 Diego M. Rivera, *Detroit Industry, north wall,* **1932–33.** Fresco, 17 ft 8½ in. × 45 ft (5.4 × 13.7 m).

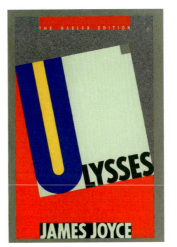

1.25 Cover of *Ulysses,* by James Joyce, 1986. Designer: Carin Goldberg.

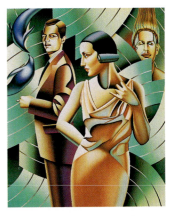

1.26 Cover image from *The Penguin Pool Murder,* a Hildegarde Withers Mystery, by Stuart Palmer. Art Director & Designer: Krystyna Skalski, Illustrator: John Jinks.

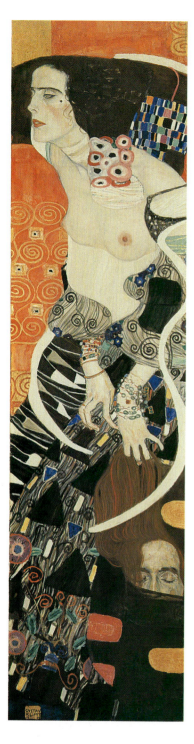

1.27 Gustav Klimt, Salomé, 1909. Oil on canvas, 70⅛ × 18⅛ in. (178 × 46 cm).

source and create the illusion of space. Both approaches are appropriate to the literary content. Many readers consider *Ulysses* one of the most complex novels ever written: any suggestion that the corrected text may increase clarity could be welcome. On the other hand, twisting plots and surprise endings delight the readers of mystery novels. For them, simplicity is rarely a virtue.

Flat shapes have been combined with dimensional volumes in Gustav Klimt's *Salomé* (1.27). In this horrific tale from the *New Testament*, John the Baptist, held prisoner in the palace, has rejected the sexual advances of Salomé, the king's niece. After she performs a stunning dance, the delighted king grants her a single wish. In revenge, Salomé asks for the head of the prophet John. Klimt's painting is dominated by the beautiful Salomé whose curled fingers clutch the suspended head of the prophet. Flat patterns and color surround the volumetric figures, while two curving lines add a sinuous energy to the center of the design.

Types of Shape

The **format,** or outer edge of a design, provides the first shape in the composition. For example, the circular shape of the 100-yuan coin substantially affects the dragon composition on the front and the landscape on the back (1.28). Likewise, the tall rectangle used for Klimt's *Salomé* compresses the sordid drama into a narrow, vertical shape, while the long horizontal rectangles used by Douglas and Rivera provide a broad panorama.

Postive and Negative

As shown in Figure 1.29A, this basic compositional shape is often called the **negative shape,** or **ground,** while any shape added to this compositional playing field is called a **positive shape,** or **figure.** Depending on the location within the ground, the figure can become dynamic or static, leaden or buoyant (1.29 B–D).

1.28 1988 silver coin from China, worth 100 Yuan, obverse & reverse.

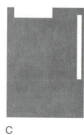

A B C D **1.29**

1.30 Bill Brandt, *Nude*, 1952. Gelatin silver print.

When the figure and ground are equally well designed, every square inch of the image becomes engaged. In Bill Brandt's photograph (1.30), the dark negative shapes define the positive figure while the brightly lit arm, face, and breast define the edges of the dark ground. In a cubist painting, such as Georges Braque's *Man with a Guitar* (1.31), the figure and ground often merge and shift, constantly activating the space inside and outside the musician. In such paintings, the simple fixed viewpoint of Newtonian physics and traditional perspective have been shattered. Echoing Einstein, the cubists dissolved matter to create compositional energy.

Figure/ground reversal creates another kind of force, as first the positive then the negative shapes command attention. M. C. Escher was a master of figure/ground reversal, as shown in this fragment from *Metamorphosis II* (1.32). Bees change into hexagons that soon change into lizards. Shifts between the black and white shapes continually animate the 13-foot-long composition.

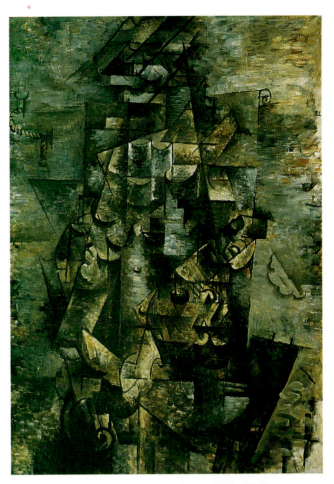

1.31 Georges Braque, *Man with a Guitar*, 1911–12. Oil on canvas, 45¾ × 31⅞ in. (116.2 × 80.9 cm).

1.32 M. C. Escher, part of *Metamorphosis II*, 1939–40. Woodcut in black, green, and brown, printed from twenty blocks on three combined sheets, 7½ × 153⅜ in. (19 × 390 cm).

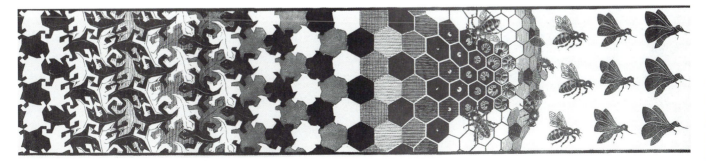

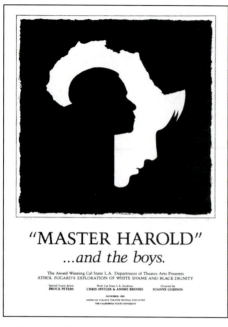

1.33 David McNutt, *"Master Harold" . . . and the Boys,* 1985. Poster.

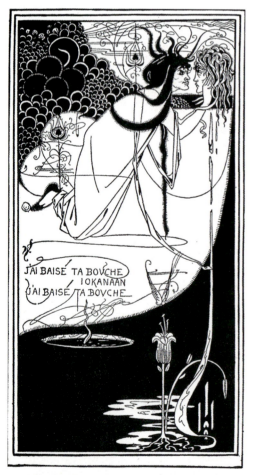

1.35 Aubrey Beardsley, *Salomé with the Head of John the Baptist,* 1894. Line block print, 11 × 6 in. (27.9 × 15.2 cm).

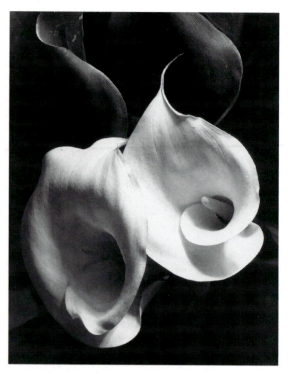

1.34 Imogen Cunningham, *Two Callas,* c. 1929. Gelatin silver print.

Figure/ground reversal is often used to create mutiple interpretations using minimal shapes. In Figure 1.33, David McNutt uses a single white shape on a black ground to create the head of a master and a servant within the outline of Africa. Used to advertise a South African play, the poster immediately communicates a basic human relationship within a specific cultural context.

Rectilinear/Curvilinear

Rectilinear shapes are dominated by straight lines and angular corners, while curves and flowing lines create **curvilinear shapes,** as shown in this photograph by Imogen Cunningham (1.34). Simple rectilinear shapes, such as squares and rectangles, are highly cooperative. When placed within a standard format, they easily lose their identity and become part of a unified design. Curvilinear shapes, especially circles, are often less cooperative. They retain individuality even when they are partially concealed by other shapes.

Aubrey Beardsley combined rectilinear and curvilinear shapes to create his *Salomé with the Head of John the Baptist* (1.35). The rectilinear format is strongly defined by three repeated lines. Within

this boundary, curving black and white shapes create a complex composition that is dominated by the bubble pattern in the upper left corner, Salomé with John's head in the right corner, and a flower at the bottom edge. Packed with lines and shapes, this drawing captures many aspects of a complex story.

A very different combination of rectilinear and curvilinear shapes activates Robert Rauschenberg's *Brace* (1.36). The central image of three baseball players is surrounded by agitated rectangles to the right, left, and bottom, while a solid line extends from the catcher to the top edge. Bold, curving brush strokes add power to the painting. Occupying only a small fraction of the composition and surrounded by vigorously painted shapes, the circle *still* dominates the design: we *have* to keep our eyes on the ball!

Geometric/Organic

Geometric shapes are distinguished by their crisp, precise edges and mathematically consistent curves. They dominate the technological world of architecture and industry and also appear in crystalline structures and natural growth patterns, such as the spiral. In Valerie Jaudon's *Tallahatchee* (1.37), geometric shapes provide a clarity, harmony, and universality comparable to a mathematical equation. **Organic shapes** are more commonly found in the natural world of plants and animals, sea and sky. As shown in Helen Frankenthaler's *Interior Landscape* (1.38), organic shapes can bring an unpredictable energy in a design.

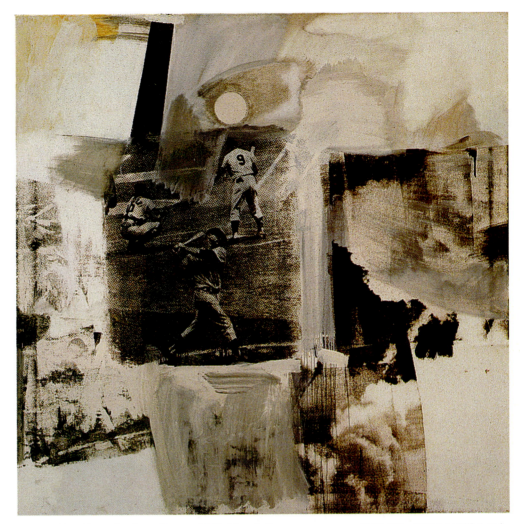

1.36 Robert Rauschenberg, *Brace,* 1962. Oil and silkscreen on canvas, 60 × 60 in. (152.4 × 152.4 cm).

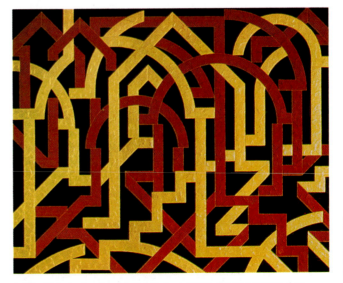

1.37 Valerie Jaudon, *Tallahatchee,* 1984. Oil and gold leaf on canvas, 6 ft 8 in. × 8 ft (2 × 2.4 m).

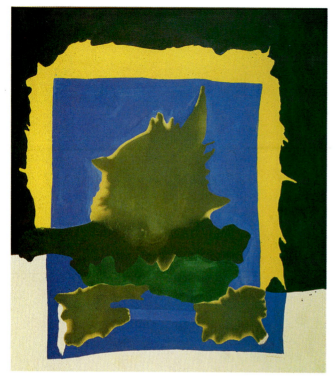

1.38 Helen Frankenthaler, *Interior Landscape*, 1964. Acrylic on canvas, 8 ft 8⅞ in. × 7 ft 8⅝ in. (266 × 235 cm).

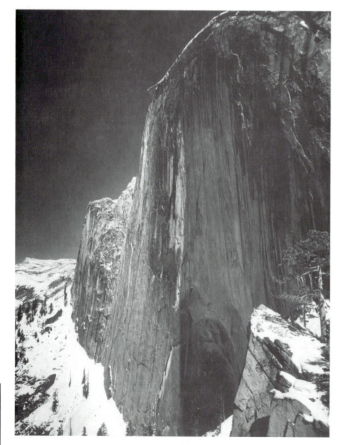

1.39 Ansel Adams, *Monolith, The Face of Half Dome, Yosemite Valley.* Photograph.

Representational, Nonobjective, and Abstract Shapes

Representational or **descriptive shapes** are derived from specific subject matter and strongly based on perceptual reality. For example, in Ansel Adams' *Monolith, The Face of Half Dome, Yosemite Valley* (1.39), every toehold on the steep cliff is clearly defined. Indeed, Adams' photograph gains its power from the clarity of its description. **Nonobjective shapes** such as circles, squares, and triangles are **pure forms,** created without reference to specific subject matter. Between these two extremes, **abstract shapes** are derived from a visual source, but are so transformed that they bear little resemblance to the referent. As a result, the abstracted cliff in Moskowitz's *Seventh Sister* (1.40) becomes a universal representation of a vertical surface as well as a painting of a particular cliff.

When working descriptively, the artist gains meaning through the reference to reality. Drawing from their own experience, viewers can expand on the visual information presented. When nonobjective shapes are used, the energy in the design must come from the visual relationships created. Compositional relationships such as the orientation of shapes, interaction of color, and the use of the format edge must now generate all of the impact.

Working abstractly, the artist can retain the power of association while accentuating visual dynamics. By reducing the factory structure to a series of interlocking verticals, circles, and diagonals, Charles Demuth created a graceful abstraction of an architectural space in Figure 1.41. Likewise, while Cartier-Bresson's *Valencia* (1.42) is photographically descriptive, its power is based on a complex composition as well as on specific content. Sharply focused and framed by the window, the policeman's face dominates the foreground. Squeezed between the target shapes and the wall on the left, the boy turns toward us apprehensively. The dissected target is balanced by the monocle on the right and the boy's face on the left. Horizontal rectangles compress three of the four corners of the composition. The resulting interplay of shapes creates a complex dialog between childhood fears and adult authority.

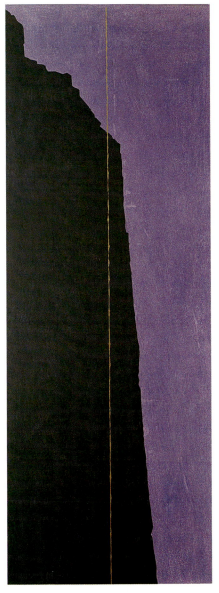

1.40 Robert Moskowitz, *Seventh Sister,* **1982.** Oil on canvas, 108 × 39 in. (274.3 × 99 cm).

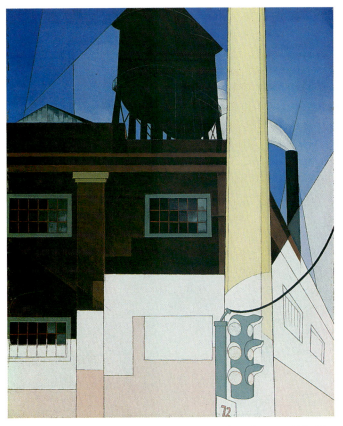

1.41 Charles Demuth, . . . *And the Home of the Brave,* **1931.** Oil on composition board, 29¹/₂ × 23⁵/₈ in. (74.8 × 59.7 cm).

Degrees of Definition

Definition is the degree to which a shape is distinguished from both the ground area and the other shapes within the design. **High definition,** creates strong contrast between shapes and tends to increase clarity and immediacy of communication. For this reason, the diagrams used in this book generally use black figures on a white ground. **Low-definition** shapes, including gradations, transparencies, and soft-edged shapes, can increase the complexity of the design and often encourage multiple interpretations.

1.42 Henri Cartier-Bresson, *Valencia,* **1933.** Photograph.

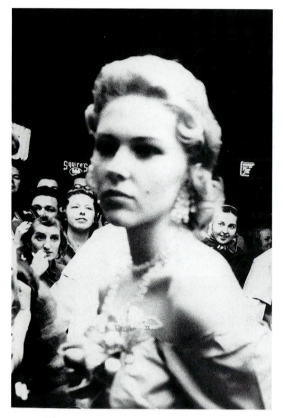

1.43 Robert Frank, *Movie Premiere, Hollywood,* from *The Americans,* 1955–56. Gelatin silver photograph, 12½ × 8⅜ in. (31.75 × 21.27 cm).

Definition is an inherent quality in photography. In addition to variations in focus, the photographer can choose finer-grained film and slick paper for a sharper focus and coarser-grained film and matte paper for a softer focus. Variations in definition can change meaning. In *Movie Premiere, Hollywood* (1.43), Robert Frank reverses our expectations, both spatially and conceptually. He focuses on the faces of the worshiping crowd rather than on the somber actress, who seems trapped by her fans. The meaning of the photograph shifts from a Hollywood cliché to an exploration of the darker side of fame.

Definition also plays an important role in drawing. Many mediums, including graphite and charcoal, can be used to create strong, clear lines as well as soft, fuzzy shapes. In Sidney Goodman's *Man Waiting* (1.44), this effect enhances the illusion of space while simultaneously creating a sense of mystery. The darker, more clearly defined shapes in the upper torso seem to push toward us while the legs, hips, and chair dissolve into the background.

Expressive Uses of Shape

The shape of each page plays a major role in Claire Van Vliet's design for *Aunt Sallie's Lament* (1.45). A square cover, dominated by a diamond shape, sets the stage for this tale of an old woman's lost love. Bits of dialog appear on the pages, contrasting her broken heart with her friends' joyous weddings. As the book and the story unfold, the diamond-shaped pages gradually accumulate to form the image of a completed quilt.

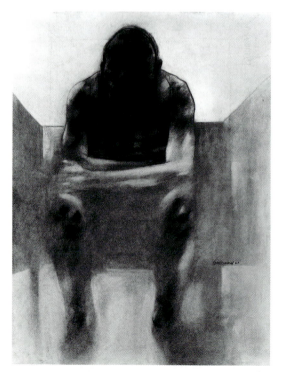

1.44 Sidney Goodman, *Man Waiting,* 1961. Charcoal on paper, 25⅝ × 19⅛ in. (65.1 × 48.7 cm).

1.45 Claire Van Vliet, book cover of *Aunt Sallie's Lament,* by Margaret Kaufman. Chronicle Books, 1993.

A series of concentric circles creates the target shape that dominates Jasper Johns' *Target with Plaster Casts* (1.46). Nine figurative fragments line the upper edge. Equally attracted to the body parts above and the target below, we enter a visual combat zone as soon as we encounter this painting. To add further complexity, scraps of newspaper were embedded in the colored wax from which the painting was constructed. This **collage** (an image constructed from fragments initally designed for another purpose) adds a verbal undercurrent to a powerful visual image.

Collage plays an even bigger role in Romare Bearden's *The Dove* (1.47). The outer edges of each photographic fragment create one set of shapes. The textures and volumes within each of these fragments create a second set of shapes. Through the combination of the cut and photographic edges, Bearden has created a complex pattern of shifting shapes.

Texture

Defining Texture

The surface quality of a two-dimensional shape or three-dimensional volume is called **texture. Tactile texture** can actually be felt. **Visual texture** can be created using multiple shapes or through the simulation of physical texture. Texture creates a bridge between two- and three-dimensional design. Through an appeal to our sense of touch, it creates a unique connection between image and audience.

Creating Texture

Texture can be created in four major ways.

First, each material has its own textural quality. The

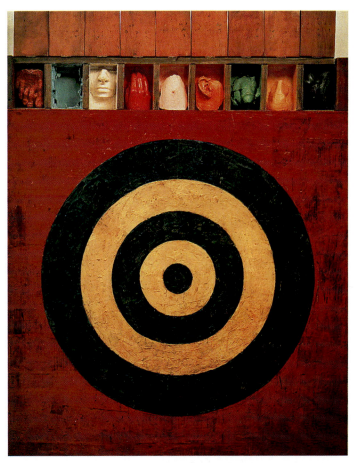

1.46 Jasper Johns, *Target with Plaster Casts,* 1955. Encaustic and collage on canvas with objects, 51 × 44 × 2½ in. (129.5 × 111.8 × 6.4 cm).

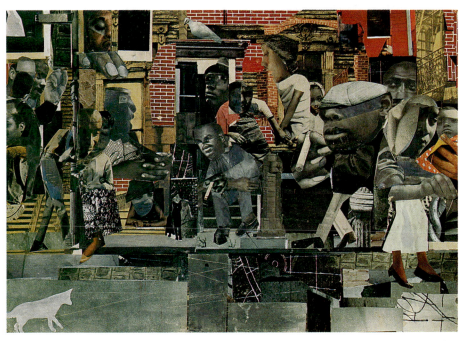

1.47 Romare Bearden, *The Dove,* 1964. Cut-and-pasted paper, gouache, pencil, and colored pencil on cardboard. 13⅜ × 18¾ in. (34 × 47.5 cm).

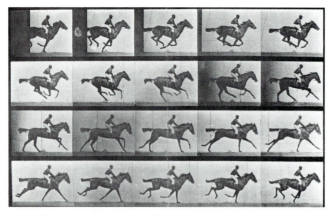

1.48 Eadweard Muybridge, *Galloping Horse, Motion Study—Sallie Gardner, owned by Leland Stanford, running at 1.40 gait over the Palo Alto track, June 19, 1878.* Collotype print, 9⁹⁄₁₆ × 12 in. (23.5 × 30.5 cm).

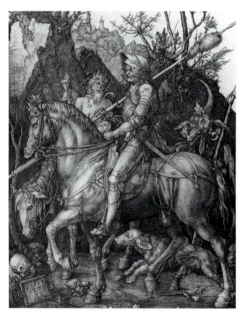

1.49 Albrecht Dürer, *The Knight, Death and the Devil,* 1513. Engraving, 11 × 14 in. (28 × 36 cm).

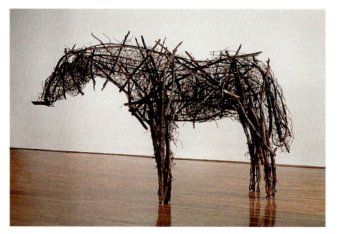

1.50 Deborah Butterfield, *Large Horse #4,* 1979. Steel, wire, sticks, 77 × 124 × 33 in. (195 × 315 × 84 cm).

smooth surface of Eadweard Muybridge's photograph (1.48) invites us to concentrate on the illusion of the galloping horse rather than on the reality of the paper on which it is printed. Albrecht Dürer's engraving of a horse (1.49) is more strongly textured. The embossed ink and the masterful cross-hatching give the print a wonderful texture. Using chicken wire and strips of wood, Deborah Butterfield created an extremely textural sculpture for her *Large Horse* (1.50). In contrast to the animal's passive pose, every surface of its body is highly agitated.

Second, physical variations in a surface can create powerful textures even when the artwork is primarily two dimensional. Constructed from scraps of canvas, zippers, and welded steel, Lee Bontecou's collage (1.51) extends more than an inch from the wall. The dark, open ovals invite entry into an even more extensive world, which seems to exist below the surface.

Third, texture can be created through multiplication of individual marks or shapes. In Figure 1.52, African-American painter Glenn Ligon repeatedly stenciled the phrase "I feel most colored when I am thrown against a sharp white background." As the density of the words increases, the words begin to fuse together, creating variations in the visual texture while reducing verbal clarity.

1.51 Lee Bontecou, *Untitled,* 1964. Welded steel with canvas, 6 ft × 6 ft 10 in. × 1 ft 6 in. (1.82 m × 2.1 m × 46 cm).

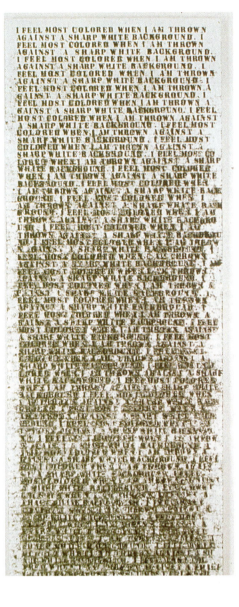

1.52 Glenn Ligon, *Untitled (I feel most colored when I am thrown against a sharp white background)*, 1990. Oilstick and gesso on wood, each panel 6 ft 6 in. × 30 in. (2 m × 76.2 cm).

1.53 René Magritte, *The Red Model II*, 1937. Oil on canvas, 72 × 53½ in. (183 × 136 cm).

Finally, texture can be created through an invented pattern that simulates a textured surface. Belgian artist René Magritte was a master of textural illusion. In *The Red Model II* (1.53), a pair of shoes metamorphose into the bare feet that rest on the sharp gravel ground. Two coins and a scrap of newspaper complete the scene. In the background, a wooden wall presents an even more convincing illusion. Here, representation is used to raise a series of questions rather than to supply simple answers.

Expressive Uses of Texture

Textural Density and Orientation

Density and **orientation** are important aspects of both visual and actual texture. Finer marks, tightly packed, can suggest spatial distance while larger marks tend to advance spatially. In Douglas Smith's illustration of a prison (1.54), texture has been combined with perspective to create a convincing illusion of space. The lines of mortar between the bricks all point toward the truck in the center, while the bricks themselves diminish in size as the distance increases.

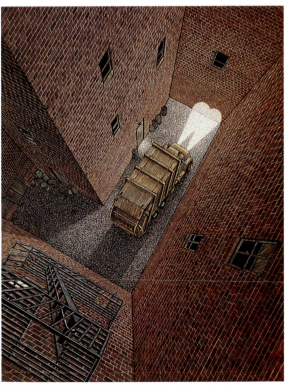

1.54 Douglas Smith, *No Turning*, 1986. Scratchboard and watercolor, 11½ × 15 in. (29.2 × 38.1 cm).

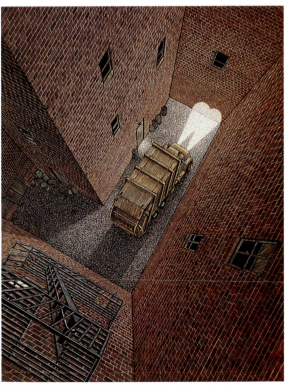

A very different use of texture animates Giorgio Morandi's *Paesaggio del Poggio* (1.55). The marks made are relatively uniform in size. A pattern of horizontal marks brings stability to the sky, while a series of intersecting diagonals activates the vegetation in the foreground. Areas of light and dark have been created through cross-hatching. The recurrent orientation of marks helps to unify the image.

1.55 Giorgio Morandi, *Paesaggio del Poggio (View of Poggio)*, **1927.** Etching on copper, 15 × 16⅛ in. (38.1 × 41.1 cm).

Illusory Texture and Trompe L'Oeil

Through careful observation and painstaking work, artists can create a remarkably convincing textural illusion.

Illusory texture adds weight to shapes and can suggest three-dimensional volume. In Charles Sheeler's *Feline Felicity* (1.56), texture has been used in three ways. First, the fur of the

1.56 Charles Sheeler, *Feline Felicity*, **1934.** Black crayon on paper, 22 × 18 in. (55.9 × 45.7 cm).

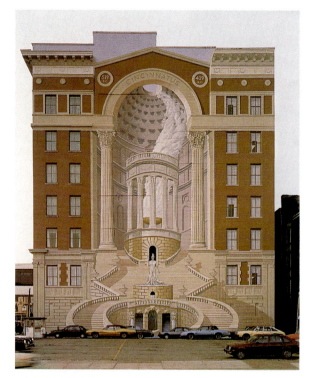

1.57 Richard Haas, *trompe l'oeil* mural on Brotherhood Building, Cincinnati, OH.

cat is distinguished from the wood of the chair by the drawing of the texture. Second, the cat's texture adds volume; this is clearly a substantial, well-fed animal. Third, by drawing on a textured sheet of paper with conte crayon, Sheeler unifies the whole image with a subtle, pervasive texture.

Taken to an extreme, illusory texture can so resemble reality that a deception occurs. By replicating architectural details, Richard Haas created an amazing dialog between illusion and reality in Figure 1.57. *Trompe l'oeil*, the French term meaning "to fool the eye," can become simply an exercise in technical virtuosity, or it can significantly alter our understanding of reality. In large scale, as on a city wall, a trompe l'oeil painting can actually appear to extend an architectural space.

Marks and Meanings

Every mark an artist makes can add to or subtract from the composition as a whole. When the texture is random or discordant, the composition will suffer. When the texture is deliberate and appropriate, the composition will improve. For example, each brush stroke in Ben Marra's *Self-Portrait* (1.58) describes a different facet of the face. Just as a sculptor carves out a portrait in plaster, so Marra has carved out this portrait in paint.

In Van Gogh's *The Starry Night* (1.59), the texture of oil paint serves three distinct purposes. First, it creates an invented texture that simulates the tactile surface of the trees in the foreground. Second, it brings great energy to every painted shape: we feel the wind; we become mesmerized by the glowing whirlpools of light. Finally, we become connected to the artist himself. His hand is clearly evident in every mark. He speaks to us with each brush stroke made.

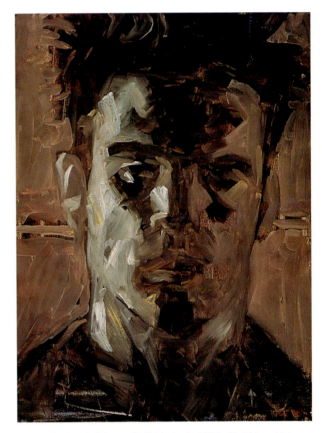

1.58 Benjamin Marra, *Self-Portrait*, 1998. Oil, 8½ × 11 in. (21.6 × 28 cm).

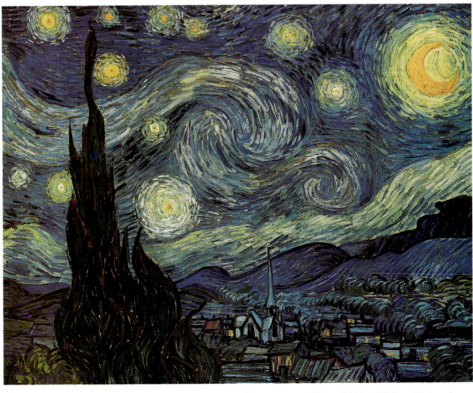

1.59 Vincent Van Gogh, *The Starry Night*, 1889. Oil on canvas, 29 × 36½ in. (73.7 × 92.1 cm).

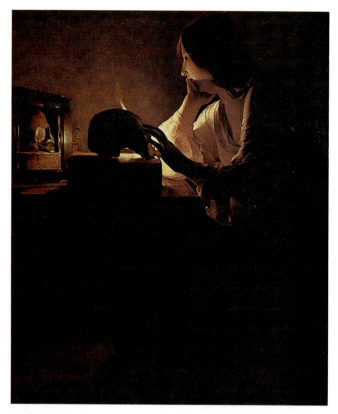

1.60 Georges de la Tour, *The Repentant Magdalene*, c. 1640. Oil on canvas, 44½ × 36½ in. (113 × 93 cm).

1.62 Deborah Remington, *Capra*, 1974. Oil on canvas, 6 ft 4 in. × 5 ft 7 in. (1.93 × 1.7 m).

Value

Defining Value

Value is determined by the relative lightness or darkness of a surface. The context in which an object is placed is crucial. In *The Repentant Magdalene* (1.60) by Georges de la Tour, the flame of a single candle illuminates a darkened room. The same candle, placed outdoors, would become nearly invisible on a sunny day.

1.61

A **value scale,** consisting of a series of gradated values demonstrates this effect (1.61). A solid gray line, extending from left to right, is clearly defined when it is placed on a black background. As it crosses over the middle grays and into the white area, it appears to darken. In the center, it merges with the gray background. As shown in Deborah Remington's *Capra* (1.62), the glowing effect created by gradual changes in value can add expansive power to a painting.

Value and Volume

When a full range of values is used, two-dimensional shapes can be transformed into illusionistic volumes that suggest three-dimensional forms. Figure 1.63 shows the transformation of a flat circle into an illusionist volume. We begin with a simple outline, then add the **attached shadows,** or values, that directly define the basic form. Addition of a **cast shadow** in the third image grounds the sphere, while a separation between the shadow and the sphere creates a floating effect.

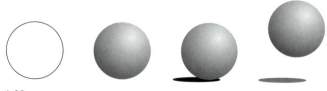

1.63

This illusion of space is so convincing that sculptural forms can appear to rise from a two-dimensional surface. The earliest oil painters used **grisaille,** or a gray underpainting, to define volume. Color was then added to this dimensional matrix using transparent layers of paint. In *The Ghent Altarpiece* (1.64), Jan van Eyck used both grisaille painting and full color. The statues painted at the bottom of the image are defined with gray, while color has been added to the kneeling figures in red. Subtle variations in value give all the figures a remarkable illusion of space.

Expressive Uses of Value

Darker values tend to sink while lighter values tend to rise. In Charles Demuth's . . . *And the Home of the Brave* (see 1.41), the dark values that dominate the upper half of the painting tend to compress the lighter values at the bottom. The tension between these forces of light and dark adds energy to the austere painting.

Ray K. Metzker used a very different distribution of value to energize *Philadelphia* (1.65). Surrounded by darkened buildings in a silent city, the commuters huddle together under the brightly lit bus shelter like actors in a mysterious play.

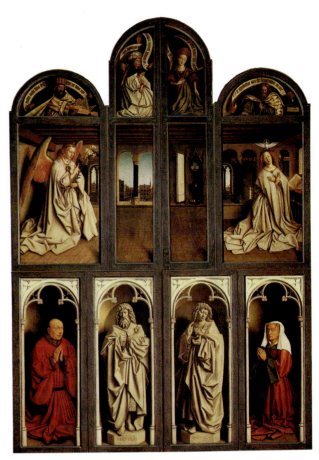

1.64 Jan van Eyck, *The Ghent Altarpiece* (closed), completed 1432. Oil on panel, approx. 11 ft 6 in. × 7 ft 7 in. (3.5 × 2.33 m).

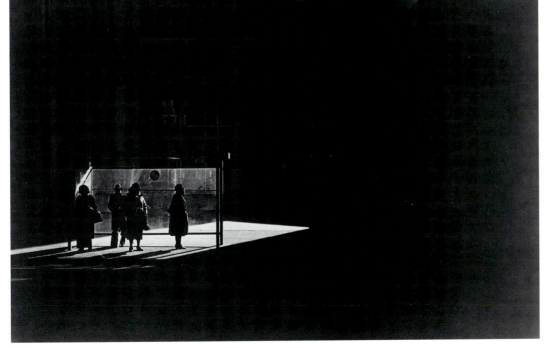

1.65 Ray K. Metzker, *Philadelphia*, **1963.** Gelatin silver print on paper, 6⅛ × 8¾ in. (15.4 × 22.3 cm).

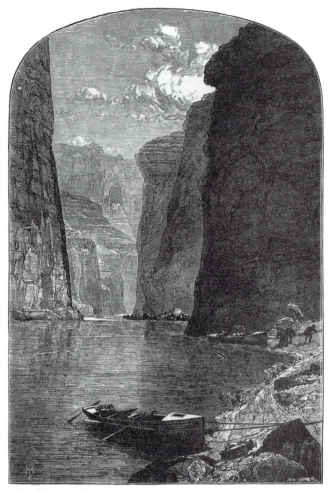

1.66 Thomas Moran, *Noon-Day Rest in Marble Canyon*, from *Exploration of the Colorado River of the West*, by J. W. Powell, **1875.** Wood engraving after an original sketch by Thomas Moran, 6½ × 4⅜ in. (16.5 × 11 cm).

Value is also used by landscape painters to create an illusion of space. The distribution of values in Thomas Moran's *Noon-Day Rest in Marble Canyon* (1.66) is typical. The darker, more clearly defined shapes in the foreground gradually fade until the cliffs in the background are more suggestive than definite. As we will see in Chapter Three, this effect is one of the simplest ways to create the illusion of space.

Value and Lighting

Filmmakers and set designers are especially aware of the expressive uses of value. Working with a wide range of lights, including sharply defined **spotlights** and more diffused **floodlights,** they can increase or decrease the illusion of space, emphasize an object or an action, and influence our emotional response to a character.

Four common forms of lighting are shown in Figure 1.67. As described by Herbert Zettl in *Sight, Sound, Motion: Applied Media Aesthetics*, a **key light** is the primary source of illumination. Placing this light at a 45-degree angle can enhance the illusion of space. Addition of a **backlight** separates the actor from the background and adds definition. When a **fill light** is added, the contrast between light and dark becomes less harsh, and the actor may appear less formidable. In dance performances, **side lighting** is often used to increase drama while enhancing dimensionality.

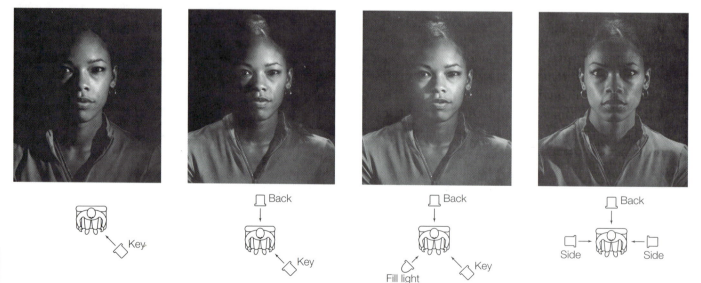

1.67 John Veltri, Lighting Techniques from *Sight, Sound, Motion: Applied Media Aesthetics*, 3rd ed., by Herbert Zettl, 1999.

All these aspects of lighting are used expressively in *Casablanca,* a classic film directed by Michael Curtiz. The lighting is fairly dark when we first enter Rick's Café Americain, the saloon where most of the action occurs. In this dark and mysterious place, a man will be shot, a seduction will be thwarted, and a romance will be rekindled. In the same shot, the piano player, Sam, and the audience members closest to the stage are brightly lit as Sam sings an optimistic song (1.68A). A strong sidelight is often used on the two villains in the film, Major Strasser and Captain Renault, to make them more formidable and enhance the texture in their faces (1.68B). By contrast, much softer light is used for the faces of Victor and especially the heroine, Ilsa, who is emotionally and politically vulnerable (1.68C).

Indeed, light is used to accentuate Ilsa's emotions throughout the film. When she tries to explain to Rick the reason that she had left him in Paris two years earlier, she wears a pure white dress and enters the darkened saloon like a virginal beam of light (1.68D). Later, when she visits Rick in his apartment, shadows cover her face, accentuating her conflicting emotions as she tries to decide whether to remain with Victor, whom she idealizes or return to Rick, whom she loves. In the final scene at the airport, diffused lighting again emphasizes Ilsa's vulnerability (1.68E). She and Victor disappear into the foggy night, escaping from Casablanca, while Rick and a reformed Renault stroll away together to join the foreign legion.

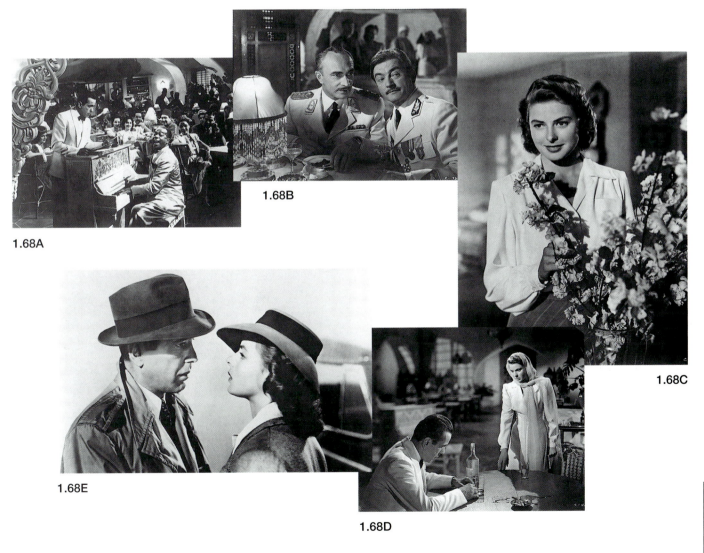

1.68A

1.68B

1.68C

1.68E

1.68D

Profile:
Phillia Yi, Printmaker

Energy and Expression Using Woodcut on a Large Scale

Phillia Changhi Yi has revitalized the ancient process of woodcut through her large-scale prints. Drawing directly on luan plywood, Yi cuts away the negative shapes and inks the raised positive shapes to create abstract images that vigorously combine color, texture, and movement. Yi has exhibited widely, with over fifteen solo shows and numerous international group shows to her credit. She lectures widely and has taught workshops at Manhattan Graphics Center, Women's Studio Workshop, and the Southern Graphics Council Conference. She is currently the chair of the Art Department at Hobart and William Smith Colleges.

MS: The energy in your images immediately attracts attention. What is its source?

PY: Conflict is my primary source, conceptually and compositionally. As a woman from Korea living in the United States, I find myself caught between cultures. This isolates me in an interesting way and gives me a unique persepective. My work reflects the day-to-day dilemmas and tension of my multicultural experience.

Crisis moments often trigger ideas, but historical events are never treated literally. I combine abstract imagery with representational elements in my prints. Both flat and illusory space is created, suggesting an altered sense of time and scale. "Tight" movement is juxtaposed with fluid shapes, and warm and cool colors are used in opaque and translucent layers. This activates the psychological space and creates a complex, highly charged composition.

MS: Your family is dominated by doctors and businesspeople. How did you become an artist?

PY: Getting the right encouragement at the right time gave me the confidence to pursue art. All of my five siblings are talented, I think, but for them, choosing an art career seemed too risky. My father encouraged me to study graphic design, but I found that printmaking was my real passion. My mentor, Professor Romas Viesulas at Tyler School of Art, said that I had the commitment and ability for a career in art. His confidence gave me confidence.

MS: How do you develop your images?

PY: I begin with a month of drawing, usually in charcoal, on 29 × 41 in. sheets of printmaking paper. In the draw-

ings, I work out my images and ideas. Social and political themes dominate. The beating of Rodney King by members of the Los Angeles Police Department and the subsequent burning of Koreatown inspired *Dance*. The historical lack of funding for medical research for women inspired *Silence*.

The Other Side deals with the power of women, who must prevail in a world dominated by men. The whole composition is based on the intersection between these two forces, near the center of the print. In a sense, the large black shape represents the unconscious, while the curving red shape suggests that which is conscious, palpable, and real. I am interested in the uneasy alliance, or balance, between complex life forces, rather than a simple battle between adversaries. Each corner is treated differently, adding more variety and energy to the print.

MS: The size of *The Other Side* piece is extraordinary. Using eight panels, you have created a print that is 12 feet long!

PY: When I was studying printmaking at the State University of New York, New Paltz, I was surrounded by printmakers. The size of the printing press, acid trays, rollers, and other equipment seemed to limit the size of the artwork. When I went to Tyler in Philadelphia, my roommate, who was a painter, introduced me to her friends. Some were completing a 5 × 7 ft painting a day! I realized that the small size and slow process of printmaking had historically given it a "second-class" status. I was determined to overcome this perception, so I developed a working method that is forceful, spontaneous, and direct. There is still a great deal of deliberation, but the cutting and printing processes are relatively fast.

MS: Some artists work very methodically over a long period of time while others work in short, intensive bursts. What is your approach?

PY: I have adapted my method to my situation. I have obligations as a teacher, a mother, and an administrator, so summer is my only solid block of work time. A regular schedule is best for me. At the beginning of the summer, I go to the studio for a few hours each day. I soon increase this to about 6 hours a day for drawing. When I am cutting the blocks and printing, I often work for 8 to 10 hours a day. I am very consistent.

MS: What is the best work method for your students?

PY: Success is primarily based on commitment. I would say that art-making is about 5 percent talent and inspiration and 95 percent tenacity and hard work. A professional or a serious student continues to work despite obstacles. It is important for students to explore ideas and make mistakes; that is the best way to learn.

MS: What is the purpose of your artwork?

PY: Art is expression, not explanation. Artists must be attentive, noticing every detail of experience. Art both reflects and influences society and culture. In that sense, I feel that artists have a responsibility to their generation, not just to create objects of beauty, but to create objects of truth—whether they are beautiful or not.

My ideas come from my daily life and my personal experience, both good and bad. The most important characteristic is my belief that art should be expressed in terms of human experience. My work is essentially optimistic: I embrace all that the world has to offer.

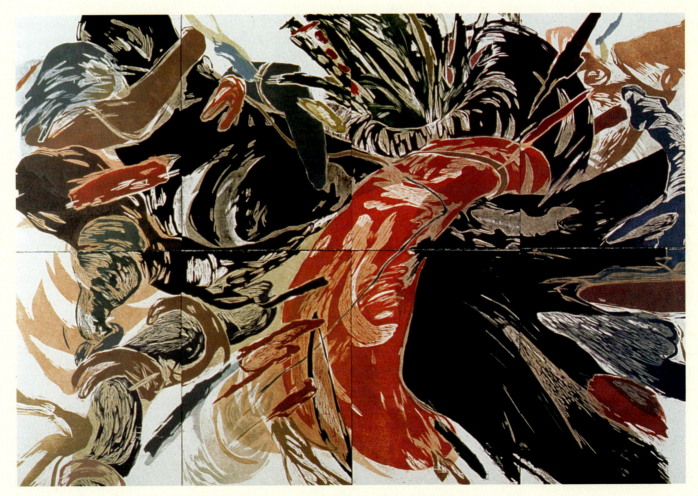

Phillia Changhi Yi, *The Other Side*, 1993. Color woodcut, 84 × 120 in. (213 × 305 cm).

Summary

- The basic elements of two-dimensional design are line, shape, texture, value, and color.

- Lines can contain, define, dissect, and connect. When multipled to create cross contours and cross-hatching, lines can create both value and volume.

- A shape is created whenever an area is enclosed. The figure, or positive shape, is most prominent, while the ground, or negative shape, provides the surrounding context. When the figure and ground shapes are equally strong, figure/ground reversal can occur, adding energy to the design.

- There are many types of shapes, including rectilinear, curvilinear, geometric, organic, representational, nonobjective, and abstract. When gradated, shapes can appear volumetric.

- Texture refers to the visual or tactile surface of a shape. Visual texture can be created through multiple marks, while physical variations in the surface create tactile textures.

- Lightness or darkness in an artwork is called value. Value can be used to create the illusion of space, to shift compositional balance, or to heighten emotion.

Keywords

abstract shape
actual line
attached shadow
backlight
calligraphic line
cast shadow
closure
collage
contour line
cross contour
cross-hatching
curvilinear shape
definition
density

descriptive shape
figure
figure/ground reversal
fill light
floodlight
format
geometric shape
gesture drawing
gradation
grisaille
ground
hatching
high definition

illusory texture
implied line
key light
line
low definition
negative shape
nonobjective shape
organic shape
orientation
positive shape
pure form
rectilinear shape
representational shape
shading

shape
sidelight
spotlight
tactile texture
texture
trompe l'oeil
value
value scale
visual texture
volume
volume summary

1. Experiment with the widest range of lines your pencil, brush, or marker can create. How can a line become more dynamic? How can lines be used to create the illusion of space?

2. What is the relationship between the visual elements and the format in which they are placed? The edge of the format is like an electric wire: carefully used, it can generate great energy.

3. Experiment with a wide variety of shapes: rectilinear, curvilinear, geometric, organic, positive, negative. Which type of shape is most appropriate for the idea you want to communicate?

4. Is every square inch of the composition fully engaged? Note especially the role of negative space in creating a balance with positive elements.

5. What happens when some or all of the shapes in your design are gradated? How do variations in the direction of the gradation affect the illusion of space?

6. How many different textures can be created with the medium you are using? Which texture is most appropriate for your particular image? Can textural contradiction add to the meaning of your art work?

7. Experiment with the range of values used in your composition. What happens when a full range of values is used? What happens when a narrow range of values is used? How can attached or cast shadows affect meaning?

Roy R. Behrens, *Design in the Visual Arts.* Englewood Cliffs, NJ, Prentice-Hall, Inc. 1984.

Frank Cheathan, Jane Hart Cheathan, Sheryl A. Haler, *Design Concepts and Applications.* Englewood Cliffs, NJ, Prentice-Hall, Inc., 1983.

David A. Lauer and Stephen Pentak, *Design Basics,* 5th edition. Orlando, FL, Harcourt, Brace & Company, 2000.

Donis Dondis, *A Primer of Visual Literacy.* Cambridge, MA, MIT Press, 1973.

Edward Hill, *The Language of Drawing.* Englewood Cliffs, NJ, Prentice-Hall, Inc., 1966.

Jack Fredrick Myers, *The Language of Visual Art: Perception as a Basis for Design.* Orlando, FL, Holt Rinehart and Winston, Inc. 1989.

Herbert Zettl. *Sight, Sound, Motion: Applied Media Aesthetics.* 3rd edition. Belmont, CA, Wadsworth Publishing Company, 1999.

Color and Composition

Initial design planning is often done in black and white. Working within these limitations, we can focus on developing our ideas and creating basic compositions. Relationships among visual elements can be seen most clearly when the design is distilled down to the bare essentials. By expanding the palette to include all aspects of color, we begin to work with a much more complex set of variables, including harmony, contrast, and symbolic meaning. Because of its complexity, color requires a chapter of its own.

Color immediately attracts attention. The small red lines in Gerrit Rietveld's *Model of the Schröder House* (2.1) are more powerful than the surrounding black, white, and gray walls. An interior designer may use rose-red walls in a restaurant to increase emotional warmth while using light blue walls in a day care center to encourage calm. In Caravaggio's *The Deposition* (2.2), the blood-red robe behind the dead man adds a critical compositional shape as well as symbolic meaning. Even very small children, presented with a collection of bottles filled with liquid in various colors, will group the bottles by color rather than by size or shape. The visual and emotional force generated by color is extraordinary. By harnessing its power, we can add conceptual complexity and compositional strength to any design.

2.1 Gerrit Rietveld, Model for the Rietveld–Schröder House, 1923–24. Glass and wood, 7⅜ × 28⅜ × 19¼ in. (44.1 × 72.1 × 48.9 cm).

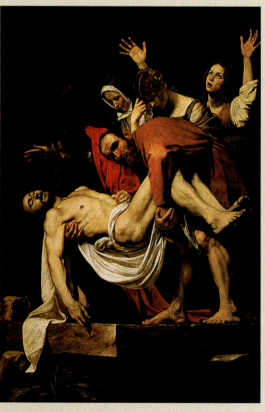

2.2 Caravaggio, *The Deposition*, 1604. Oil on canvas, 9 ft 10⅛ in. × 6 ft 7⅞ in. (3 × 2.03 m).

Studying Color

Color theory is a science as well as an art. Indeed, it was mathematician Sir Isaac Newton who developed the first scientific experiments relating color and light. In *The Art of Color*,[1] Johannes Itten lists the following approaches to color theory:

- The physicist studies electromagnetic wavelengths in order to measure and classify color.

- The chemist, working with the molecular structure of dyes and pigments, seeks to produce highly permanent colors and excellent paint consistency.

- The physiologist investigates the effects of color and light on our eyes and brain.

- The psychologist studies the expressive effects of color on our mind and spirit.

An artist combines all these areas of knowledge. Like the physicist, the artist can create new wavelengths through color mixing. Like the chemist, the artist must be aware of the safety and permanence of dyes and pigments. When using color to create the illusion of space or to shift visual balance, the artist puts into practice theories developed by physiologists. Finally, the psychological effects of color strongly influence both communication and expression.

Seeing Color

Color and light are inseparable. Without light, there can be no color. When white light passes through a prism, a spectrum of colors from violet to red becomes visible (2.3). When white light hits an apple (2.4), the red wavelengths are reflected while the other colors are absorbed. When there is limited light, as at night, we see a world of light and dark values, rather than a world of full color.

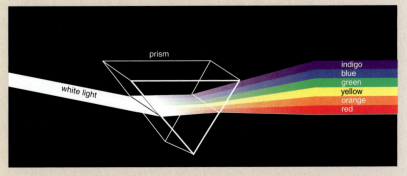

2.3 When white light passes through a prism, the spectrum becomes visible.

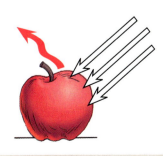

2.4 Reflected light defines this red apple.

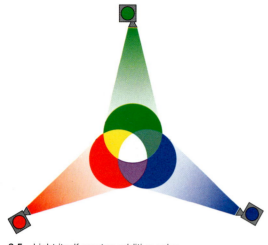

2.5 Light itself creates additive color.

2.6 Subtractive color is created when light is reflected off a surface.

Two primary systems are created through this interplay of color and light. Light in itself creates **additive color.** Video artists, theatrical set designers, and Website artists primarily work with additive color. Red, green, and blue are the primary colors in this system. When these colors are combined as beams of light, white light results (2.5).

Subtractive color is created when light is reflected off a surface. Pigment colors are created through such reflected light. As with the actual red apple, a painted red apple appears when the red wavelengths of light are reflected while the other colors are absorbed. The subtractive primaries are cyan blue, magenta red, and yellow (2.6). When mixed, they produce a type of black. Painters, printmakers, and illustrators use subtractive color in various forms, including acrylics, pastels, and inks. A printed computer image is also created through reflected light. Since most foundation color projects require the use of reflected light, the remainder of this chapter focuses on subtractive color.

Colors are never seen in isolation. The blue sheet of paper we examine in an art supply store reminds us of the blue of the sky, the ocean, or the fabrics in a clothing store. Lighting also affects our perceptions. Incandescent light creates a warm orange glow, while standard fluorescent lights produce a bluish ambiance. When our blue paper is added to a design, it is further affected by the other colors chosen. This effect, called **simultaneous contrast,** is demonstrated in Figure 2.7. When we place a square of blue on a yellow square, the blue appears darker and cooler. The same blue square appears much lighter when it is placed on a black ground.

2.7 When we place a square of blue on a yellow square, the blue appears darker and cooler. The same blue appears much lighter when it is placed on a black background.

This effect is especially dramatic when the blue square is placed on a scarlet square. The orange-red and cyan blue are **complementary colors:** they are opposites on a color wheel. Two types of cells, known as rods and cones, are arranged in layers on the retina of the eye and serve as photoreceptors. The rods record lightness and darkness, while the cones are used to distinguish the red from the blue. According to **opponent theory,** the cones can register only one color in a complementary pair at a time. Constant shifting between the opposing colors creates a visual overload at the edges of the shapes, resulting in an electric glow.

The same characteristic of human vision can be used to create an **afterimage.** If we stare at a cyan-blue dot for a minute, then stare at a white sheet of paper, an orange-red shape will seem to appear. Jasper Johns used this effect to create *Flag* (2.8). Part of a series of paintings based on the American flag, this print presents a reversal of the usual colors at the top. If we stare at this flag, then shift our attention to a white sheet of paper, we will once again see the familiar red, white, and blue.

2.8 **Jasper Johns,** *Flag*, **1968.** Lithograph, printed in color, composition: 34⅝ × 25⅞ in. (87.9 × 65.7 cm).

Defining Color

Hue

The **hue** of a color is determined by its wavelength. For example while blue has a wavelength of 480 to 460 millimicrons, red has a wavelength of 800 to 650 millimicrons.[2] Red, blue, green, yellow, and so forth are all hues, or names, of colors.

Physicists, painters, and philosophers have devised numerous systems to organize hues. Johannes Itten's 12-step color wheel and the Albert Munsell color system are the familiar examples. The Itten model (2.9) has the advantage of simplicity and clarity. Red, blue, and yellow **primary colors** are in the center. These colors can be mixed to produce virtually all other colors. The **secondary colors** of green, orange, and violet follow. These colors are mixed from adjacent primaries. A circular spectrum of **tertiary colors** completes the wheel. The 10-step

2.9 The 12-step Itten color wheel.

2.10 The 10-step Munsell color wheel.

2.11 Munsell color tree, 1972. Clear plastic chart, 10½ × 12 in. (26.7 × 30.5 cm); base size 12 in. (30.5 cm) diameter; center pole size 12⅝ in. (32.1 cm) high; chip size ¾ × 1⅜ in. (1.9 × 3.5 cm).

Munsell color wheel (2.10) more accurately identifies cyan blue, magenta red, and yellow as the primaries, while the three-dimensional Munsell color system (2.11) provides examples of changes in color value and intensity as well as hue.

Artists use a wide range of hues to capture the richness of reality. In *Wheel of Fortune* (2.12), Audrey Flack used a full spectrum of hues to define various objects in relentless detail. However, a limited number of hues can be equally effective. By limiting his palette, Robert Lazuka created an image with hypnotic power in *Thoughts of Summer* (2.13).

Value

In color theory, **value** refers to the relative lightness or darkness of a color. By removing hue from the equation, we can create a simple value scale (2.14A) that shifts from white to black through a series of grays. As shown in Figure 2.14B, hues such as violet, blue, and green are inherently darker in value than pure yellow or orange. When white is added to a hue, the resulting **tint** will be lighter in value. The addition of black produces a darker **shade.** The addition of both white and black creates a **tone.** Tints and shades of red are shown in Figure 2.14C.

2.12 Audrey Flack, *Wheel of Fortune,* **1977–78.** Oil over acrylic on canvas, 8 × 8 ft.

2.13 Robert Lazuka, *Thoughts of Summer,* **1999.** 21 × 21 in. (53 × 53 cm).

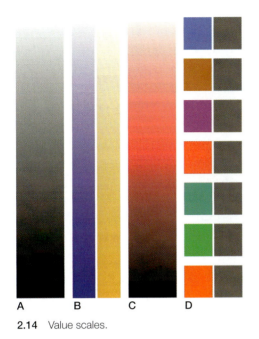

2.14 Value scales.

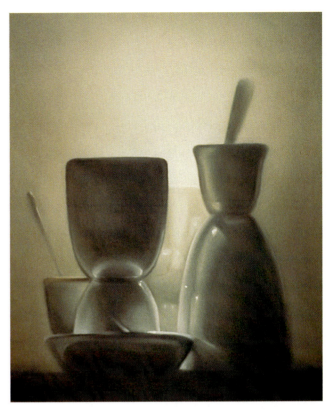

2.15 Nicora Gangi, *Vision*, 1994. Pastel, 10 × 14 in. (25 × 36 cm).

Translation of color into value is shown in 2.14D. Despite the wide variety of hues, all these colors have essentially the same value.

Initial design work is often done in the basic values of black, white, and gray. This simple palette provides dramatic contrast while eliminating the other color variables of hue, intensity, and temperature. Through this limitation we can focus our attention on line, shape, and texture. Furthermore, value in itself can be highly expressive. As shown in Figure 1.39 on page 1-12, Ansel Adams used black and white photography to enhance the grandeur of the Sierra mountains. Color would diminish the impact of *Man Waiting* (1.44) by Sidney Goodman. And film lovers have adamantly argued against the colorization of classic American films such as *Casablanca* and *Citizen Kane*.

As with hue, a narrow range of values can be as effective as a wide range. In *Vision* by Nicora Gangi (2.15), light and dark values transform a simple still life into a theatrical drama. The limited range of values in David Hockney's *Mist* (2.16) is equally effective. The gray-green palm trees dissolve into the peach-colored fog as quietly as a whisper.

Likewise, color is a dominant force in some paintings, while value is the dominant force in others. Henri Matisse's *Green Stripe* (2.17) is defined by

2.16 David Hockney, *Mist*, 1973. From The Weather Series. Lithograph in 5 colors, edition 98, 37 × 32 in. (93.9 × 81.2 cm).

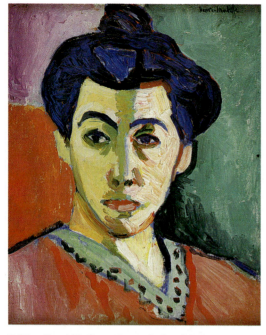

2.17 Henri Matisse, *Green Stripe (Madame Matisse),* **1905.** Oil on canvas, 16 × 12 ¾ in. (40.6 × 32.4 cm).

2.18 Romaine Brooks, *Self-Portrait,* **1923.** Oil on canvas. 46¼ × 26⅞ in. (117.5 × 68.3 cm).

color, whereas value defines Romaine Brooks' *Self-Portrait* (2.18).

Intensity

Intensity, saturation, and **chroma** are all words used to describe the purity of a color. Taken directly from the tube, primary colors such as phthalocyanide blue, quindacradone magenta, and hansa yellow, and secondary colors such as phthalocyanide green, cadmium orange, and acra violet, or dioxazine purple, provide the greatest intensity. The intensity diminishes when the colors are mixed, especially when cheap paint is used.

Figure 2.19 offers three intensity scales. Column A shows the most intense primary and secondary colors. Column B demonstrates the loss of intensity when black is added. In column C, two complementary colors are mixed, producing a range of elegant, low-intensity colors.

High-intensity colors are often used to maximize impact. Grace Hartigan's *City Life* (2.20) explodes with energy, as the rich blues, reds, and

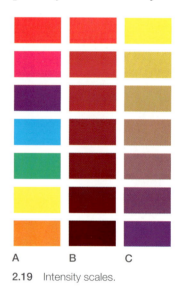

2.19 Intensity scales.

yellows dance across the canvas. Using too many intense colors, however, can reduce rather than increase impact. In Figure 2.21, Arshile Gorky used a combination of brilliant primary colors and low-intensity earth tones to create a magical image.

A similar comparison can be made between the Japanese robes in Figures 2.22 and 2.23. The first offers an evocation of spring. Delicate plum tree blossoms spread across the gradated purple background, which dissolves into open space. The composition and colors of this robe, like the season it depicts, suggest potential growth rather than full fruition. The second robe depicts summer. Crowded with intensely colored patterns, the composition is bursting with energy. The potential suggested in the first robe has been fulfilled.

2.20 Grace Hartigan, *City Life,* **1956.** Oil on canvas, 81 × 98½ in. (205.7 × 250.2 cm).

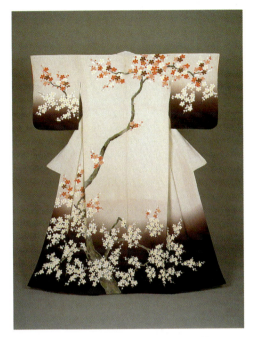

2.22 Woman's Kimono, 20th century. Silk crepe, painted design of plum tree in blossom, 58 × 48 in. (147.3 × 121.9 cm).

2.21 Arshile Gorky, *The Liver Is the Cock's Comb,* **1944.** Oil on canvas, 6 ft 1¼ in. × 8 ft 2 in. (1.86 × 2.49 cm).

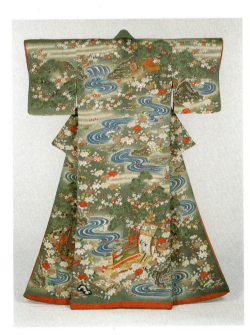

2.23 Kosode with Flowing Water, Pine Trees, Bridge, and Scroll, Japan, Edo period (1615–1867). Silk plain weave with yuzen dyeing, stenciled imitation tie-dyeing, and silk and gilt thread, back length 67 in. (170.2 cm).

2.24 Separation of the color wheel by temperature.

Temperature

Temperature refers to the heat a color generates, both physically and psychologically. Try laying six colored squares on fresh snow on a sunny day. By the end of the day, the warm-colored squares of red, yellow, and orange will sink into the melting snow, while the blue, green, and violet squares will remain closer to the surface. Figure 2.24 shows a simple division of the color wheel by temperature.

Color temperature plays a critical role in creating the illusion of space. Under most circumstances, warm colors advance while cool colors recede. This effect is demonstrated very clearly in Kenneth Noland's *A Warm Sound in a Gray Field* (2.25). The scarlet ring with its yellow halo pushes toward us, while the blue-black circle pulls us inward. The small red dot in the center of the composition further activates the void by creating another advancing shape.

In *Quinault* (2.26), Suzanne Bloom and Ed Hill used a similar combination of warm and cool colors to create a very different illusion of space. A volumetric wooden ring dominates the image, targeting the tree stump in the center. A lake and blue mountains recede into the background. Combining traditional photography with computer graphics, these collaborators have created an image based on natural and artificial sources.

By combining warm and cool colors, we can cause various areas in a painting to expand or contract. In Wolf Kahn's *The Yellow Square* (2.27), the green and violet pastels

2.25 Kenneth Noland, *A Warm Sound in a Gray Field*, 1961. 6 ft 10½ in. × 6 ft 9 in. (2.1 × 2.06 m).

2.26 MANUAL (Suzanne Bloom and Ed Hill), *Quinault,* from *A Constructed Forest,* **1993.** Chromogenic print, 24 × 36 in. (61 × 91.4 cm).

defining the exterior of the barn gently pull the viewer into the painting, while the blazing yellow window inside the barn pushes out as forcefully as the beacon in a lighthouse. This effect, described by painter Hans Hofmann as "push/pull" can play an even more important role in nonobjective paintings since they rely so heavily on basic visual forces for their impact. In Hofmann's *Magnum Opus* (2.28), this push/pull effect is heightened by variations in definition, from the loosely painted reds to the sharply defined yellow rectangle.

Because our perception of warm and cool color is based on psychological as well as physical experience, color temperature offers a wide range of expressive possibilities. Warm and cool colors evoke a physical response in Kiera Cunningham's textbook cover design (2.29). The bright yellow flame and the scarlet, yellow, and brown stripes energize the design and forcefully launch the balloon.

2.27 **Wolf Kahn,** *The Yellow Square,* **1981.** Oil on canvas, 44 × 72 in. (112 × 183 cm).

2.28 **Hans Hofmann,** *Magnum Opus,* **1962.** Oil on canvas, 84⅛ × 78⅛ in. 213 × 198 cm).

2.29 Kiera Cunningham, Cover of *Thermodynamics,* by Çengel and Boles.

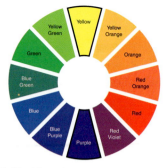

2.30 Monochromatic color system.

2.31 Guy Goodwin, *Tracers–Side Order,* 1999. Resin, polyurethane, ink on polycarbonate, 51 × 54 × 4 in. (130 × 137 × 10 cm).

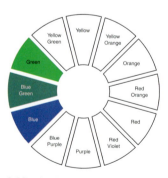

2.32 Analogous color system.

2.33 Paul Cézanne, *Houses in Provence (Vicinity of L'Estaque),* 1880. Oil on canvas, 25⅝ × 32 in. (65 × 81 cm).

Composing in Color
Color Systems

Variations in hue, value intensity, and temperature can result in millions of colors. Because relationships among colors are so critical to the success or failure of a design, many theories of **color harmony** have been developed to help artists, architects, and designers make good choices. The simple Itten color wheel can help illustrate the five traditional systems.

Monochromatic

Variations on a single hue are used in a **monochromatic** system (2.30). A range of values is often used to help increase the illusion of space. The advantage of this system is a high level of unity: all the colors are strongly related. Boredom, due to the lack of variety, is a potential disadvantage. In *Tracers–Side Order* (2.31), Guy Goodwin used a variety of textures, patterns, and words to add interest to a fairly monochromatic painting.

Analogous

Adjacent colors in the spectrum are used in an **analogous color** scheme (2.32). As with monochromatic harmony, a high degree of unity is ensured, but the wider range of hues offers greater variety and interest. In *Houses in Provence* (2.33), Paul Cézanne used analogous colors to create a highly unified landscape.

Complementary

The palette dramatically expands in a complementary system (2.34). Complementary colors are opposites. When mixed, they produce a neutral brownish or grayish black. When used in a composition, however, they become ideal partners: each increases the power of the other. In Henri Toulouse-Lautrec's *A Corner of the Moulin de la Galette* (2.35), the adjacent reds and greens are highly animated, while the browns they created when mixed add coloristic unity.

Any two complements will generate extreme simultaneous contrast. The red and green in Victor Vasarely's *Vega Per* (2.36A) add another level of energy to an optical circus. When we replace the green with the cyan blue from the Munsell color system (2.36B), the design becomes even more agitated. The cones in our eyes shift back and forth between the two complements, electrifying the image.

Each complementary pair has its own distinctive strengths. Violet and yellow provide the widest value range, while orange and blue provide the widest range of temperature. Red and cyan or red and green are similar in value and create the most extreme agitation when juxtaposed. In all cases, by using two complements plus black and white, we are able to create a range of colors that can suggest the full spectrum.

2.34 Complementary color system.

2.35 Henri Toulouse-Lautrec, *A Corner of the Moulin de la Galette*, 1892, Paris. Oil on cardboard, 39⅜ × 35⅛ in. (100 × 89.2 cm).

2.36A Victor Vasarely, *Vega Per*, 1969. Oil on canvas, 64 × 64 in. (162.6 × 162.6 cm).

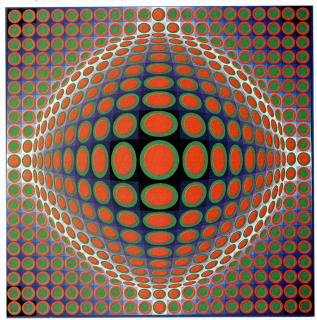

2.36B In this variation on 2.36A, cyan blue has been used to create even more electricity.

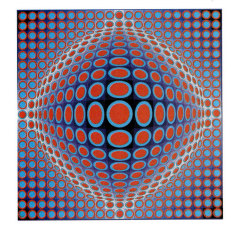

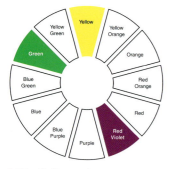

2.37 Split complementary system.

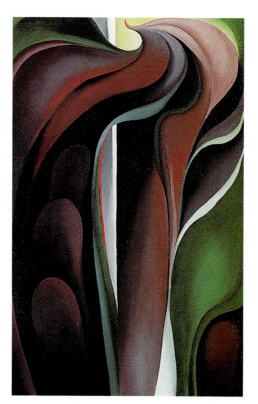

2.38 Georgia O'Keeffe, *Jack in the Pulpit No. V,* **1930.** Oil on canvas, 48 × 30 in. (122 × 76 cm).

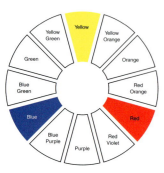

2.39 Triadic system.

2.40 Joel Katz Design Associates, Cover of *Philadelphia Architecture: A Guide to the City,* 2nd ed., 1984.

Split Complementary

An even wider range of possibilities is offered by the **split complementary** system (2.37). Rather than pair colors that are in opposite positions on the color wheel, the artist completes the scheme using the two colors on either side of one of the complements. Georgia O'Keeffe's *Jack in the Pulpit No. V* (2.38) is dominated by rich green and violets, with accents of yellow at the top of and a line of scarlet down the center of the composition.

Triadic

The triadic system pushes the choices even farther apart so that they are now located in a triangular position, equally spaced around the wheel (2.39). This scheme is often used when variety and a strong impact are essential, as in Figure 2.40.

Chromatic Grays and Earth Colors

While the Itten color wheel can help us identify many kinds of relationships, two important types of colors are not included: chromatic grays and earth colors. A **chromatic gray** is made from a mixture of color, rather than a simple blend of black and white. The result is both subtle and vibrant. In *The Magpie* (2.41), the grays vary widely, from the purples and blue-grays in the shadows to the golden-gray light in the foreground and the silvery grays for the snow-covered trees. This is not a dark, sullen winter day; through the use of chromatic grays, Claude Monet makes the

warm light and transparent shadows sparkle in the crisp air.

Earth colors, including raw sienna and burnt sienna, raw and burnt umber and yellow ochre, are made literally from pigments found in soil. Generally warm in temperature, when used together they create a type of analogous harmony. Browns, oranges, and tans accentuate the gestural energy and organic shapes in *Bush Cabbage Dreaming at Ngarlu* (2.42), by Australian artists Cookie Stewart Japaljarri, Alma Nungarrayi Granites, and Robin Japanangka Granites. When used alone or in combination with higher-intensity colors, earth colors can bring welcome variety to design.

Color Combinations

Disharmony

Selecting harmonious colors can make the difference between a visual atrocity and a visual delight. As a result, color harmony is the subject of endless books offering advice to artists, architects, and surface pattern designers. Nonetheless, cultural definitions of harmony are as changeable as popular music. In a search for fresh and eye-catching images, designers in all fields invent new color combinations each year. The pink, gray, and black prized by designers in one year may seem passé in the next year. Furthermore, when the subject matter in a painting is disturbing, conventional harmony is inappropriate. In *Triptych* (2.43), Francis Bacon used an unusual combination of pinks, grays, blues, and black to produce a painting that is as disturbing as it is beautiful.

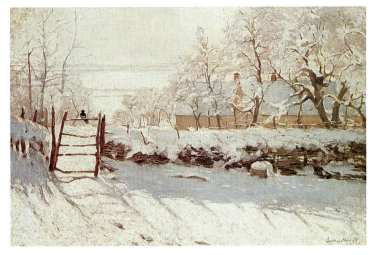

2.41 Claude Monet, *The Magpie*, 1869. Oil on canvas, 35 × 51 in. (89 × 130 cm).

2.42 Cookie Stewart Japaljarri, Alma Nungarrayi Granites, and Robin Japanangka Granites; *Bush Cabbage Dreaming at Ngarlu;* Yuendumn, Central Australia, 1986. Acrylic on canvas, 47½ × 93½ in. (120.5 × 237.5 cm).

2.43 Francis Bacon, *Triptych,* 1972. Oil on canvas, one of 3 panels, each 78 × 58 in. (198.1 × 147.3 cm).

2.44 Nancy Crow, *Double Mexican Wedding Rings 1*, 1988. Hand quilted by Marie Moore. 72 × 72 in. (183 × 183 cm).

2.45 Guerrilla Girls, "Do women have to be naked to get into the Met. Museum? Less than 5% of the artists in the Modern Art sections are women, but 85% of the nudes are female," 1989. Poster, 11 × 28 in. (27.9 × 71.1 cm).

Color Distribution

Through careful distribution, even the most disharmonious colors can work beautifully. In Nancy Crow's *Double Mexican Wedding Rings 1* (2.44), radial symmetry, combined with a strong use of pattern, helps harmonize colors we would expect to clash. Creating such harmony between opposing visual forces adds vitality and gives the composition a distinctive look.

In Figure 2.45, the Guerrilla Girls used an intense yellow and glowing violet to heighten the impact of a black and white layout. Designed to call attention to the disparity in visibility between male and female artists, the poster had to be as powerful as possible. The violet words in the text offer a direct indictment of the exhibition policies of a major museum.

Weight and Balance

The effect of color on visual weight and balance is equally dramatic. In *Icarus* (2.46), by Henri Matisse,

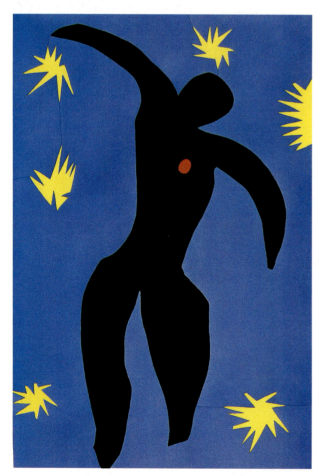

2.46 Henri Matisse, *Icarus*, from *Jazz* series, 1947. Gouache on paper, cut and pasted, 17⅛ × 13⅜ in. (43.6 × 34 cm).

2.47 Wolf Kahn, *Evening Meadow*, 1987. Oil on linen, 18 × 29 in. (46 × 74 cm).

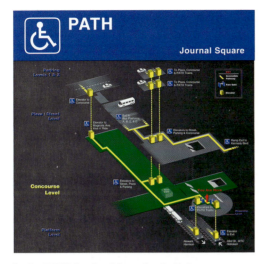

2.48 PATH Station Maps, Louis Nelson Associates, Inc., NY. Graphic designer: Jennifer Stoller.

2.49 Joseph Spadaford, *Illustrated Man*, 1998. Acrylic and airbrush on illustration board.

the black shape of the body "falls" into the surrounding blue sea, while the scarlet heart continues to pull the figure upward, away from death. Through an astute use of color, Matisse eloquently retells the Greek myth of the boy who flew too close to the sun, melting his wax wings and plunging into the ocean. Likewise, in Wolf Kahn's *Evening Meadow* (2.47), the yellow-orange meadow burns with afternoon light, while the band of dark green trees and the cobalt sky suggest the weight of an impending night.

Emphasis/Focal Point

Color can also be used to highlight essential areas in a composition. The subway map in Figure 2.48 provides a good example. Cooler areas of gray, green, and blue, placed on a black background, provide basic structural information. The bright yellow lines show the path through the subway. Red, which is used at only one point in the diagram, clearly locates the viewer on the map.

Color Keys

A **color key,** or dominant color, can heighten psychological as well as compositional impact. The blues that dominate Joe Spadaford's *Illustrated Man* (2.49) suggest both the magic and mystery of the night. At the other extreme, in Egon Schiele's *Portrait of Paris von Gütersloh* (2.50), the flaming orange around and within the figure places the anxious man in an emotional electric chair.

2.50 Egon Schiele, *Portrait of Paris von Gütersloh*, 1918. Oil on canvas, 55¼ × 43¼ in. (140.3 × 109.8 cm).

2.52 Alfred Stieglitz, *The Terminal,* c.1892. Chloride print, 3½ × 4½ in. (8.8 × 11.3 cm).

2.53 Keisei Eisen, *Oiran Parading in a Blue Dress,* c. 1830. Woodblock print, 29 × 9¾ in. (73.7 × 24.8 cm).

2.51 Alice in Chains, "Dog's Breath" **Website.** Sony Music Creative Services, Santa Monica, CA. Graphic Interface Designer: Mary Maurer.

2.54 Andrew Wyeth, *Wind from the Sea,* 1947. Tempera on masonite, 18½ × 27½ in. (47 × 69.9 cm).

Color and Communication

Contrast

Contrast, an inherent aspect of value, can heighten impact and shift meaning. A gritty, high-contrast photograph such as Figure 2.51 creates a very different world than does a delicate, low-contrast photograph such as Alfred Stieglitz's *The Terminal* (2.52). Japanese woodblock prints, such as Keisei Eisen's *Oiran Parading in a Blue Dress* (2.53), often combine the elegance of subtle color with the impact of contrast. Crisp shapes provide clarity, while color gradation adds grace.

Emotional Effects

Colors are never emotionally neutral. The subtle browns and greens in Andrew Wyeth's *Wind from the Sea* (2.54) suggest the sepia color of a nineteenth-century photograph and evoke the slow pace and serenity of a countryside at rest. Richard Diebenkorn's *Interior with Book* (2.55), painted only 12 years later, provides a very different interpretation of a similar interior/exterior scene. The yellows and oranges in the background push toward us, while the solid blocks of blue pull inward, flattening the image. The tension and power thus generated create a California landscape that is a world apart from Wyeth's New England. The color in Sandy Skoglund's *Radioactive Cats* (2.56) creates yet another interpretation of an interior space. The gray humans seem lifeless, while the lime-green cats glow with an inquisitive energy that may be toxic!

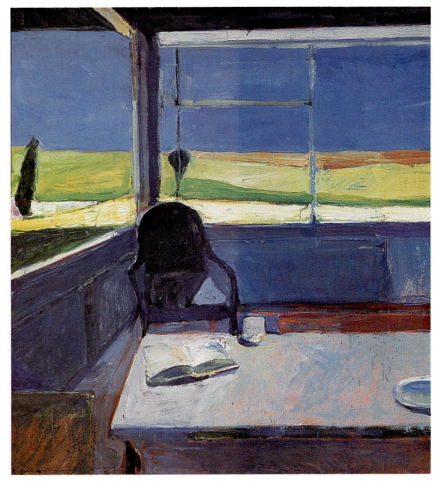

2.55 Richard Diebenkorn, *Interior with Book,* 1959. Oil on canvas, 70 × 64 in. (178 × 163 cm).

2.56 Sandy Skoglund, *Radioactive Cats,* 1980. Cibachrome print, 30 × 40 in. (76.2 × 101.6 cm).

2.57 **Butterfly Maiden, Hopi Kachina.** Carved cottonwood, 13½ in. (35 cm).

Symbolic Color

Colors are often assigned symbolic meaning. These meanings may vary widely from culture to culture. In *The Primary Colors*, Alexander Theroux writes:

> [Blue] is the symbol of baby boys in America, mourning in Borneo, tribulation to the American Indian and the direction South in Tibet. Blue indicates mercy in the Kabbalah and carbon monoxide in gas canisters. Chinese emperors wore blue to worship the sky. To Egyptians it represented virtue, faith, and truth. The color was worn by slaves in Gaul. It was the color of the sixth level of the Temple of Nebuchadnezzar II, devoted to the planet Mercury. In Jerusalem a blue hand painted on a door gives protection . . . and in East Africa, blue beads represent fertility." [3]

In Hopi culture, colors symbolize spatial location and geographic direction. Butterfly Maiden, a benevolent spirit, is represented by the Kachina doll in Figure 2.57. Red represents a southerly direction, white the east or northeast, and blue or green the west. The polished black granite used for the Vietnam Veterans Memorial (2.58) is equally symbolic. The Vietnam War, with its 50,000 dead, was a black period in the life of America. From a distance, the memorial is a dark gash in the earth. Upon entering the site, the viewer confronts himself or herself through the mirrored effect of the polished wall. And, at sunrise, the wall can become golden as it reflects the morning light.

2.58 **Maya Ying Lin, Vietnam Veterans Memorial, The Mall, Washington, D.C., 1981–83.** Polished black granite.

Four self-portraits by Käthe Kollwitz demonstrate the unique power of each approach to color. A monochromatic drawing on a cream-colored paper (2.59) has a simple eloquence, while a more developed value drawing (2.60) provides solidarity and creates the illusion of space. Higher contrast (2.61) adds drama and dimensionality, while a full palette (2.62) creates a sense of immediacy and life.

Color, well used, is one of the most expressive elements of art and design.

2.59 Käthe Kollwitz, *Self-Portrait in Profile, Facing Left, I,* **1889.** Lithograph, 5⅞ × 5⅞ in. (15 × 15 cm).

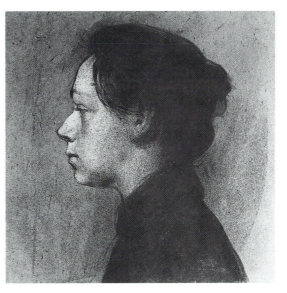

2.60 Käthe Kollwitz, Self-Portrait in Profile, Facing Left, II, **1889.** Lithograph in two colors, 5⅞ × 5⅞ in. (15 × 15 cm).

2.61 Käthe Kollwitz, *Selbstbildnis und Aktstudien (Self-portrait and Nude Studies),* **1900.** Pencil, dark gray ink wash, with white and yellowish highlights, on heavy brown paper, 11 × 17½ in. (27.8 × 44.5 cm).

2.62 Käthe Kollwitz, *Selbstbildnis im Profil Nach Rechts,* **c. 1900.** Pastel on laid paper, 19 × 14⅜ in. (46.8 × 36.5 cm).

Profile:
Ann Baddeley Keister, Weaver

Color, Construction, and
Communication: Designing a Tapestry

Ann Baddeley Keister is a nationally renowned fiber artist. She has a BFA and an MFA from the University of Kansas and received further training in Aubusson tapestry techniques from Jean Pierre Larochette at the San Francisco Tapestry Workshop. Her work has been exhibited both nationally and internationally and is in many private and corporate collections, including The Vanguard Group, The Discovery Channel, and the Indianapolis Museum of Art.

Keister is a professor of Foundations at Grand Valley State University. She maintains an active schedule of lectures and has taught many workshops both in tapestry and in the use of Adobe Illustrator as a design tool, including a session at the National Surface Design Conference in 1997 and for the Kentucky Crafts Foundation in 1998. Keister has received an Indiana Individual Artist Fellowship and an NEA Arts Midwest Fellowship. She has recently finished a large-scale tapestry, now installed in the new downtown campus for Grand Valley State University in Michigan.

MS: When I look at your work, I am impressed by the very deliberate use of design in your complex, narrative tapestries. These images could be painted or done on a computer so much more quickly. What is the advantage of weaving? What attracted you to fiber arts?

AK: My undergraduate degree actually was a general degree in design, which allowed me to explore a number of different craft and fine art media, including textiles. The University of Kansas has a great fiber facility, and since I had learned how to knit and sew at the age of seven, the materials of textile art just felt natural and familiar to me. I love making the structure through the repetitive action of weaving. And, I'm attracted to the pliability of the material. For me, metals are too unforgiving, clay is too messy—fiber, as a material, just feels "right" to me. I feel that there is a strong symbiosis between the images that I am interested in making and the material from which those images are constructed. One seems to feed off the other.

MS: Designer Paul Rand said, "Art is an idea that has found its perfect form. Design is the means by which this is realized." And, it is often said that art is about expression, while design is about communication. Is your work both art and design?

AK: Yes, and it is also craft and decoration. Contemporary fiber arts is such a diverse field. I love pure pattern

and I love storytelling. I love looking at beautiful colors and want to offer the viewer a visual feast through my work!

MS: What is your usual work process?

AK: Many of my projects begin with a commission. I determine the client's requirements, then puzzle over possible solutions. With *Memory*, during a walk along the Grand River, I saw an historical marker describing a late-nineteenth-century flood. I began to think about this terrible storm that washed away bridges and created piles of logs careening through the city. I immediately realized that this event could provide my image.

Next, I made a number of pencil sketches, which were developed further on the computer. I have an extensive knowledge of color theory, and this actually gives me the freedom to choose my colors very intuitively. I am using a lot of blue in this piece, since it is one of the school's colors, and I have a lot of discordant colors, which seem appropriate for such a devastating event.

A full-size, 6 × 10 ft computer print comes next. I match colors from my collection of approximately 200 colors of wool yarns. One strand on the loom is made up of six strands of yarn. I use a lot of optical mixing to create very subtle gradations. Finally, I weave the piece. The most useful thing I learned from my teachers is this: DO YOUR WORK! There is no substitute for action. Weaving

is slow and simply has to be done consistently. During my summer work time, I am in the studio from about 9 in the morning to 6 in the evening, an average of five or six days a week. Since weaving is an activity that makes demands on the body and the concentration, I do take breaks in my daily work with forays into the garden or other household chores. This is one reason that I find working at home so satisfying. My domestic interests in cooking, the garden, and my home often find their way into my imagery as well.

MS: What are your criteria for excellence?
AK: I seek unity between concept and composition. Each of the formal elements—line, shape, texture, and color—

is essential. There is almost always a dynamic sense of space in my work, which makes the tapestry read well in an architectural setting. I seek an inseparable connection between imagery, technique, and material.

MS: Do you have any advice for my students?
AK: Take the time to be inventive. Try out many possibilities. If you don't like an image, don't do it! Invent another way to solve the problem. The joy you bring to the creative process will be apparent in the final design.

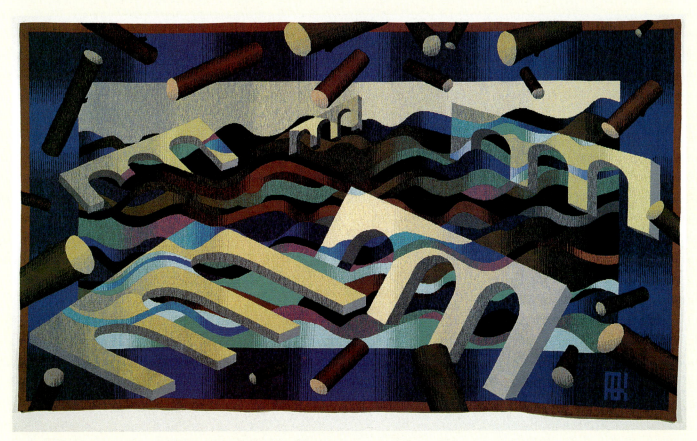

Ann Baddeley Keister, *Memory*, 2000. Wool tapestry, 6 × 10 ft (1.83 × 3.1 m).

Summary

- Color immediately attracts attention. Its emotional and physiological impact can heighten communication.

- Red, green, and blue are the additive color primaries. Cyan blue, magenta red, and yellow are the subtractive color primaries.

- The four basic qualities of color are hue (the name of the color), value (its lightness or darkness), intensity (its purity), and temperature (warmth).

- Major color systems include monochromatic, analogous, complementary, split complementary, and triadic.

- The level of color harmony must match the expressive intent. Disharmony is often more expressive than harmony.

- Color can expand a shape, shift compositional weight, create a focal point, or heighten emotion.

Keywords

accent color
additive color
afterimage
analogous color
chroma
chromatic gray
color harmony
color key
complementary
 color
contrast

hue
intensity
monochromatic
opponent theory
primary color
saturation
secondary color
shade
simultaneous
 contrast

split complementary
subtractive color
symbolic color
temperature
tertiary color
tint
tone
triadic
value

1. What is the advantage of a limited color palette? What is the advantage of a broad color palette? Which will better serve your needs in a specific design?

2. When a limited palette is used, how can a few colors create the greatest impact? When a broad palette is chosen, what strategies can be used to create unity?

3. What is the advantage of transparent colors? What is the advantage of opaque colors?

4. What can gradation contribute to your design?

5. To what extent should traditional harmony be used? When is disharmony more appropriate?

6. Try exaggerating your distribution of colors; unconventional proportions can result in distinctive design.

Josef Albers, *Interaction of Color*. New Haven, CT, Yale University Press, 1963.

Frans Gerritsen, *Theory and Practice of Color*. New York, Van Nostrand Reinhold, 1975.

Johannes Itten, *The Art of Color*. New York, Van Nostrand Reinhold, 1974.

Harald Kuppers, *Color: Origin, Systems, Uses*. New York, Van Nostrand Reinhold, 1972.

Harold Linton, *Color Model Environments*. New York, Van Nostrand Reinhold, 1985.

Albert Munsell, *A Color Notation*. Munsell Color, 1981.

Richard B. Norman, *Electronic Color*. New York, Van Nostrand Reinhold, 1990.

John F. Pile, *Interior Design*. New York, Harry N. Abrams, 1988.

Two-Dimensional Design: Organization

Imagine yourself practicing jumpshots on a deserted basketball court. By focusing all your attention on the basket, you can master the sequence of moves needed to score. Next, imagine yourself playing in a high-paced game, surrounded by skillful and cooperative teammates. The skills you practiced alone become heightened as you take passes and make shots in an actual game. The complexities increase and the stakes rise when players fill the court.

Developing a complex design can be equally exhilarating. Just as a boundary line defines the basketball court, so the outer edge of a composition defines the design, creating the playing field for a visual game. When the parts of the puzzle are multiplied, we can create more complex forms of balance, increase the illusion of space, and explore the implications of movement. Opposing forces generate energy. When one element becomes dominant, other elements must become subordinate. The opportunities for visual invention are endless.

Pay attention. This chapter completes the first stage of the rocket we are using to launch the imagination. As a result, there is a *lot* of information here. Four fundamental principles of composition are presented in the first section, followed by an extended discussion of the illusion of space and the illusion of movement. Finally, profiles of graphic designer Ken Botnick and painter Ken Stout demonstrate uses of composition for very different purposes.

Basic Composition

Composition may be defined as "the combination of multiple parts into a harmonious whole." Two-dimensional compositions are constructed using line, shape, texture, color, and value. Even the most elusive idea can be expressed eloquently when the visual components fit together just right. Teamwork is essential. As with a basketball team, the individual parts of any compositional puzzle are less important than the composition as a whole.

Unity and Variety

Unity and variety are the cornerstones of visual communication. **Unity** may be defined as oneness, togetherness, or cohesion. The main purpose of com-

Figure 3.8, by Shaykh Muhammad, 28 humans, five animals, three tents, and four carpets fill a single book page. The painting just bustles with activity. At the other extreme, the large open space in Jim Dine's sculptural painting (3.9) adds a dangerous quality to a collection of ordinary tools. Suspended above this void, the sharp tools seems ready to fall at any moment.

Michelangelo's *Creation of Adam* (3.10) clearly demonstrates the expressive power of proximity. Jehovah's hand, on the right, nearly touches Adam's hand, on the left. Less than four inches of space separate the two. In this cosmology, all of human history begins when the spark of life jumps this gap. If the hands had been placed too far apart or too close together, the spark that animates both the man and the painting would have been lost.

Continuity

Continuity creates a fluid connection among compositional parts. In Frank Stella's *Lac Laronge IV* (3.11), the curving lines and shapes flow from one circle to the next, creating a sense of movement. Continuation by eye direction is shown in Figure 3.12. The woman on the left looks right; the woman on the right looks left. Both faces are cut off, or **cropped,** by the border. Our eyes move between the women, keeping our attention focused on the advertisement and on the jewelry being sold.

Similarity

Any similarity in a design tends to increase unity. In Aaron Macsai's *Panels of Movement* (3.13), similar lines, shapes, textures, and colors, were used in each of the 10 panels from which the bracelet was constructed.

Visual Systems

An underlying pattern or grid can be used to create connections among even the most

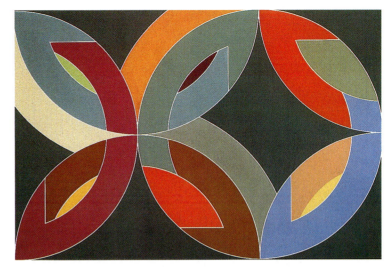

3.11 Frank Stella, *Lac Laronge IV,* 1969. Acrylic polymer on canvas, 9 ft ⅛ in. × 13 ft 6 in. (2.75 × 3.11 m).

3.12 Example of cropping and continuity.

3.13 **Aaron Macsai,** *Panels of Movement.* Bracelet, 18K gold, sterling, copper, ⅞ × 7 in. (2 × 18 cm).

3.14 Example of unifying pattern. Four patterned shapes give structure to a random collection of shapes.

3.15 Alfred Stieglitz, *Paula,* Berlin, **1889.** Contact print on azo, dry plate, 8⅞ × 6½ in. (22.5 × 16.5 cm).

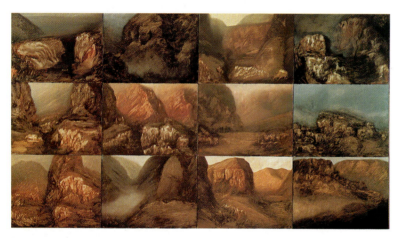

3.16 James Lavadour, *The Seven Valleys and the Five Valleys,* 1988. Oil on canvas, 54 × 96 in. (137 × 244 cm).

disparate visual elements. In Figure 3.14, a crisp pattern of diagonal lines has been used to unify a variety of separate shapes. If this pattern were removed, the composition would become unstable. By using the unifying pattern, the designer was able to create a lively, informal layout while retaining a feeling of unity. In *Paula* (3.15), Alfred Stieglitz used a dominant light source to produce a similar effect. The woman writing a letter is surrounded by various objects on the table and pictures on the wall. The pattern of diagonal lines unifies the various parts of the image and contributes to the contemplative mood.

A grid can provide both proximity and pattern. For example, the three horizontal lines and four vertical lines in Lavadour's *The Seven Valleys and the Five Valleys* (3.16) create a clear structure with each of the 12 landscapes in perfect proximity. Even when the grid is fairly loosely constructed, as with the 1995 Audubon Society Annual Report (3.17), the recurrent vertical and horizontal divisions help increase unity.

Closure

Given enough clues, the human mind will automatically connect visual fragments.

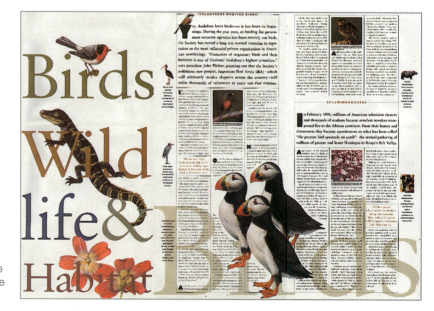

3.17 Pentagram Design, NYC, National Audubon Society 1995 Annual Report. Page showing three puffins and the words: Birds, Wild life & Habitat.

Closure, as this action is called, is an especially powerful force in visual communication. We can mentally connect four lines to create a square (3.18). Thousands of letters can be connected to form a face (3.19). Skillfully chosen, a few clues can be used to convey a complex message. In Figure 3.20, closure helps us read the disordered words at the top of the design and then helps us connect these words to the doll's face in the image below. The text provides us with the title of the play; the image provides us with the emotion.

3.18

Closure makes it possible to communicate using implication. Freed of the necessity to provide every detail, the artist can convey an idea by using suggestion, rather than description. When the viewer completes the image in his or her mind, it is often more memorable than a more explicit image. Experienced filmmakers use implication with particular care. By suggesting rather than showing the witch, directors Eduardo Sanchez and Daniel Myrick substantially heightened the feeling of terror in *The Blair Witch Project*.

Weight and Gravity

Visual weight refers to the inclination of shapes to float or sink based on their solidity and compositional location. Solid shapes generally weigh more than open shapes. Shapes that appear to extend beyond the upper edge of the format tend to rise, while shapes that appear to extend below the format tend to sink.

The vertical, horizontal, or diagonal orientation of a line or shape also affects visual weight. Try this simple experiment. Which is the most dynamic and which is the most static position for the box in Figure 3.21? Most viewers find positions A and B the most **static,** or stable. The box stands still, with the vertical and horizontal edges reconfirming the stability we experience when objects are at rest in the real world. In contrast, position C and especially position D place the box in a **dynamic** position, caught halfway between standing and falling.

3.19 Because of closure, hundreds of separate shapes can be combined to create a face.

3.20 Cyclone Design, *Turn of the Screw.* Theater poster.

3.21 Which box is the most static? Which is the most dynamic?

3.23 Tetsurō Sawada, *Brilliant Scape (Blue)*,1985.
Silkscreen, 22⅞ × 15¾ in. (58 × 40 cm).

3.22 Bernice Abbott, *Exchange
Place,* New York, 1934. Photograph.

Bernice Abbott's photograph of New York skyscrapers (3.22) demonstrates the power of orientation. Using dramatic vertical shapes within a tall vertical format, she captured the soaring energy of Wall Street within a small image.

Even the most abstract design is governed by gravity. In Figure 3.23, a rectangle filled with horizontal lines suggests the stability and tranquility of a landscape. Image stability would increase even more if the format were positioned horizontally. Instead, by using a vertical orientation and devoting the upper half to a gradated blue shape, Tetsurō Sawada has combined the serenity of a landscape with the expansive feel of the soaring sky.

Visual weight can also refer to the relative importance of a visual element within a design. In Vernon Fisher's *Objects in a Field* (3.24), the image of the astronomical observatory has great visual weight despite its small size. Centrally located in the upper half of the painting, it commands our attention while creating a connection to the parachutist in the foreground.

In *Moonrise, Hernandez, New Mexico, 1941* (3.25) Ansel Adams combined balance, gravity, and movement to create an image that is both tranquil and dramatic. The squarish format, dominated by horizontal lines, provides stability. The quiet village sinks to the bottom of the photograph. The moon, positioned just to the right of compositional center, pulls us into the velvety black sky at the top half of the composition. An equilibrium in visual forces creates a magical image.

3.24 Vernon Fisher, *Objects in a Field*, 1986. Acrylic on canvas, 8 × 8 ft (2.4 × 2.4 m).

Balance

A variety of visual elements can work cooperatively within a balanced design. As with physical balance, visual **balance** requires equilibrium, or equality in size, weight, or force among design elements. Unlike physical balance, however, visual balance can be created through absence as well as presence. For example, in *Moonrise, Hernandez, New Mexico, 1941,* the crowded village filling the bottom half of the composition is easily balanced by the open sky above.

Symmetrical Balance

Designers generally use various forms of symmetry and asymmetry to create balance. Let's start by dividing the format down the center. In strict **symmetrical balance,** shapes or volumes are mirrored on either side of this vertical axis (3.26A). A shift in this axis (3.26B) creates symmetry between the top and bottom of the design. Symmetrically balanced images can be harmonious, evocative, or confrontational, depending on the subject matter and compositional context. In Figure 3.27, symmetrical balance brings grace and serenity to the Taj Mahal, while in Figure 3.28, symmetrical balance creates a confrontation.

3.25 Ansel Adams, *Moonrise, Hernandez, New Mexico, 1941.* Photograph.

3.26 Examples of symmetrical balance.

3.27 Taj Mahal, Agra, India.

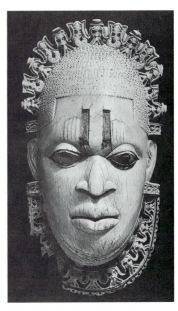

3.28 Nigerian Belt Mask, 16th century. Ivory, 9⅜ in. (23.8 cm).

Radial Symmetry

3.29

Now divide the format horizontally as well as vertically. With **radial symmetry,** lines and shapes are mirrored both vertically and horizontally, with the center of the composition acting as a focal point (3.29). An expanded approach to radial symmetry is shown in Judy Chicago's *Rejection Quintet: Female Rejection Drawing* (3.30). Because the format is now divided diagonally as well as vertically and horizontally, the entire design radiates from the center.

Within a square or circular format, radial symmetry is often used to generate four types of dynamic balance:

- **Centrifugal balance** occurs when the visual forces expand outward (3.31A).

- **Centripetal balance** occurs when the visual forces move inward, suggesting a compression of space. Figure 3.31B whirls inward, propelled by four spiraling extensions to the circle, while Figure 3.31C pulls inward on a more direct path.

- **Concentric balance** occurs when the boundary is repeated in diminishing size to create a bull's-eye effect (3.31D). Used skillfully, concentric balance can harness both the expanding energy of centrifugal balance and the compressive energy of centripetal balance. This star pulls us inward while simultaneously pushing outward.

A final variant on radial balance is the spiral (3.31E). A spiral can heighten energy in a circular format or generate movement within a rectilinear format. In Rubens' *Tiger Hunt* (3.32 A), the compositional spiral twists inward and breaks apart, creating a painting that swirls with energy. The compositional drawing in Figure 3.32B demonstrate this effect.

3.30 Judy Chicago, *Rejection Quintet: Female Rejection Drawing,* **1974.** Prismacolor and graphite on rag / board, 39⅝ × 29⅝ in. (101 × 75 cm).

A

B

C

D

E

3.31

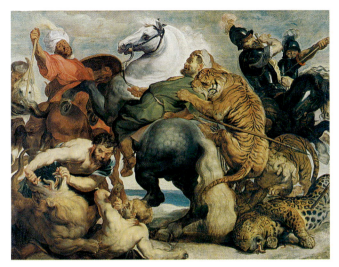

3.32A Workshop of Peter Paul Rubens, *Tiger Hunt*, c. **1616.** Oil on canvas, 38⅞ × 49¼ in. (98.8 × 125 cm).

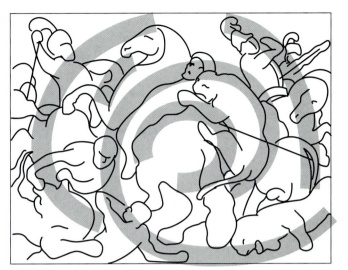

3.32B Diagram of compositional forces.

Asymmetrical Balance

Asymmetrical balance creates equilibrium between visual elements that differ in size, number, weight, color, or texture. Depending on the degree of difference and the overall organization, the resulting design may be stable, dynamic, or nearly chaotic. Asymmetrical balance generates a lot of energy and is often used for eye-catching posters that must aggressively compete for viewer attention.

Many strategies can be used to create asymmetrical balance.

- A large shape is placed close to the fulcrum, while a small shape is placed further away. Just as a child at the end of a seesaw can balance an adult near the center, so large and small shapes can be balanced in a design (3.33A).

- Multiple small squares, acting together, can balance a large square (3.33B).

- A small, solid square can balance a large, open circle. The solidity and stability of the square give it additional weight (3.33C).

- A textured shape placed near the fulcrum can be balanced by a distant open shape (3.33D).

A

B

C

D

3.33

A B C D

3.34 Examples of asymmetrical balance.

Asymmetrical balance becomes even more interesting when the format is added. Because the negative space (or ground) is just as important as each positive shape, more complex compositions can now be created.

- A small shape placed near the bottom of the format balances a large shape placed along the top. Especially within a tall rectangle, shapes placed near the top tend to rise while shapes placed near the bottom tend to sink (3.34A).

- When the small square intersects the bottom edge and the large square moves away from the edge, the differences in weight become even more pronounced (3.34B).

- Here the top shape gains energy through its diagonal orientation. Three bottom shapes are now needed to create balance (3.34C).

- Finally, a small, aggressive shape can balance a large, passive shape (3.34D).

Balance in a composition shifts each time a visual element is added or subtracted. A complex network of negative and positive lines and shapes creates the balance in Mondrian's *Composition with Blue and Yellow* (3.35). The large yellow square positioned along the top edge is easily balanced by the small blue rectangle that sinks to the bottom. In Frank Miller's digital design (3.36), a horizontal line extends from left to right in descending steps.

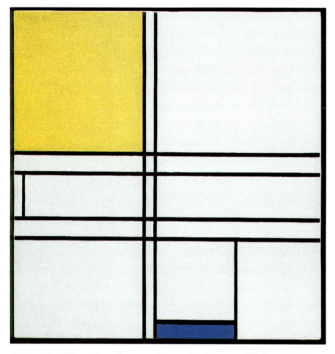

3.35 Piet Mondrian, *Composition with Blue and Yellow*, 1935. Oil on canvas, 28¾ × 27¼ in. (73 × 69.2 cm).

3.36 Frank Miller, *Untitled*, 1997. Digital image.

3.37 Frida Kahlo, *Las Dos Fridas*, **1939.** Oil on canvas, 69⅕ × 69⅕ in. (176 × 176 cm).

3.38 Isamu Noguchi, *Red Cube (648)*, **1969.** Steel painted red, height 28 ft (8.53 m).

Four broken vertical lines divide the design into three major sections. Within these sections, the curving satellite dishes, clock, and letters add both unity and variety.

Each type of balance has its advantages. The symmetrical balance Frida Kahlo used for her double self-portrait (3.37) is symbolically appropriate and compositionally stable. Painted in response to her divorce from painter Diego Rivera, it presents the beloved Frida in a native costume on the right and the rejected Frida in European dress on the left. A linear vein connects the women's hearts. On the other hand, in Figure 3.38 asymmetrical balance is used to accentuate the dynamic orientation of Isamu Noguchi's *Red Cube*. This photographic composition is as dynamic as the cube itself. When the type of balance used is appropriate to the content of the artwork, both expression and communication increase.

Scale and Proportion

Proportion refers to the relative size of visual elements *within* an image. When we compare the width of the head to its height, we are establishing a proportional relationship (3.39). **Scale** refers to

3.39 Proportion is an essential part of figure drawing.

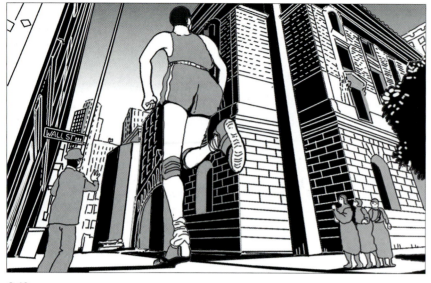

3.40

3.41 Michael Bierut, *Save Our City.* Design Firm: Pentagram, NYC.

3.42 Georgia O'Keeffe, *Pelvis with Moon,* 1943. Oil on canvas, 30 × 24 in. (76.2 × 61 cm).

the size of an image or object when compared to our own human size. Compared to the awestruck pedestrians, the large-scale athletes running through the city in Figure 3.40 seem to possess superhuman strength.

Most designs distribute information quite evenly within the format, with only modest size variation among the parts. Exaggerating these proportions can be eye-catching because the image immediately stands out from the norm. When this visual impact is matched to the message conveyed, the results can be memorable. In *Save Our City* by Michael Bierut (3.41), the large black rectangle at the top presses down on the white shape below, covering the top part of the word "Save." Meanwhile, the vertical white text suggests a city skyline and helps pull the white half of the poster upward. This tension between the upper and lower sections of the design perfectly matches the urgency of the message.

When the scale of images and objects is exaggerated, a number of expressive possibilities occurs. In *Pelvis with Moon* (3.42), Georgia O'Keeffe held a bone up to the sky, trapping patches of blue within the voids while expanding the bone to a cosmic scale. *Intermission* (3.43), a 50-foot-long painting for the Walton Arts Center, presented various challenges to painter Ken Stout. The physical size of

3.43 Ken Stout, *Intermission*, **1994.** Oil on canvas, 9 × 50 ft (2.74 × 15.24 m). Also see enlargement, page 3-39.

the painting had to become an asset, rather than a liability. To this end, Stout created a swirling panorama of figures engaged in a wide variety of activities, onstage, backstage, and in the audience. Two men in the balcony further contribute to the action, as one aims a peashooter and another launches a paper airplane. This large-scale painting creates a panorama of action both on and off the stage.

Emphasis

Emphasis is used to give part of a design particular prominence. Emphasis is often used to attract attention. Because the viewer must first stop and *look* at the painting, poster, or photograph if communication is to occur, emphasizing the most important aspect of a design is crucial. A tour of three Websites provides examples of compositional clarity, compositional confusion, and compositional complexity, all due to emphasis.

The GTS Companies Website (3.44) is a model of simplicity, clarity and restraint. Information is sized and organized according to its significance. The company name is prominently displayed, followed by a description of services provided. By clicking on three simple boxes, viewers can get detailed information on major divisions in the company and additional links are provided in a column on the left. An update on company activities appears in an open box when the visitor enters the site. The blues that dominate the design provide unity, while a single red header is used for emphasis.

By contrast, the Website shown in Figure 3.45 is overloaded with competing information, beginning with the banner ads at the top of the screen. Multiple typestyles, colors, buttons, and layers of information all compete for attention. There are no supporting actors in this play; each visual element is accorded star status, regardless of importance.

3.44 GTS Companies Website.

3.45 An example of bad Website design.

3.46 Website from Naturally New Zealand Holidays Ltd.

3.47 Pentagram Design, **Magazine.** Publisher: Art Center College of Design, Pasadena, CA.

The 1998 Naturally New Zealand Website (3.46) is an example of compositional complexity. All the colors, images, and typestyles used reflect the upscale adventure touring promoted by the company. The green band on the left provides a menu of links, so that the visitor can easily proceed to any interesting section. Graphic buttons provide immediate links to a map of New Zealand, general information, and booking inquiries. Further specific topics of interest are listed by location. Using simple animation, the boot button moves from a horizontal position to a diagonal position to indicate trip difficulty as the climb becomes steeper. The entire site provides easy access to information, even for a novice Web surfer.

Separation and Connection

Any **anomaly,** or break from the norm, tends to stand out. Because we seek to connect and unify any verbal or visual information we are given, a mismatched shape immediately attracts attention. In Figure 3.47, the word "design" is emphasized through its separation from the word "magazine." By breaking the bottom edge, this shape gains even more power. Jennifer Bartlett's *Yellow and Black Boats* (3.48) creates an even stronger separation between various parts in a composition. Two boats have completely escaped the painting and entered the physical world.

3.48 Jennifer Bartlett, *Yellow and Black Boats,* 1985. Oil on three canvases, each 10 ft × 6 ft 6 in (3 × 2 m). Yellow boat: Wood and enamel paint, 14 × 60½ × 31 in. (35.6 × 153.7 × 78.7 cm). Black boat: Wood and flat oil-base paint, 6 ft 6 in. × 5 ft 8 in. × 3 ft 2 in. (2 × 1.73 × .097 m).

3.49 Joana Kao, *I Never Liked Musical Chairs*. Bracelet, 24K, 2¾ × 1¾ in. (7 × 4 cm).

3.56 Book of Kells: Opening page, St. Luke's Gospel. Trinity College, Dublin. 9½ × 13 in. (24 × 33 cm).

Creating a clear pattern can increase conne̶c̶t̶ ̶s̶ in a among visual elements. Conversely, any break pattern accentuates separation. In Figure 3.1, white umbrellas establish the pattern that is so tifully broken by the single red umbrella. In *I N Liked Musical Chairs* (3.49), metalsmith Joana K created a pattern using seven tiny chairs conne by a silver chain. The figure at the end of the ch̶ breaks the pattern. Here, compositional separa̶ ̶n̶d̶. conveys the sense of isolation felt by a child eje̶ ̶n̶t̶, from the game.

Location

The very location of a line or shape within the for mat can attract attention. The compositional cente̶ ̶t̶ particularly powerful. In *Flash Point*, (3.50) Sam Francis placed a white square in the middle of his painting. Surrounded by explosive energy, this shape becomes a focal point through its central location and distinctive stability.

The focal point in Gericault's *Raft of the Medusa* (3.51) was created using a pattern of compositional lines. The arms and legs of the sailors, the floorboards of the raft, and even the angle of the sail all direct our attention toward the rescue ship in the upper right corner. This dramatic use of eye direction greatly increases the painting's emotional power. One-hundred-and-forty-nine survivors from a sinking ship began a desperate journey on the raft; when rescued two weeks later, only 15 survived. The pattern of bodies and extended arms pulls us irre-sistibly toward the sailor at the front of

3.51 Théodore Gericault, *Raft of the Medusa*, 1818–19. Oil on canvas, 16 ft 1 in. × 23 ft 6 in. (4.9 × 7.2 m).

Left Vanishing Point

Viewer's Location Point

Eye Level

Right Vanishing Point

Bottom Vanishing Point

3.63 Three-point perspective.

3.64 **Ely Itara, Jr.** Pen and ink, 9 × 10 in. (22.8 × 25.4 cm).

3.65 **Rogier van der Weyden,** *Deposition,* **from an altarpiece commissioned by the Crossbowman's Guild, Louvain, Brabant, Belgium, c. 1435.** Oil on panel, 7 ft 2⅝ in. × 8 ft 7⅛ in. (2.2 × 2.6 m).

Three-point perspective is used when the lines receding into space appear to converge at two vanishing points on the eye level, plus a third point placed above or below the eye level. This occurs when the viewer is facing a *corner* of the cube, rather than the front or a simple edge (3.63). Now, all the lines converge at the various vanishing points: none of the lines parallel the edge of the paper. As shown in Figure 3.64, three-point perspective is often used by comic book artists to create menacing architecture or to provide an aerial view.

Other Spatial Systems

Overlap. This is a the simplest way to suggest space, and it can be especially effective when combined with size variation. In *Deposition* (3.65), Rogier van der Weyden used overlap combined with value to create convincing human figures within a crowded compositional space.

Size variation. Because the diminishing size of distant objects is a basic characteristic of human vision, any systematic variation in size will increase the illusion of space. This effect is demonstrated most clearly when the distance is great. In Adams' *Yosemite Valley from Inspiration Point* (3.66), the large size of the cliffs in the foreground creates the illusion of space.

Definition. Sharply focused shapes also tend to advance, while blurred shapes tend to recede. In a landscape, water droplets in the air blur outlines and add a bluish color to distant shapes, creating an effect known as **atmospheric perspective.** Atmospheric perspective dissolves the most distant mountains in *Yosemite Valley from Inspiration Point*, extending the space even further.

Location. Visual elements placed near the top of the page tend to recede, while shapes placed at the bottom tend to advance. In *A Thousand Peaks and Myriad Ravines* (3.67), the mountains at the top of the scroll appear more distant despite their large size.

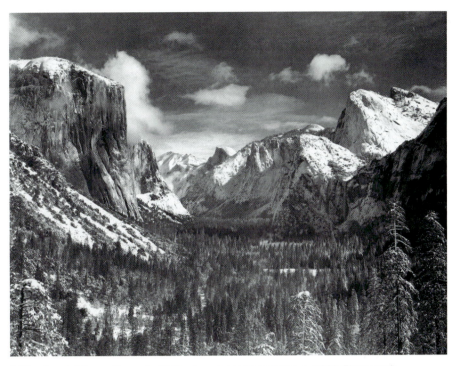

3.66 Ansel Adams, *Yosemite Valley from Inspiration Point*, c. 1936. Photograph.

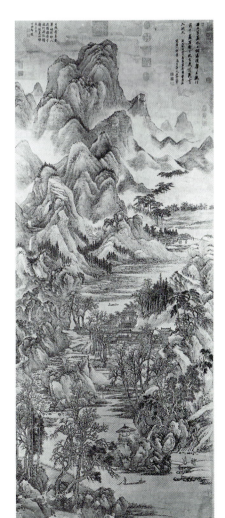

3.67 Wang Hui, *A Thousand Peaks and Myriad Ravines*, Qing dynasty, 1693. Hanging scroll, ink on paper, 8 ft 2½ in. × 3 ft 4½ in. (2.54 × 1.03 m).

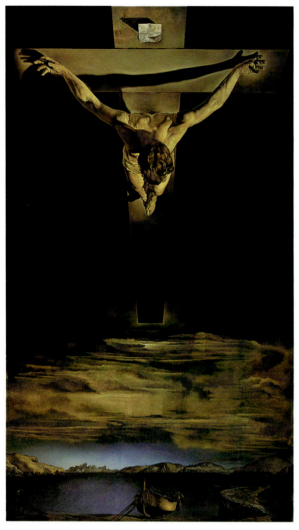

3.68 Salvador Dali, *Christ of St. John of the Cross,* 1951. Oil on canvas, 80⅝ × 45⅝ in. (204.8 × 115.9 cm).

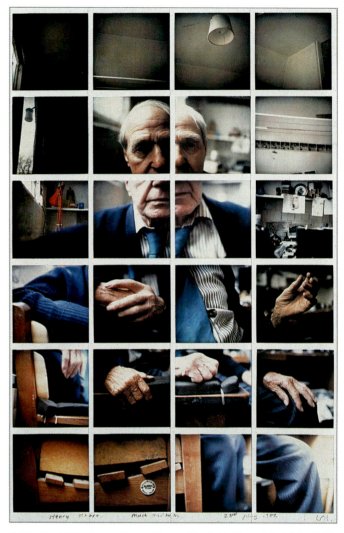

3.69 David Hockney, *Henry Moore Much Hadham 23rd July 1982,* **1982.** Composite Polaroid, 21 × 14 in. (53 × 36 cm).

Expressive Uses of Space

Through the illusion of space, artists invite viewers to enter an imaginary world. Expression can be heightened when the world created is particularly intriguing or when the spatial illusion is especially dramatic.

Amplified Perspective. This technique changes our interpretation of the crucifixion of Christ in Dali's *Christ of St. John of the Cross* (3.68). Dramatic three-point perspective emphasizes the importance of the note pinned at the top of the cross. As we look down, the vulnerability of Jesus emphasizes his humanity while the hovering position of the figure suggests his divinity.

Constructed Space. In his portrait of sculptor *Henry Moore* (3.69), David Hockney used multiple photographs to expand space and suggest the passage of time. The repeated hands gesture to us as we visually converse with the old master.

Layers of Space. Separating compositional space into foreground, middle ground, and background presents many expressive possibilities while increasing compositional complexity. Layers of space are used extensively in the film *Citizen Kane*. In Figure 3.70, young Charlie Kane plays in the background while his mother in the foreground signs over his care to a lawyer. His father, who is opposed to this action, occupies the middle ground, caught between the mother and the child. The tensions in the family, the determination of the mother, and the innocence of the child are heightened when Charlie shouts "the Union forever!" as part of his game. When the lawyer takes charge of him, the family will be split apart forever. These three layers of space communicate complex emotions while simultaneously telling a story.

Spatial Complexity. When you have mastered the skills needed to create the illusion of space, the creative and expressive possibilities expand. The swirling space in Thomas Hart Benton's *City Building* (3.71) has been constructed using a combination of conflicting spatial systems. The size variation between the figures in the foreground and the ship in the background creates a strong sense of space, which is extended even further by the faint skyscrapers in the distance. The dark cranes and pulleys, however, tend to push forward in space, creating a conflict between the background and the foreground. The curving white line extending from the center of the painting to the upper edge complicates matters even further. Part of the wall itself, this bit of molding disrupts the illusion of space by drawing our attention to the flat surface. In this mural, Thomas Hart Benton orchestrated contrasting compositional forces to create an explosive image.

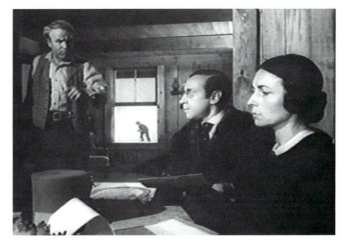

3.70 Scene from *Citizen Kane*. Three layers of space divide this shot from *Citizen Kane*: the mother in the foreground, the father in the middleground, and the child in the background.

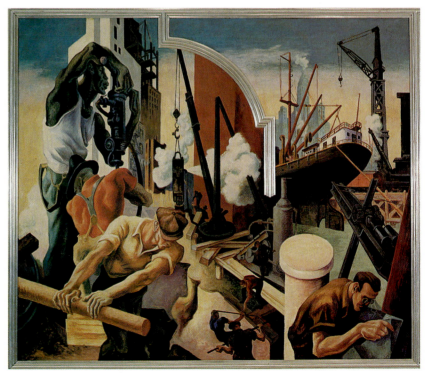

3.71 Thomas Hart Benton, *City Building*, from the mural series *America Today*, 1930. Distemper and egg tempera on gessoed linen with oil glaze. 7 ft 8 in. × 9 ft 9 in. (2.3 × 3 m).

A

B

C

D

E

3.72A–E

The Dynamics of Space: Bringing *Mulan* to Life

Animators use the illusion of space with great inventiveness. Freed from the restrictions of reality, they invent and explore space with abandon. Indeed, every type of space is used beautifully in Disney's *Mulan*. From the opening shots to the grand finale, the illusion of space is of critical importance to the visual and conceptual power of the film.

- *From Line to Space.* At the end of the opening credits, a linear ink drawing is gradually transformed into an image of the Great Wall of China (3.72A-C). Cast shadows and variations in light create an illusion of space, providing a stage for the action to follow.

- *Overlap.* After a brief battle with Shan-Yu and his men, a Chinese soldier lights a signal fire to warn of the invasion. With Shan-Yu filling the foreground, we see six different towers, with signal fires gradually blazing forth from each (3.72D). Here, overlap and size variation enhance the illusion of space.

- *Linear perspective* is used in the next sequence when General Li enters the imperial palace to inform the emperor of the invasion. One-point perspective is used to create the large, majestic hall (3.72E). As the general approaches the throne, the angle of vision shifts to an aerial view. Three-point perspective is now used to emphasize the insignificance of the figures within this great hall (3.72F).

- *Atmospheric perspective* is often used as the troops travel through the mountains. After learning of the death of his father in battle, Captain Shang walks to the edge of a cliff. Like the massive mountains in the background, his seemingly invincible father has dissolved in the mist. A small figure within a large landscape, Captain Shang remains sharply focused, dignified, and powerful even as he grieves (3.72G).

- *Camera Angles.* **Camera angles** determine the amount and type of space to be included in each shot. An aerial view can provide the sweeping panorama needed to convey the enormity of a battle, while a low camera angle can provide an expansive view of the sky. The major battle scene in *Mulan* beautifully demonstrates the critical role a camera angle can play in a film. The enormity of the enemy forces is first shown in Figure 3.72H. A low camera angle positions the vast enemy army along a ridge, above the small company of Chinese soldiers. As the Mongols pour over the ridge and gallop toward Mulan, the camera angle shifts to a slanted, oblique view (3.72I), then to a complete aerial view (3.72J). The shifting perspectives give us a more comprehensive view of the extent of the battle and emphasize the hopelessness of the emperor's warriors, who are confronted with an apparently invincible enemy. When Mulan grabs the one remaining cannon and races forward to create an avalanche, an aerial view is again used to show her vulnerability against the advancing Huns. Throughout the battle, shifts in camera angle provide the emotional and compositional power needed to create a dramatic battle sequence using the fewest number of shots.

F

G

H

J

I

Illusion of Movement

Mulan is constructed from thousands of tiny frames. When run through a film projector, they create the fluid movement that is the hallmark of Disney animation. Animation is possible because we have the perceptual ability to integrate the sequential images into a continuous flow. Substantial audience involvement is also required to create the illusion of movement. Presented with multiple images on a single surface, we must feel the movement, complete the action, or anticipate the next event. Based on our day-to-day experience in an ever-changing world, we use our imagination to connect static images to create the illusion of movement.

The Kinesthetic Response

Kinesthetics is the science of movement. Through the very process of walking, we consistently engage in a complex balancing act as we fall forward, then catch ourselves with the next step. When confronted by a life-sized figure such as this man from Robert Longo's *Men in Cities* series (3.73), the lunging movement of the model resonates on a physical level. Based on our personal experience, we feel as well as see the gesture. Capturing the gesture at the right moment is critical. In Myron's *Discus Thrower* (3.74), the athlete is caught at the moment *before* the whirling vortex of energy explodes, releasing the disc. By capturing this moment rather than the moment of release, the sculptor has trapped within the marble the energy of the throw.

The Decisive Moment

Photographer Henri Cartier-Bresson used his understanding of impending change to formulate a theory of photography he called "the decisive moment." A pioneer in the use of the 35-mm camera, he, too, caught images at the moment of greatest impact, creating photographs that are charged

3.73 Robert Longo, *Untitled*, 1980. From the *Men in Cities* series. Crayon & graphite on paper, 40½ × 28 in. (102.9 × 71.1 cm).

3.74 Myron, *Discus Thrower (Diskobolos).* Roman copy after the original bronze of c. 450 B.C. Marble, height 5 ft 1 in. (1.54 m).

ordinary stairs; in the context of the film, this spiraling descent becomes especially nightmarish. Another famous example occurs in *Citizen Kane*, a film that is often described as the best American movie of all time. The millionaire Kane has been deserted by his wife. Despite his wealth and power, he is now completely alone, isolated in a world of his own megalomania. As he slowly walks down the corridors of his castle (3.90), his silent figure is repeated again and again and again. No matter how many figures fill the room, Kane has only himself for company.

3.90 Still from *Citizen Kane*, by Orson Welles.

Maximizing Visual Impact

Complexity can be a virtue in design. It is like killing two birds with one stone: you are getting as much as possible from every visual element. On the other hand, complication in an artwork can be an obstacle. Complication is like throwing 20 stones at one bird—and missing. By focusing on compositional relationships and creating an ideal balance among visual elements, clarity of communication and powerful emotion can emerge.

Profile:
Ken Stout, Painter

Immediacy and Energy in Large Scale

Ken Stout is an internationally renowned figurative painter. He has shown his work widely, including group shows at the Nelson-Atkins Museum of Art in Kansas City and the Butler Museum of American Art, as well as solo shows at the Goldstrom Gallery in New York City, the Arkansas Art Center, and the Cité Internationale des Arts in Paris. Stout has received numerous awards including a National Endowment for the Arts Painting Award in 1990 and the Arkansas Arts Council painting award 1999 as well as residencies at the MacDowell Colony in Vermont, and the Cité Internationale de Arts in Paris.

Intermission was commissioned by the Walton Arts Center in Fayetteville, Arkansas, funded by Saatchi and Saatchi in 1992 and permanently installed in 1994.

MS: How did *Intermission* begin?
KS: I actually began work on the mural in 1989. During visits to Paris and Madrid, I was bowled over by a Toulouse-Latrec mural I saw at the Orsay Museum, and by a mural by Delacroix at St. Sulpice. Both were vibrant with energy, and the strident reds and greens in the Delacroix sent the viewer's eyes hurtling around and through the composition. I also loved Velasquez' *Las Meninas* and Goya's frescos for their immediacy and fearlessness. I was interested in the mural project because it gave me an opportunity to combine the immediacy of drawing with the richness of painting.

MS: Why show the intermission, not the play?
KS: It is a moment in time that is highly charged. The mural depicts a cross section of the theater, from backstage to stage and from audience to lobby. The performer on stage is like a toggle switch, connecting the audience to the action backstage. As he bows through the closing curtain, the audience begins to break apart, dissolving into its own private plays. Applause fills the theater, children begin to awaken and neighbors discuss the performance. I wanted to pull the viewer in to a scene bursting with energy, as if all things were in orbit, pushing and pulling, as in dance. The whole painting is a gesture, an embodiment of bodies in motion, with both the volumes and voids ignited with energy.

MS: I know that you love art history and that your preliminary research on this project was extensive. What did you learn from the masters?
KS: Mostly I learned ways to increase compositional complexity without sacrificing gestural energy. These compositional lessons helped me sustain a vigorous visual pace for all 50 feet of the painting.

Technically, though, my work method was more exploratory and direct than is the usual practice.

First, the 300 premiliary drawings and paintings I did stand as autonomous images in themselves. I learned from all of them—but didn't copy any of them when I painted the mural. I confronted the painting directly, rather than replicating ideas I had worked out beforehand.

Second, I didn't graph out, slide project, or otherwise draw the outlines on the canvas. I just drew blue lines to divide the canvas into halves, quarters, and eighths, then drew freehand, using a brush attached to a three-foot-long bamboo pole, starting with light washes in earth colors, then building up more layers as necessary.

Finally, every figure was painted from life, using over 50 community members as models. They were amazingly generous and patient, considering it wasn't putting a penny in their pockets. This process increased the connection between the audience and the artwork, and we had a great party for everyone when the painting was installed. I continue to meet these townspeople on the street, and as participants in the project, they have a continuing relationship with the painting.

MS: So, it sounds like you didn't really know what would happen when you began to paint each day.
KS: Each model, each pose, and each prop provided variations and surprises. I actually used at least two models for each figure in the painting, which basically means that there is another 50-foot-long painting underneath the one that you see!

MS: What advice do you have for my students?
KS: Take risks. Without daring, indeed, without great daring, there is no beauty. We must go beyond ourselves if we are ever to fulfill our real potential.

Ken Stout, *Intermission,* 1994. Oil on canvas, 9 × 50 ft (2.74 × 15.24 m).

Georgiana Nehl, *Sun/Star* **(detail), 1996.** Oil paint on gessoed wood, 25¾ in. w. × 13¼ in. h. × 1 in. d. (65 × 34 × 3 cm)

Concepts and Critical Thinking

In *A Kick in the Seat of the Pants,* Roger Von Oech identifies four distinct roles in the creative process. An *explorer* learns as much as possible about a problem. Research is crucial. Ignorance of a topic may result in a superficial solution, while finalizing the first solution envisioned often results in a cliché. An *artist* experiments with a wide variety of solutions, using all sort of combinations, proportions, and materials. By creating 10 answers to each question, the artist can select the best solution rather than accepting the only solution. Next, the *judge* assesses the work in progress and determines what revisions are required. Innovative ideas are never fully developed when first presented; most need extensive revision and expansion. Being able to recognize the potential in a raw design is invaluable. Rather than discard an underdeveloped idea, you can identify its potential and determine ways to increase its strength. Finally, the *warrior* implements the idea. When the project is large and complex, implementing the plan requires great tenacity. When obstacles appear, the warrior assesses the situation, determines the best course of action, and then completes the project.

We will explore each of these roles in this section. Playing the right role at the right time is essential. Judging a design prematurely or galloping onto the visual battlefield before exploring the terrain can crush creativity. Strategies for cultivating creativity and improving time management are discussed in Chapter Four. Chapter Five deals with concept development and visual problem solving. Chapter Six is devoted to critical thinking and provides specific ways to improve any design.

A
IS FOR APOLLO, WHOSE
ARROWS NEVER MISS

U
IS FOR URANIA THE MUSE OF
CELESTIAL FORCES IS SHE

Seeking Connections

Seeing the similarity among seemingly disparate parts has often sparked a creative breakthrough. For example, Egyptian hieroglyphs became readable when a young French scholar realized that they carried the same message as an adjacent Greek inscription on a slab of stone. By comparing the two and cracking the code, Jean-François Champollion opened the door for all subsequent students of ancient Egyptian culture.

Conviction

Creative people value existing knowledge. Since new ideas are often derived from old ideas, it is foolish to ignore or dismiss the past. However, creative people also love change. Never satisfied with routine answers to familiar questions, they constantly consider new possibilities and often challenge the authorities. Convinced of the value of their ideas, they tenaciously pursue an independent path.

Complexity

In lecture classes, we must accurately take notes during lectures, memorize facts, and collect and analyze data. We are encouraged to think rationally, write clearly, and present our ideas in a linear progression. In studio classes, exploration, experimentation, and intuition are encouraged, especially during brainstorming sessions. Synthesis, emotion, visualization, spatial perception, and nonlinear thinking are highly valued.

To be fully effective, a creative person needs to combine the rational with the intuitive. While intuition may be used to generate a new idea, logic and analysis are often needed for its realization. As a result, the actions of creative people are often complex or even contradictory. As noted by psychologist Mihaly Csikszentmihalyi,[1] creative people often combine:

- Physical energy with a respect for rest. They work long hours with great concentration, then rest and relax, fully recharging their batteries. They view balance between work and play as essential.

- Savvy with innocence. They use common sense as well as intellect in completing their work, yet remain naive, open to experience. Creative people tend to view the world and themselves with a sense of wonder, rather than cling to preconceptions.

- Responsibility with playfulness. When the situation requires serious attention, creative people are remarkably diligent and determined. They realize that there is no substitute for hard work and drive themselves relentlessly when nearing completion of a major project. On the other hand, when the situation permits, a playful, devil-may-care attitude may prevail, providing a release from the previous period of work.

- Risk-taking with safe-keeping. Creativity expert George Prince has noted two behavioral extremes in people.[2] Safe-keepers always look before they leap, avoid surprises, punish mistakes, follow the rules, and watch the clock. A safe-keeper is most comfortable when there is only one right answer to memorize or one solution to produce. Risk-takers are just the opposite. They break the rules, leap before they look, like surprises, are impetuous, and may lose track of time. A risk-taker enjoys inventing multiple answers to every question.

An imbalance in either direction inhibits creativity. The safe-keeper lives in fear, while the extreme risk-taker lives brilliantly—but briefly. Creative thinking requires a mix of risk-taking and safe-keeping. When brainstorming new ideas, open-ended exploration is used: anything is possible. But when implementing new ideas, deadlines, budgets, and feasibility become major concerns. The risk-taker gets the job started; the safe-keeper gets the job done.

- Extroversion with introversion. When starting a new project, creative people are often talkative and gregarious, eager to share insights and explore ideas. When a clear sense of direction develops, however, they often withdraw, seeking solitude and quiet work time. This capacity for solitude is crucial. Several studies have shown that talented teenagers who cannot stand solitude rarely develop their creative skills.

- Passion with objectivity. Mature artists tend to plunge into new projects, convinced of the significance of the work and confident of their skills. Any attempt to distract or dissuade them at this point is futile. However, when the model or rough study is done, most artists will pause to assess progress to date. This period of analysis and judgment may occur in a group setting or may be done by the artist alone. In either case, the emotional attachment required while creating is now replaced by a dispassionate objectivity. Work that does not pass this review is redone or discarded, regardless of the hours spent in its development. In major projects, this alternating process of creation and analysis may be repeated many times.

- Disregard for time with attention to deadlines. Time often dissolves when studio work begins. An artist or designer can become engrossed in a project: when the work is going well, six hours can feel like 20 minutes. On the other hand, an acute attention to deadlines is necessary when preparing an exhibition or working for a client.

- Modesty with pride. As they mature, creative people often become increasingly aware of the contributions to their success made by teachers, family, and colleagues. Rather than brag about past accomplishments, creative people tend to focus on current projects. On the other hand, as creative people become aware of their significance within a field, they gain a powerful sense of purpose.

Distractions are deleted from the schedule, and increasingly ambitious goals are set. When the balance is right, all these complex characteristics fuel even greater achievement.

Goal Setting

The "Imagineer" has one of the most prized jobs within the Disney corporation. Combining imagination with engineering, Imagineers create new ideas that can be effectively *realized.* This combination is crucial. Creativity without result accomplishes nothing.

Goal setting is especially important for the most highly creative people. A wide range of interests and a disregard for time constraints can make them scatterbrained. As humans, our behavior is goal-directed. Every action occurs for a reason. When we focus our attention on a specific task, we can accomplish just about anything. Goals help us channel our energy and manage our time. When we reach our goals, our self-esteem increases, which then helps us overcome obstacles. And, with each goal met, our knowledge increases. Michael LeBoeuf has diagrammed this effect clearly (4.1).

A Goal-Setting Strategy

Self-knowledge is essential. To be effective, goals must be authentic. No matter how hard you try, you will never really fulfill your potential by pur-

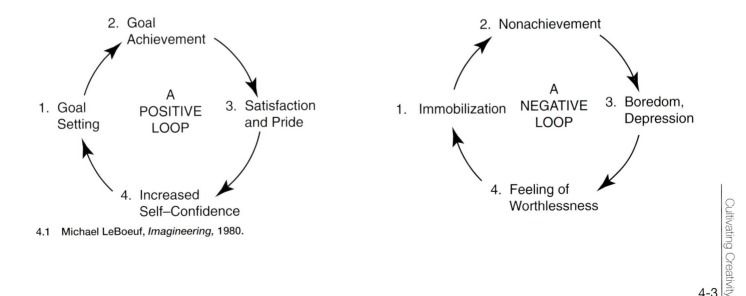

4.1 Michael LeBoeuf, *Imagineering*, 1980.

and with the person behind them, in order to make a continuous image with graceful transitions. In effect, all 20 participants become members of a creative team. Finally, each 8½ × 11 in. section was photocopied and traded, providing each person with the completed artwork. In a collaboration of this kind, everyone gains, both in the learning process and in the sharing of the product.

Reduce Stress

Finally, good time management can help you avoid excessive stress. When you are pushing beyond familiar limits, some stress is inevitable. Excessive stress, however, leads to illness, anger, insomnia, mental paralysis, exhaustion, and depression. Here are some strategies that can help.

No Blame

No matter what happens, blaming yourself or others is never useful. Work on the solution rather than remaining stuck in the problem.

Keep Your Balance

A mix of emotional, spiritual, physical, and intellectual activities will help feed all areas of your psyche. No matter how significant a particular assignment may appear to be, remember that it is only one aspect of your life. Taking a break can often give you the fresh perspective you need to solve a difficult problem. Value rest. When the balance is right, your time off can actually increase your productivity.

Positives Attract

A creative person seeks change. Any change tends to present a combination of obstacles and opportunities. Focusing on the opportunities rather than on the obstacles increases confidence. Furthermore, an upbeat, positive attitude attracts other creative thinkers, while a negative, excessively critical attitude drives creative thinkers away. By assuming that you *can* do the job well, you start the spiral of accomplishment needed to fully realize your creative potential. Accentuate the positive!

Georgiana Nehl, *Sun/Star* (detail), 1996. Oil paint on gessoed wood, 25¾ in. w. × 13¼ in. h. × 1 in. d. (65 × 34 × 3 cm).

Profile:
Nancy Callahan, Artist, and Diane Gallo, Writer

Storefront Stories: Creating a
Collaborative Community

Nancy Callahan (left in photo) is a leader in the field of artists' books and is known for her creative work in screen printing. She has exhibited her work widely, and in 1994, she was one of four artists chosen to represent the United States at the International Book and Paper Exhibition in Belgium. In 1999 she participated in the International Artists' Book Workshop and Symposium in Mor, Hungary. In addition to her full-time teaching at the State University of New York at Oneonta, Callahan has taught workshops at major book centers around the country, including the Center for Book Arts in New York City and The Women's Studio Workshop.

Diane Gallo (right in photo) is an award-winning writer, performance poet, and a master teacher. Her film work has received awards from the American Women in Radio & Television and nominations from the American Film Institute. Gallo teaches creative writing and life-story workshops at universities and cultural institutes throughout the country and is a visiting poet with the Dodge Foundation Poetry Program, a humanist scholar with the National Endowment for the Humanities Poets in Person program, and co-founder of the newly formed Association of Teaching Artists.

Callahan and Gallo began working together in 1984 as a photographer/writer team for the Binghamton Press. As a result of many years of collaborative teaching, they became the first teaching artist team working with the Empire State Partnership project, jointly sponsored by the New York State Education Department and the New York State Council of the Arts. In 1996 they received fellowships to the Virginia Center for the Creative Arts where they began working on a major project that led to their selection by the Mid-Atlantic Foundation for their millennium project. Funded by the National Endowment for the Arts, the project—Artists & Communities: America Creates for the Millennium— named Callahan and Gallo as two of America's 250 most creative community artists.

MS: You've gained a lot of recognition for your recent text-based installations. Please describe Storefront Stories.

NC: Over the past two years we've had an extraordinary collaborative experience. As an extension of our writing, we developed a new type of text-based installation. One day as we worked on a story about ironing, we playfully hung a single wrinkled white shirt in the front window of our studio in Gilbertsville, New York. Below the shirt, we placed a small sign that said, "No one irons anymore." As the lone shirt turned, it attracted attention, causing people on the sidewalk to stop, read the window, and react. Storefront Stories was born.

DG: Objects became words, words transformed objects. Week by week, using storefront windows as a public stage, we wrote and presented installments of autobiographical stories. In one town, a single window was changed every ten days, creating an ongoing narrative. In another, we used five windows in a row, like pages in a book. Bits of text and symbolic objects were used to tell stories about personal change. Stories and objects—combined with the unexpected street location—sparked curiosity and started a community dialog.

MS: How did members of the community become participants?

NC: They just began telling us their stories. An elderly woman on her way to the post office stopped to tell us the story of how she had learned to type on an old Smith typewriter, just like the one in the window. Eleven-year-old boys on bicycles stopped by. A mother brought her children to the windows each week to read the story aloud. Couples strolling by in the evening asked, "What's coming next?"

DG: People talked to us easily, asking questions and encouraging us. Many times, we'd return to find handwritten stories, comments, and suggestions. We watched passersby examine the windows and heard them laughing and talking to each other as they pieced together the story. When a viewer made a good suggestion, we incorporated the idea into the next window. When community members saw their ideas so quickly incorporated, they realized they were more than passive viewers. They were now active participants, with a vital involvement in the artistic process. The collaboration which began between two artists quickly expanded, engaging the entire town.

Diane Gallo and Nancy Callahan, *Storefront Stories*, 1999. Mixed medium installation, 6 × 6 × 6 ft (1.83 × 1.83 × 1.83 m).

MS: In your household installations you create complete environments to frame your stories. To create these environments, you spend many hours scouting thrift shops and garage sales searching for just the right objects to evoke an exact time and place. Why are these objects so important?
NC: Household objects are the vocabulary of the everyday world. Everyone feels comfortable with them. The objects are a bridge—they allow the viewer to cross easily from everyday life into the world of our installations.
DG: After the object is safely in the viewer's mind, it becomes a psychic spark which triggers associations and amplifies memories. For example, while we were doing the ironing installation, a delivery man who stopped for a moment to watch us work said, "I don't know anything about art," and began talking deeply and at length about how when he was a boy, his mother took in ironing to make extra money so that he could have a bicycle.
NC: His narrative then created another layer of collaboration.

MS: When you began creating the installations, did you expect this kind of public reaction?
NC: No. It was a shock. From the moment we hung that first wrinkled shirt in the studio window, people on the street were responsive. The immediate feedback was exhilarating.

MS: What are the characteristics of a good collaboration?
DG: Quiet attention is crucial. We both have to really listen, not only to words but also to the implications.
NC: Always tell the truth. There can be no censoring. If something's bothering you, it's important to talk about it right away. Honesty and careful listening build trust. When you trust your partner, you can reveal more.

MS: When people first see your installations, many are almost overwhelmed. Why?
DG: We're balancing on a fine line between life and art, between the personal and the universal, the public and the private, the conscious and the unconscious. We're working on the edge of consciousness, looking for things you might only be half aware of under ordinary circumstances. It's like watching a horizon line in your mind, waiting for a thought or answer to rise.

Summary

- Creativity and design both require new combinations of old ideas.

- Creative people are receptive to new ideas, are curious, have a wide range of interests, are attentive, seek connections, and work with great conviction.

- Creative people combine rational and intuitive thinking. While intuition may be used to generate a new idea, logic and analysis are often needed for its completion. As a result, the actions of creative people are often complex or even contradictory.

- Goals you set are goals you get. Establishing priorities and setting appropriate goals will help you achieve your potential. Good goals are challenging but attainable, compatible, and self-directed. Deadlines encourage completion of complex projects.

- Creating a good work area, completing tasks in an appropriate sequence, making the most of each work period, maintaining momentum, and reducing stress are major aspects of time management.

- Collaborative work can help us expand our ideas, explore new fields, and pursue projects that are too complex or time-consuming to do alone.

1. What qualities have you noticed in unusually creative people? Reading a biography of your favorite artist or designer may provide further insight into the creative process.

2. What are your primary goals? How can a general goal be translated into a specific action?

3. Under what conditions do you work best? How can you cultivate the conditions most favorable to your own creative thinking?

Anne Lamott, *Bird by Bird: Some Instructions on Writing and Life*. New York, Anchor Books,1998.

Mihaly Csikszentmihalyi, *Creativity: Flow and the Psychology of Discovery and Invention*. New York, HarperCollins, 1996.

John Briggs, Fire in the Crucible: *Understanding the Process of Creative Genius*. Grand Rapids, MI, Phanes Press, 2000.

David Bohm, *On Creativity*. New York, Routledge, 2000.

Michael LeBoeuf, *Imagineering: How to Profit from Your Creative Powers*. New York, McGraw-Hill, 1980.

Howard Gardner, *Art, Mind and Brain: A Cognitive Approach to Creativity*. New York, Basic Books, Inc., 1982.

Howard Gardner, *Frames of Mind: The Theory of Multiple Intelligences*, New York, Basic Books, Inc., 1985.

Denise Shekerjian, *Uncommon Genius: How Great Ideas Are Born*. Penguin Books, New York, 1991.

Doris B. Wallace and Howard E. Gruber, editors, *Creative People at Work*. New York, Oxford University Press, 1989.

Problem Seeking and Problem Solving

Artworks are generally experienced visually. By learning the basic elements of design and exploring many approaches to composition, you can increase the visual power of your work. Composition, however, is only part of the puzzle. With the continuing emphasis on visual communication throughout our culture, the ideas being expressed by artists and designers have become more varied and complex. As a result, conceptual invention is now as important as compositional strength. New ideas invite development of new images. When the concept is fresh and the composition is compelling, expression and communication expand.

Problem Seeking

The Design Process

In its most basic form, the creative process can be distilled down to four basic steps. When beginning a project, the designer asks:

1. What is required?
2. What existing designs are similar to the required design?
3. What is the difference between these designs and the required design?
4. How can we transform, combine, or expand these existing designs?

By studying the classic Eames chair, we can see this process clearly. Charles and Ray Eames were two of the most innovative and influential designers of the postwar era. Trained as an architect, Charles was a master of engineering and had a gift for design integration. Trained as a painter, Ray brought a love of visual structure, a sense of adventure, and an understanding of marketing to their work. Combining their strengths, this husband-and-wife team designed furniture, toys, exhibitions, and architecture, and directed over 80 experimental films.

5.1 Marcel Breuer, Armchair, Dessau, Germany, 1925. Tubular steel, canvas. 28^{11}/₁₆ in. h. × 30^5/₁₆ in. w. × 26¾ in. d. (72.8 × 77 × 68 cm).

5.2 Alvar Aalto, Paimio Lounge Chair, 1931–33. Laminated birch, molded plywood, lacquered, 26 × 23¾ × 34⅞ in. (66 × 60.5 × 88.5 cm).

5.3 Overstuffed Chair.

5.4 Adirondack Chair.

Their first breakthrough in furniture design began in 1940, when they entered a competition sponsored by the Museum of Modern Art. Many architects had designed furniture, and the Eameses were eager to explore this field. Many similar products existed. The most common was the overstuffed chair, which continues to dominate many American living rooms. Extensive padding on a boxy framework supported the sitter. Another popular design was the Adirondack chair, made from a series of flat wooden planes. Of greatest interest, however, were designs by architects such as Marcel Breuer (5.1) and Alvar Aalto (5.2). These designs used modern materials and clearly displayed their structure.

By comparing existing chairs with the chair required, Charles and Ray could identify some qualities they wanted to retain and some qualities that needed change. The familiar overstuffed chair (5.3) was bulky and awkward, but it was comfortable. The Adirondack chair (5.4) was easy to mass-produce, but too large for interior use. The modern chairs were elegant and inventive but were expensive and often uncomfortable. The Eameses wanted to produce a modern chair that was comfortable, elegant, and inexpensive.

During World War II, the Eames team had designed and manufactured molded plywood splints that were used by doctors in the U.S. Navy. After extensive research and

5.8 Ray Rogers, Vessel, New Zealand, 1984. Large, pit-fired (porous and nonfunctional) with "fungoid" decorative treatment in relief. Diameter approximately 21⅔ in. (55 cm).

5.9 Vera Lisková, *Porcupine*, 1972–80. Flame-worked glass, 4¼ × 11 in. (10.8 × 28.2 cm).

Study Nature

Ceramicist Ray Rogers is inspired by many natural forms, including mushrooms, stones, and aquatic life. His spherical pots (5.8) often suggest the colors, textures, and economy of nature. In Figure 5.9, Vera Lisková used the fluidity and transparency of glass to create a humorous version of a prosaic porcupine. Through an inventive use of materials, both artists have reinterpreted nature.

Visit a Museum

Artists and designers frequently visit all kinds of museums. Carefully observed, the history and physical objects produced by any culture can be both instructive and inspirational. Looking at non-Western artwork is especially valuable. Unfamiliar concepts and compositions can suggest new ideas and fresh approaches. Beau Dick's *Mugamtl Mask* (5.10) is one example. First developed by a man who had revived from a deadly illness, it depicts the supernatural abilities (including flight) that he gained during his experience. His descendants now have the right to construct and wear this special mask. By understanding the story and studying the mask structure, you can more readily generate your own mask based on your own experiences.

Characteristics of a Good Problem

Regardless of its source, the problem at hand must fully engage either the artist and the designer. By courageously confronting obstacles and seeking solutions, the artist/designer can develop increasingly ambitious work. Whether it is assigned or invented, a good problem includes many of the following characteristics.

Significant

When substantial amounts of time, effort, and money are being spent, it is wise to prioritize problems and focus on those of greatest consequence. Whether the project is the construction of the pyramids at Giza or completion of your bachelor's degree, assessing the importance of the project within a larger framework is important. Identifying and prioritizing major goals

can help you determine the significance of a job. Balancing this analysis with a sense of adventure can help you combine the best qualities of a risk-taker and a safe-keeper.

Socially Responsible

With the human population above six billion, it is unwise to pursue a project that squanders natural resources. In the past 20 years, designers have become increasingly aware of the environmental and social consequences of their actions. What natural resources will be required for a major project, and how will you dispose of resulting waste? Increasingly, designers consider the environmental as well as the economic implications of each project.

Comprehensible

It is almost impossible to solve a problem you don't understand. When working on a class assignment, ask questions if the assignment is unclear to you.

Leaves Room for Experimentation

It is important to distinguish between clear definition and restrictive limitations. Consider these two assignment descriptions:

5.10 Beau Dick, *Mugamtl Mask (Crooked Beak)*, 1993. Red cedar, cedar bark, paint, 24 × 26 × 16 in. (61 × 66 × 40.6 cm).

1. **Organize at least 10 photocopies in such a way that they convey an idea or emotion.**

2. **Organize 10 photographs by American Civil War photographer Mathew Brady in order to tell a story about the life of Abraham Lincoln.**

In the first case, the requirements of the project are clearly stated, but the solution remains open to invention. In the second case, the *solution* as well as the *problem* is described. For the inventive artist or designer, there are no "bad" problems, only bad solutions. Nonetheless, when limited to a narrow range of possible solutions, even the most inventive person will become ineffective. If you find yourself in a strait-jacket, rethink the problem and try a fresh approach.

5.15A Susan Cohn, *Cosmetic Manipulations*, 1992. Silver, binding wire, masking tape.

5.15B Susan Cohn, *Cosmetic Manipulations*, 1992. Earring. 750 yellow gold, 375 pink gold, anodized aluminum; earring piece: 2½ × 3½ in. (6.5 × 9 cm); earring line: 4 in. (10 cm).

you may make a series of different solutions to the same idea: either approach is fine. Just keep moving. An open, nonjudgmental attitude is essential.

Thinking with Your Fingers

It is useful to make physical sketches as well as visual sketches when planning a three-dimensional object. Most physical objects are seen from many angles. While it is possible to draw multiple views, compositions can often be constructed more quickly from inexpensive materials such as paper, cardboard, wire, or plasticine. As shown in Figures 5.15A and 5.15B, a sketched structure can often be refined and used to create a much more polished final piece. Jeweler Susan Cohn developed a whole series of earrings and brooches from these *Cosmetic Manipulations*.

Model-Making

When working two dimensionally, it is often necessary to make one or more full-sized rough drafts to see how the design looks when enlarged. Refinements made at this stage can make all the difference between an adequate solution and an inspired solution.

Prototypes, models, and maquettes serve a similar purpose when you are working three dimensionally. A **maquette** is a well developed three-dimensional sketch. Figure 5.16A shows Peter Forbes's maquette for *Shelter/Surveillance Sculpture*. In this chipboard "sketch" Forbes determined the size of the sculpture relative to the viewer and developed a construction strategy. As a result, when he constructed the final eleven-foot-tall sculpture, Forbes was able to proceed with confidence. A **model** is a technical experiment. A **prototype** can be quite refined, as with the fully functional test cars developed by automobile companies. In addition to the aesthetic benefit of these preliminary studies, it is often necessary to solve technical problems at this stage. Is the cardboard you are using heavy enough to stand vertically, or does it bow? Is your adhesive effective? If there are moving parts, is the action fluid and easy, or does the structure consistently get stuck?

5.18 Leslie Leupp, *Three Bracelets: Solidified Reality, Frivolous Vitality, Compound Simplicity,* 1984. Steel, plastic, linoleum, laminate, aluminum. Constructed, each 3 × 4 × 3 in. (8 × 10 × 8 cm).

5.19 Lisa Gralnick, *Three Bracelets,* 1988. Black acrylic, gold, hollow construction, left to right: 3 × 3½ × 3½ in; 4½ × 3½ × 3 in; 3½ × 3½ × 3½ in; (7.6 × 8.9 × 8.9 cm; 11.4 × 8.9 × 7.6 cm; 8.9 × 8.9 × 8.9 cm).

Metaphorical Thinking

Metaphors, similes, or **analogies** are figures of speech that link one thing to another. Through this connection, the original word is given the qualities of the linked word. For example, when Robert Burns wrote the simile "My love is like a red red rose," he gave the abstract concept of "love" the attributes of a glorious, colorful, fragrant, thorny, and transient rose.

Metaphorical thinking creates a bridge between an image and an idea. Take the phrase, "I have butterflies in my stomach." This phrase is widely used to describe nervousness, often before a performance. Substitute other insects for "butterflies," such as bees or wasps. How does this change the meaning? To push it even further, start with the phrase, "My mind was full of clouds." What happens when "clouds" is replaced by mice on treadmills, rats in mazes, shadowy staircases, beating drums, screaming children—or even butterflies? When my mind is full of butterflies, I am happy, but butterflies in my stomach indicate fear. In addition to expanding your ideas, metaphors can help provide specific images for elusive ideas.

Metaphorical thinking and symbolism have always been used by artists and designers to heighten an idea or an emotion. Exaggerated metaphors are often used in advertising design.

5.20 "Y2K's coming.
Don't just sit there."
Iomega Corporation.

The massive wave that threatens the computer user in Figure 5.20 is a metaphor for the destructive power of the Y2K computer bug that once seemed likely to create massive computer failures on January 1, 2000.

Picasso's *Guernica* (5.21) is also full of metaphors. In *A World of Art*, Henry Sayre offers the following description:

> The horse, at the center left, speared and dying in anguish, represents the fate of the dreamer's creativity. The entire scene is surveyed by a bull, which represents at once Spain itself, the simultaneous heroism and tragedy of the bullfight, and the Minotaur, the bull-man who for the surrealists stood for the irrational forces of the human psyche. The significance of the electric light bulb at the top center of the painting, and the oil lamp, held by the woman reaching out the window, has been much debated, but they represent, at least, old and new ways of seeing.[2]

Rather than showing exploding bombs or collapsing buildings, Picasso filled his painting with abstracted animals, screaming humans, and various light sources. In so doing, he focused on the meaning and emotion of the event, rather than the appearance.

introduction to chemistry, and a book by Jorge Luis Borges—and several others waiting in the wings!

MS: How do you get your ideas?
HL: Just about anything in my environment and experience can generate an idea—a book I read, a conversation, a walk in the woods . . .

MS: Your ideas are pretty complex. How do you communicate this information?
HL: Using association, I try to put as many ideas as possible into the forms I construct. For example, Biological Abstraction III, which depicts an ovary and associated seed structures, also embodies references to dandelion seeds, diving bells, and bomb casings. Each reference contains another piece of information which expands on a physical quality of the object and adds another layer of meaning. I'm not interested in making copies of the structures I study. Instead, I try to understand and express their essential forces and overriding themes.

MS: Please describe your working process.
HL: First, I identify a system for study. Since I am especially interested in human anatomy and physiology, I think of a system as an organ or group of organs in the human body. In this series, I have studied the female reproductive tract, the skin, the respiratory tract , and the inner ear.

Once I have chosen a system, I study it at microscopic and macroscopic levels to try to learn something about the relationship between its structure and function. Scale is really important: the microscopic view reveals an astonishing level of complexity in the simplest of structures! During this phase, I also look for materials that share the structural and functional properties of my system's cellular building blocks. I experiment by combining these materials to see how they might work together. At the same time, I begin to make plans and drawings for different aspects of the piece. When I have gathered enough information to give me a solid foundation, I begin construction.

MS: It sounds so orderly! My creative process is much more chaotic.
HL: Actually, my process is definitely *not* as linear as it sounds! The research, while extensive, is never complete: all art-making requires a balance between analysis and intuition. The materials always have something new to teach me if I am willing to learn. This element of unpredictability can be frustrating and uncomfortable, but it is absolutely essential. If I play it safe, if I'm inflexible, too insistent on sticking to a set plan, the resulting piece will be dull and lifeless. For me, learning comes from experimenting and making mistakes. It is the desire to learn about my materials, myself, and the world around me that keeps me actively engaged during many hours of physical work.

MS: I think we can appreciate the function of science in our culture. What is the function of art?
HL: For me, art helps to stimulate thought, encourage contemplation, increase understanding, and express emotion. Like science, it gives us a way to see beyond everyday experience and embrace the complexity and beauty of our world.

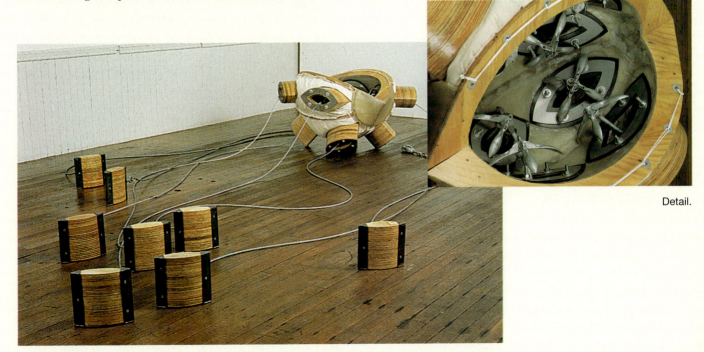

Detail.

Heidi Lasher-Oakes, *Biological Abstraction III*, 1996. Wood, fiberglass, foam rubber, canvas, steel, dinghy anchors, rubber gasket material, fabricated and purchased hardware. Primary structure: 4 ft l. × 4 ft w. × 3½ ft h. (1.21 × 1.21 × 1.07 m), entire assembly approx. 15 ft l. (4.5 m).

Summary

- Concept and composition are equally important aspects of art and design.

- Designers usually solve problems presented by clients. Artists usually invent aesthetic problems for themselves. Both explore many alternatives before achieving the desired result.

- Ideas come from many sources, including common objects, nature, mythology, or history.

- Good problems are significant, socially responsible, comprehensible, achievable, and authentic. They provide basic parameters without inhibiting exploration.

- Convergent thinking is highly linear. The word "prose" can help you remember the steps.

- Divergent thinking is nonlinear and more open-ended. It is less predictable and may lead to a creative breakthrough.

- Any idea can be expanded or enriched using brainstorming. List-making, using a thesaurus, mapping, and creating connections are common strategies.

- Visual and verbal research can provide the background information needed to create a truly inventive solution.

- Pursuing an idea through variations on a theme, metaphorical thinking, or interdisciplinary connections can help you realize its full potential.

Keywords

analogy	interdisciplinary	model
brainstorming	thinking	prototype
convergent thinking	maquette	simile
divergent thinking	metaphor	

1. How many meanings can be derived from individual words, such as "water," "hidden," or "parallel"? Use a dictionary, a thesaurus and an encyclopedia to investigate each word thoroughly.

2. How many meanings can be derived from everyday objects, such as keys, rulers, or eyeglasses? Consider every possible association and implication.

3. How many ways can an idea be visualized? Try different forms of balance, variations in emphasis, use of contrast, etc. Most professional designers make dozens of thumbnail sketches or maquettes before starting work on a final piece.

4. How do materials affect meaning? What is the difference between a marker drawing of a given subject, a charcoal drawing of the same subject, a photograph, and a wooden sculpture?

5. How many variations can be invented from a single theme? Any aspect of an image can be changed, including size, color, complexity, style, materials used, and so forth.

James L. Adams, *Conceptual Blockbusting*. Reading, MA, Addison-Wesley, 1986.

Edward de Bono, *Lateral Thinking*. London, England, Ward Educational Limited, 1970.

Malcolm Grear. *Inside/Outside: From the Basics to the Practice of Design*. New York, Van Nostrand Reinhold, 1993.

Mary Frisbee Johnson. *Visual Workouts: A Collection of Art-Making Problems*. Englewood Cliffs, NJ, Prentice-Hall, 1983.

George Lakoff and Mark Johnson. *Metaphors We Live By*. Chicago, University of Chicago Press, 1981.

Ben Shahn. *The Shape of Content*. Cambridge MA, Havard University Press, 1957.

Judith and Richard Wilde. *Visual Literacy: A Conceptual Approach to Graphic Problem Solving*. New York, Watson-Guptill, 1991.

Developing Critical Thinking

Critical thinking combines

- Careful evaluation of all available information.
- The analysis of visual relationships.
- The exploration of alternative solutions.

Critical thinking is motivated by the desire to pursue an idea to the limit. Never complacent, the best artists and designers continually seek to improve each image and expand each idea. Critical thinking is used to determine compositional strengths, expand concepts, and improve visual communication. Knowing what to keep and what to change is essential. By expanding the best aspects of a design and deleting weak areas, we can dramatically strengthen both communication and expression.

Establishing Criteria

Establishing the criteria on which judgments will be made is the first step. For example, if technical skills are being emphasized in an assignment, craftsmanship will be highly valued. Likewise, if the assignment must be done in analogous colors, a black-and-white painting will not meet the criteria, no matter how carefully it is composed. By determining the major questions being raised in each problem, we can understand the basis on which judgments will be reached. Consider:

- What is the purpose of the assignment? Does your teacher want you to learn any specific skills? What compositional and conceptual variables will you need to explore?
- What are the assignment parameters? Are there limitations in the size, style, or materials?
- When is the assignment due and in what form must it be presented?

It is important to distinguish between understanding assignment criteria and seeking the "right answer." In the first case, by determining the bound-

aries, you can fully focus your energy when you begin to work. Just as a magnifying glass can be used to focus sunlight into a powerful beam, so assignment parameters can help you focus creative energy. On the other hand, students who try to determine the "right answer" to a problem often simply want to know the teacher's solution. Such knowledge is rarely helpful. Any problem presented by a teacher simply sets a learning process in motion: you learn through your work. Since learning requires a personal process of investigation, finding your own answer is essential.

Form, Subject, and Content

The most effective compositions present a unified visualization of an idea or emotion. As a result, it is often difficult to dissect and analyze a design. Identifying three major aspects of an artwork can provide a beginning point for discussion.

Form may be defined as the physical manifestation of an idea or emotion. Two-dimensional forms are created using line, shape, texture, value, and color. The building blocks of three-dimensional forms are line, plane, volume, mass, space, texture, and color. Duration, tempo, intensity, scope, setting, and chronology are combined to create time-based art forms. For example, film is the form in which *Star Wars* was first presented.

The **subject,** or topic, of an artwork is most apparent when a person, object, event, or setting is clearly represented. For example, the conflict between the rebels and the Empire provides the subject for *Star Wars.*

The emotional or intellectual message of an artwork provides its **content,** or underlying theme. The theme of the *Star Wars* trilogy is the journey into the self. Luke Skywalker's gradual understanding of himself and acceptance of Darth Vader as his father adds an emotional undercurrent to all the events in the the entire *Star War* series.

Critique Basics:
Stop, Look, Listen, Learn

Any of these aspects of design can be discussed critically. A **critique** is the most common structure used. During the critique, the entire class analyzes the work completed at the end of an assignment. Many solutions are presented, demonstrating a wide range of possibilities. The strengths and weaknesses in each design are determined, and areas needing revision are revealed. These insights can be used to improve the current design or to generate possibilities for the next assignment.

Critiques can be extremely helpful, extremely destructive, or just plain boring, largely depending on the amount and type of student involvement. The main purpose of the critique is to determine which designs are most effective, and why. Specific recommendations are most helpful: be sure to substantiate each judgment so that your rationale is clear. Whether you are giving or

receiving advice, come with your mind open, rather than your fists closed. A critique is not a combat zone! Listen carefully to any explanations offered, and generously offer your insights to others. Likewise, receive their suggestions gracefully rather than defensively. You will make the final decision on any further actions needed to strengthen your design; if someone gives you bad advice, quietly discard it. An open, substantial, and supportive critique is the best way to determine the effect your design has on an audience, so speak thoughtfully, listen carefully, and weigh seriously every suggestion you receive.

When beginning a critique, it is useful to distinguish between objective and subjective criticism. **Objective criticism** is used to assess how well a work of art or design utilizes the elements and principles of design. Discussion generally focuses on formal concerns, such as

- The type of balance used in the composition and how it was created.

- The spatial depth of a design and its compositional effect.

- The degree of unity in a design and how it was achieved.

Objective criticism is based on direct observation and a shared understanding of assignment parameters. Discussion is usually clear and straightforward. Alternative solutions to a problem may be discussed in depth.

Subjective criticism is used to describe the personal impact of an image, the narrative implications of an idea, or the cultural ramifications of an action. Discussion generally focuses on the subject and content of the design, including

- The meaning of the artwork.

- The feelings it evokes.

- Its relationships to other cultural events.

- The artist's intent.

Because subjective criticism is not based on simple observation, it is more difficult for most groups to remain focused on the artwork itself or to reach any clear conclusions regarding possible improvements. The discussion may become more general and wide-ranging, as political or social questions raised by the works of art and design are analyzed. While these are important topics, because of the potential lack of clarity, subjective criticism may be used sparingly during the foundation year.

Types of Critiques
Description

The first step is to look carefully and report clearly. Without evaluating, telling stories, drawing conclusions, or making recommendations, simply describe the visual organization of the work presented. A **descriptive critique** can help you see details and heighten your understanding of the design. The student whose work you describe learns which aspects of the design are most eye-catching and readable and which areas are muddled and need work.

This is a particularly useful exercise when analyzing a complex piece, such as Figure 6.1. In an art history class you might write:

> *Place de l'Europe on a Rainy Day* is a rectangular painting depicting a street in Paris. A vertical lamppost and its shadow extend from the top edge to the bottom edge, neatly dividing the painting in half. A horizon line, extending from the left side and three-quarters of the way to the right, further divides the painting, creating four major quadrants. Because this horizon line is positioned above center, the bottom half of the composition is larger than the top half.
>
> A dozen pedestrians with umbrellas occupy the bottom half of the painting. At the right edge, a man strides into the painting, while next to him a couple moves out of the painting, toward the viewer. To the left of the lamppost, most of the movement is horizontal, as people cross the cobblestone streets.

6.1 Gustave Caillebotte, *Place de l'Europe on a Rainy Day,* Paris Street, 1877. Oil on canvas, 83½ × 108¾ in. (212.2 × 276.2 cm).

When using description in a spoken critique, it is useful to consider the following compositional characteristics:

- What is the format or boundary for the design? A circle or sphere presents a very different compositional playing field than a cube or a square.

- What range of colors has been used? A black-and-white design is very different from a design in full color.

- What is the size of the project? Extremes are especially notable. A sculpture that is 10 feet tall or a painting that is one-inch square will immediately attract attention.

- Is the visual information tightly packed, creating a very dense design, or is the design more spacious, with a lot of space between shapes or volumes?

Cause and Effect

A descriptive critique helps us analyze the compositional choices made by the artist. A **cause-and-effect critique** builds on this description. In a simple description, you might say that the design is primarily composed of diagonals. Using cause and effect, you might conclude that *because* of the many diagonals, the design is very dynamic. In a cause-and-effect critique, you discuss consequences as well as choices. Analyzing the same painting, you might write:

Place de l'Europe on a Rainy Day depicts a city street in Paris near the end of the nineteenth century. A vertical lamppost, positioned near the center, compositionally dissects the painting in half. A dozen pedestrians in dark clothing cross the cobblestone streets from left to right, creating a flowing movement. To the right of the post, the pedestrians move in and out of the painting, from background to foreground. Two men and one woman are the most prominent figures. The man at the far right edge pulls us into the painting, while the couple to his immediate left moves toward us, pushing out of their world and into our world. The movement that dominates each side of the painting is arrested by the lamppost. It is almost like we are getting two paintings on one canvas.

6.2 Raphael, *The School of Athens*, **1509–11.** Fresco, 26 × 18 ft (7.92 × 5.49 m). Stanza della Segnatura, Vatican, Rome.

Compare and Contrast

In a **compare/contrast critique,** similarities and differences between two images are noted. We will use the Caillebotte painting one more time, now comparing the perspective used with the perspective in Raphael's *The School of Athens* (6.2).

The city streets depicted in *The School of Athens* and *Place de l'Europe* demonstrate many differences between Renaissance and Impressionist perspective.

The one-point perspective used in Raphael's painting leads our eyes to Plato and Aristotle, positioned just below the center of the composition. The other figures in the painting are massed in a horizontal band from the far right to the far left side and in

two lower groups, to the right and left of the central figures. Our eyes are led back to the philosophers by a man sprawled on the steps to the right and by the scribes' tables on the left. Like a proscenium arch in a theater, a broad arch in the foreground frames the scene. Overlapping arches add to the depth of the painting. This composition combines the stability of one-point perspective with a powerful illusion of space.

In the Caillebotte painting, a lamppost occupies center stage, rather than a philosopher. The one-point perspective in the cobblestone street and in the buildings on the right is complicated by the two-point perspective used for a large background building on the left. This unusual illusion of space, combined with the movement of the pedestrians, creates a feeling of instability.

All these approaches are often used in art history classes. The same strategies, however, may be used in the studio, for either spoken or written critiques. Here is an example, written by two students in a basic design class. The assignment was to complete an 18 × 24 in. design, transforming the music building (Crouse College) into a labyrinth.

Looking at Cally's design (6.3), Trish wrote:

Cally's piece uses strong black-and-white contrast, with both negative and positive space clearly developed. On the other hand, my design is brightly colored, representing a kaleidoscope based on the stained glass windows in the building.

We both use the staircase as a major element. Cally's stair leads you in and around the building, creating a way to explore the space. My stair becomes part of the overall pattern.

I thought of the labyrinth as an abstract puzzle, a design you could draw your pencil through to find the ending. I wanted my design to be playful. Cally's design focuses on the psychological, creating an entry into the human mind. Cally's design is mysterious. Her staircases seem to lead nowhere.

We both use lines very deliberately. Where one line ends, another begins. Without lines in a labyrinth, it wouldn't be as puzzling or mysterious. It would just be another design, rather than a puzzle to solve or a fun house to explore.

Looking at Trish's design (6.4), Cally wrote:

The first difference I notice is that my labyrinth uses black and white to form a high-contrast composition whereas Trish uses color to transform the building into a complex pattern. My vertical format helps suggest the height of the building, which is dominated by two amazing staircases. Trish's horizontal format contains a design that is as abstract as a computer circuit board.

Next, I notice conceptual differences between our solutions. My drawing is representational, depicting a psychological labyrinth, whereas Trish's turns this labyrinth into a puzzle. She took several architectural elements of Crouse College and juxtaposed them as motifs within the drawing. The pipework, in particular, was abstracted and expanded

6.3 Cally Iden, *Transforming Crouse College into a Labyrinth.* Student work. 18 × 24 in.

6.4 Tricia Tripp, *Transforming Crouse College into a Labyrinth.* Student work. 24 × 18 in.

into an elaborate maze. It creates a definite boundary between the background and the foreground. The space is essentially flat in Trish's design: color is used to create a balanced composition rather than being used to create any illusion of space. On the other hand, because my design is representational, I used the illusion of space to create a convincing interior space.

One similarity between our drawings is in the inclusion of the staircase. Trish used the stairs as a *background* shape that adds dynamism to the composition. I used the stair as a primary motif, a means by which people using the building can explore their own minds.

For me, Trish's design creates a sense of alienation. There is no evidence of human experience here—it is a purely visual world, made up of complex shapes. It produces no strong emotion for me, no sense of mystery. It is purely visual.

On the other hand, there are hints of "the human" in my composition, but it is lost within the maze of repetitive stairs: only traces remain. This stark contrast helps communicate the confusion and mystery of my psychological labyrinth. I want to convey the feeling of being caught in a labyrinth, solving mysteries, and finding one's self.

Both critiques are honest without being abusive and offer a discussion of both concept and composition. While they are very different, each of the students clearly respects the approach taken by the other.

Greatest Strength/Greatest Potential

Many projects have one notable strength and one glaring weakness. To create a positive atmosphere, start by pointing out the strength in the work. Begin by looking for:

- The level of unity in the design and how was it achieved.

- The amount of variety in the design, and how much energy it generates.

6.5A

6.5B

- The visual rhythms used and their emotional effect.

- The attention to detail. This could include craftsmanship, conceptual nuance, or compositional economy.

- A conceptual spark. We all love to see an unexpected solution that re-defines the imaginative potential of a project.

Using Figure 6.5A as an example, you could say:

> The primary strength of this project is unity. Use of black marker throughout gives the design a simple, clean, and consistent look. The repetition of the arches helps tie it all together. Vertical and horizontal lines dominate, creating a type of grid.

Next, consider ways to improve the project. Mentally arm yourself with a magic wand. If you could instantly transform the design, what single aspect would you change? How can the potential of the project be more fully realized? Some basic questions follow.

- Is it big enough? Is it small enough?

- Is it bold enough? Is it subtle enough?

- How rich is the concept? Can it be expanded?

- How can the concept be communicated more clearly? How can the concept be communicated more fully?

The assignment was to create a labyrinth. Figure 6.5A is spatially shallow. To create 6.5B you might suggest:

> When I think about a labyrinth, I think of it as a mysterious place that I can enter and explore. As it now stands, this design is spatially flat: it gives me no place to go. For further work, you might try increasing the illusion of space. Greater size variation in the arches, with larger ones in the front and smaller ones in the back could help. Overlapping some of the arches could increase the space and add a rhythmic quality to the work. And, have you considered using gray marker for the background shapes? This would reduce the contrast and push them back in space.

6.10 Claes Oldenburg and Coosje van Bruggen, *Shuttlecocks*, 1994. South facade of the Nelson-Atkins Museum of Art and the Kansas City Sculpture Park. Aluminum, fiberglass-reinforced plastic, urethane paint, approx. 19 ft 2⅜ in. h. × 16 ft diameter (5.9 × 4.9 m).

Transformation

Works of art and design present ideas in physical form. Each composition is strongly influenced by the materials used, the relationships created, and the viewing context chosen. Consider these alternatives:

1. What happens when the medium is changed? Even when the shapes stay the same, a silver teapot is very different from a glass, steel, or ceramic teapot. Sculptor Claes Oldenburg has used transformations in material extensively, often changing hard, reflective materials into soft vinyl. This form of transformation is especially effective when the new material brings structural qualities and conceptual connotations that challenge our expectations.

2. What is the relationship of the piece to the viewer? What is the relationship between the artwork and its surroundings? What happens when a chair is reduced to the size of a salt shaker? Or when a 20-foot-tall badminton shuttlecock (6.10) is placed in front of a museum? How does any image change, both visually and conceptually, when size is dramatically reduced or increased?

3. Can a change in proportion increase impact? Working with the same basic information, a

seemingly endless number of solutions can be produced through variations in proportion (6.11).

6.11

4. Is a physical object compelling from all points of view? Does the composition of the piece encourage the viewer to view it from other angles?

5. Can a change in viewing context increase meaning? The context in which a composition is seen can dramatically alter its meaning. For example, a side of beef has a very different meaning when it is hung in a gallery rather than staying in a slaughterhouse. Likewise, pop artists such as Andy Warhol and Roy Lichtenstein brought new meaning to soup cans and comic books by using them as subject matter in their paintings.

Reorganization

Time-based work, such as visual books, comic books, film, and video, is generally constructed from multiple images. Changing the organization of the parts of the puzzle can completely alter the meaning of the piece. For example, Angela contemplates entering the building in the sequence shown in Figure 6.12. Using a different organization of the same three images, Angela now wonders what will happen when she opens the door at the top of the stairs (6.13). By repeating the image of Angela, we can present a dilemma: she is now in a labyrinth—which route should she take (6.14)?

6.12

6.13

6.14

Concept and Composition

Any compositional change affects the conceptual impact of an artwork. Henry M. Sayre provides a striking example in *A World of Art.*[1] A distilled version of his ideas follows.

Robert Rauschenberg's *Monogram* (6.15) is constructed from a stuffed goat, an automobile tire, and a painted plywood base. Seeking to combine painting and sculpture, Rauschenberg created three different versions of this piece. In the first version (6.16), he placed the goat on a shelf that extended from the center of a six-foot-tall painting. This created a connection between the painting and the goat, but diminished its sculptural impact. In the second version, Rauschenberg placed a tire around the goat's midsection and moved the animal in front of the painting (6.17). This enhanced its three-dimensionality but created too much of a

6.16 Robert Rauschenberg, *Monogram, 1st State,* c. 1955. Combine painting: oil, paper, fabric, wood on canvas, plus stuffed Angora goat and three electric light fixtures, approximately 75 × 46 × 12 in. (190.5 × 114.3 × 30.5 cm). No longer in existence.

separation between the animal and the painting. He finally hit on the right combination when he placed the painting on the floor and positioned the goat in the center. The painting retained its integrity as a two-dimensional surface, the goat retained its physical presence, and a highly unified combination of the two elements was achieved. The addition of the tire enhanced the goat's sculptural form and gave the artwork a humorous twist.

Accepting Responsibility

We have explored only a few of the many approaches to critical thinking in this chapter. Every assignment presents new possibilities for critiques, and each teacher continually invents new approaches to address the needs of a specific class.

Regardless of the specifics, however, two facts are inescapable. First, you will learn only what you want to learn. If you reject out-of-hand the alternatives suggested, or if you avoid responsibility for your conceptual and compositional choices, you will gain nothing from the critique, no matter what strategy is used. Second, there are no free rides. Everyone in the class is responsible for the success of the session. It is often difficult to sustain your attention or honestly assess your work or the work of others. When you get a superficial response to a project, insisting on further clarification is not easy. Every critique demands sincere and sustained attention from each participant. And when the responses are supportive and substantial, remarkable improvements in works of art and design can be made.

6.17 Robert Rauschenberg, *Monogram, 2nd State*, c. 1956. Combine: oil, paper, fabric, wood, plus rubber tire and stuffed Angora goat on wood, 115 × 32 × 44 in. (292 × 81.3 × 111.8 cm).

Profile:
Bob Dacey, Illustrator

Tell Me a Story: Illustrating *Miriam's Cup*

Bob Dacey is an internationally renowned artist whose drawings and paintings have been published as limited- and multiple-edition prints as well as in a wide range of books and periodicals, including *McCall's,* Ballantine Books, Book-of-the-Month Club, *Playboy*, and Scholastic Publications. His commercial clients include The White House, ABC, CBS, NBC, PBS, Mobil Oil, Sony, the U.S. Post Office, Air Japan, and many others.

Dacey has recently received a Silver Medal from the Society of Illustrators in New York for 1 of the 16 paintings he produced for Scholastic Publications illustrating a 32-page book, *Miriam's Cup,* which is themed on the Exodus of the Israelites from Egypt. The book tells the story of Miriam, the older sister of the prophet Moses. Dacey collected an extensive library of books on Egypt and spent almost a year on research. From costumes to musical instruments, Dacey insisted on getting all the details just right.

MS: Give me a bit of background on *Miriam's Cup.* What was the significance of this project, and what aspects of the story did you want to emphasize in the illustrations?
BD: *Miriam's Cup* gave me a chance to expand on my single-image work. I've always approached each illustration as a moment in time, as if it had a "before" and an "after." This book gave me a chance to push that much further. I started every painting by focusing on the emotion in the moment being depicted. I always ask myself: "What is the essence of this moment?" The composition follows. Shapes and values serve the emotional content, while movement is used to unify the composition.

MS: You have said that 75 percent of your work on this project was devoted to research. Can you describe your research, and tell me why it was so important?
BD: For *Miriam's Cup* I had to understand the culture of Egypt and the Jewish culture of the time. Fortunately, I've always had an extensive interest in both. My personal library contains more books on Egypt than the local library system. Research helped open new ideas, leading in some unexpected directions. Those bullrushes are one example. I looked up the word in three dictionaries and two encyclopedias. One of these sources mentioned that the bullrushes of ancient Egypt are papyrus, those beautiful fan-shaped reeds that can be fashioned into a kind of paper. Without that knowledge, the image I arrived at would have been impossible.

MS: I understand that you have a seven-step process by which you refine and expand your ideas. Can you describe this process as it applies to the cover image for *Miriam's Cup?*
BD: I first consider the intent of each painting: what must this piece communicate? In this painting I focused on Miriam's exuberance as she celebrates her escape from Egypt. Second, the composition must support my intent. The circular movement of the tambourine and flowers dominates this painting. The movement from the raised hand holding the tambourine, to Miriam's hair, to her face, and on to her cupped hand provides a secondary pattern. And, that cupped hand repeats the curve of the flowers. Third, the shapes depend on both the intent and the composition. If I am painting a very stoic character, I use a lot of verticals. Diagonals are used when the character or event is very dynamic. Value is fourth on my checklist. I assign value according to the mood of the painting. Lighter values are used for celebratory images, like this one; darker values dominate when the mood is somber. A mix of light and dark value is best. I base my compositions on the Golden Section [a classic use of proportion], and I often use a 60/40 proportion between light and dark values. Texture, step five, often results from the placement of shape and value—but it really deserves a place of its own, due to its importance as a constructive or destructive factor. When everything else works but the image

still suffers, textural discord is usually the culprit! Color comes next. I really have to have the other questions resolved first. Color without composition, value, or intent just doesn't cut it. This painting is dominated by rich pastel colors, which help convey the exuberant emotion.

All of this contributes to the overall image, the final step. If all of the preceding factors serve my intent, the image can emerge naturally and effectively.

MS: In addition to the extensive research you did for *Miriam's Cup*, it seems that you have a very wide range of interests in general.
BD: Well, everything feeds into my work—and I've always been interested in everything! My undergraduate majors included theater and anthropology before I settled on ad design as the field in which I finally got my degree. Now, my readings range from archaeology to philosophy to psychology to paleontology, and more. I'm also developing my interest in writing and plan to pursue a Masters in writing in order to increase my understanding of narrative.

MS: One of the questions my students often have is this: How do I get from where I am as a student to where you are as a professional?
BD: Focus on your goals, and research the field. Talk to professionals you admire. Set high standards for yourself, and be realistic about the level of professionalism and quality required.

MS: Any final bits of advice?
DB: Don't limit yourself. We all have great potential that serves the higher purpose of society. Pursue your goals with the knowledge that you can succeed. And, remain flexible and open-minded, so that you can redirect your efforts as opportunities present themselves. Read everything! Draw everything!

Bob Dacey, Cover of *Miriam's Cup* by Fran Manushkin, 1988. Scholastic Press.

Summary

- Through the use of critical thinking, an artist or designer can identify strengths and weaknesses in a project and determine the improvements that need to be made.

- Understanding the criteria on which a project will be judged helps focus critical thinking.

- Many artworks can be analyzed in terms of three basic aspects: form, subject, and content.

- Objective critiques focus on observable facts. Subjective critiques focus on feelings, intentions, and implications.

- Four common critique methods are description, cause and effect, compare and contrast, and greatest strength/greatest potential.

- Many critique methods may be used when you are working on a long-term project. In every case, there are three primary objectives: explore alternatives, delete nonessentials, and strengthen essentials.

- It is only by pushing a project to the limit that its potential will be fulfilled. Basic arithmetic, transformation, and reorganization can be used to increase compositional power.

- Responsibility for the success of a critique rests with each participant. Come with your mind open rather than your fists closed.

Keywords

cause-and-effect critique

compare/contrast critique

content

critique

descriptive critique

form

objective criticism

subject

subjective criticism

1. What is the subject matter of the artwork? What is the artist trying to say about the subject?

2. To what extent and by what means have the compositional choices supported this intent?

3. Is the artwork contained or does it seem to expand into the viewer's space?

4. What is the spatial depth of the artwork? How does space contribute to the meaning of the work?

5. How have each of the principles of design been used in this artwork?

6. By what means is the artwork unified? What adds variety?

7. What will you remember about this artwork two weeks from now?

8. If you were to make a second version of this project, what changes would you make? Why?

Sylvia Barnet, *A Short Guide to Writing about Art*, 3rd edition. Scott, Foresman, 1989.

Terry Barrett, *Criticizing Photographs: An Introduction to Understanding Images*, 2nd edition. Mountain View, CA, Mayfield, 1996.

Otto G. Ocvirk, Robert E. Stinson, Philip R. Wigg, Robert O. Bone, and David L. Cayton, *Art Fundamentals: Theory and Practice*, 9th edition. Burr Ridge, IL, McGraw-Hill, 2002.

Henry M. Sayre, *A World of Art*, 3rd edition. Upper Saddle River, NJ, Prentice-Hall, Inc., 2000.

Henry M. Sayre, *Writing about Art*, 3rd edition. Upper Saddle River, NJ, Prentice-Hall, Inc., 1999.

Amy Tucker, *Visual Literacy: Writing about Art*. Burr Ridge, IL, McGraw-Hill, 2002.

Glossary
by Mary Stewart and Peter Forbes

A

abstract form In film, a multiple-image structure, in which the parts are related to each other through their visual characteristics, such as shape, color, scale, or direction of movement.

abstract shape A shape that is derived from a perceptual source but is so transformed that it bears little visual resemblance to that source.

abstraction The reduction of an image or object to an essential aspect of its form or content.

accent A specific note in music that has been emphasized, or a shape, volume, color, and so on in visual art that has been emphasized. Using an accent, a designer can bring attention to a specific part of a composition and increase rhythmic variety in a pattern.

accent color A color that stands out from its surroundings. Often used to attract attention to a specific part of a design.

act A major division in a film or theatrical event. Acts are generally constructed from a group of sequences that gradually increase in intensity.

action-to-action transition In comic books, the juxtaposition of two or more panels showing a sequence of specific actions. This is the most common transition in American comic books.

actual lines Lines that are physically present in a design.

additive color Color created by combining projected beams of chromatic light. The additive color primaries are red, green, and blue; the secondaries are cyan, magenta, and yellow.

additive sculpture A physical object constructed from separate parts that have been connected using glues, joints, stitching, welds, and so on.

afterimage In visual perception, a ghostly image that continues to linger after the actual image has been removed.

amplified perspective The exaggerated use of linear perspective to achieve a dramatic and engaging presentation of the subject. Amplified perspective is often created using an unusual viewing position, such as a bird's-eye view, accelerated convergence, or some form of distortion.

analogous color A color scheme based on hues that are adjacent on a color wheel, such as red, orange, and yellow.

analogy A similarity or connection between things that are apparently separate and dissimilar. Analogies are often used to explain a difficult concept or unfamilar skill. For example, when a teacher describes wet plaster as having the "consistency of cream," she is using an analogy.

angle of framing The position of the frame in relation to the subject it shows. The frame may be above the subject, creating a bird's-eye view, straight on, or below the subject, creating a worm's-eye view. Also known as the camera angle.

anomaly An obvious break from norm in a design. Often used to emphasize an aspect of a design.

aspect-to-aspect transition In comic books, the juxtaposition of two or more panels showing different views of a single setting or event. This transition is often used in Japanese comic books.

assemblage An additive method in which the artist or designer constructs the artwork using objects and images that were originally created for another purpose. Essentially, assemblage can be defined as three-dimensional collage.

asymmetrical balance An equilibrium among visual elements that differ in size, number, weight, color, or texture. Asymmetrical balance is generally nonaxial and highly dynamic.

atmospheric perspective A visual phenomenon in which the atmospheric density progressively increases, hazing over the perceived world as one looks into its depth. Overall definition lessens, details fade, and contrasts become muted. In a landscape, a blue mist descends.

attached shadow A shadow connected to the surface of an object that defines its form through tonal modulation.

B

backlight A light source positioned behind a person or object that can create a silhouette or separate the person or object from the background.

balance An equilibrium among interacting and/or opposing forces in a visual composition.

base A horizontal support for a physical object, such as a marble block for mounting a bronze sculpture.

beat 1. A unit of musical rhythm that creates the pulse of a sound. 2. In acting, the most basic element in a story. A beat is an exchange of behavior, based on action and reaction.

boundary The point of division between objects, images, or experiences.

brainstorming Any of a number of problem-solving techniques that are designed to expand ideas and encourage creativity. List-making, mapping, associative thinking, and metaphorical thinking are common strategies used.

C

calligraphic line Derived from the Greek words for beautiful and writing, a flowing, and expressive line that is as personal as handwriting. Calligraphic lines generally vary in thickness and apparent velocity.

carving The removal of materials from a larger mass, gradually revealing an image or object. Carving is a subtractive process.

cast shadow A dark shape, created by the absence of light, that results from placement of an opaque object in the path of a light source.

categorical form In film, a multiple-image structure that is organized based on categories, or subsets, of a topic. For example, a film on Hawaii might focus first on the sea, then on the volcanoes, then on the plant life, then on indigenous animals.

causality The interrelation of cause and effect, based on the premise that nothing occurs without cause.

cause-and-effect A critique in which the viewer seeks to determine the cause for each visual or emotional effect in a design. For example, the dynamism in a design may be caused by the diagonal lines and asymmetrical balance used. Also known as formal analysis.

centrifugal balance Balance created when visual forces in a composition imply an outward expansion.

centripetal balance Balance created when visual forces in a composition imply an inward movement, suggesting a compression of space.

characteristic texture The inherent, or familiar, texture of a material. The gleaming reflective surface of a steel teapot and the gritty texture of clay are two examples.

chroma The purity, intensity, or saturation of a color.

chromatic gray A gray made from a mixture of color plus white rather than simply using black and white.

chronology The order in which events occur.

close-up In film, a type of framing in which the scale of the object shown is relatively large, as in a close-up of an actor's face.

closure The mind's inclination to connect fragmentary information in order to create a completed form. Closure is an essential aspect of Gestalt psychology.

collage An image constructed from visual or verbal fragments initially designed for another purpose.

color key A color that dominates an image and provides an overall visual or emotional effect.

compare/contrast critique A critique in which similarities and differences between two designs are analyzed. Often used in art history classes to demonstrate connections and divisions between historical periods.

comparison Recognition of similarity in two or more compositions. Often used in art history to demonstrate connections between images done by different artists or in different periods. The images being compared may be similar in balance, color, content, style, and so on.

complementary colors Hues that oppose one another on a traditional color wheel. When juxtaposed, complementary colors create contrast; when mixed, complementary colors neutralize each other, creating a variety of browns.

composition The combination of multiple parts to create a harmonious whole.

compression The forcing or crushing of material into a smaller, denser condition and its visual dynamics and implied psychological effects.

concentric balance The repetition of a boundary in diminishing size to create a bull's-eye effect. Concentric balance can harness both the expanding energy of centrifugal balance and the compressive energy of centripetal balance.

concept A well-developed thought or a comprehensive generalization.

condensation To be reduced to a denser form, as with the transition from a vapor to a liquid

cone of vision In perspective drawing, a hypothetical cone of perception originating at the eye of the artist and expanding outward to include whatever he or she wishes to record in an illusionistic image, such as a perspective drawing. The cone's maximum scoping angle is 45 to 60 degrees; anything outside of the cone of vision is subject to distortion.

connection 1. A unifying relationship in a composition. 2. A physical joining, through joints, welds, stitching, and so forth.

contact The meeting point between visual or structural elements in a design.

content The emotional and/or intellectual meaning or message of an artwork.

continuity A fluid connection among compositional parts.

contour line A line that describes the edges of a form and suggests three-dimensional volume.

contradictory texture The unfamiliar use of a texture or the addition of an unusual texture to the surface of an object. Meret Oppenheim's *Object*, a cup, plate and spoon covered with fur, is a familiar example.

contrast The degree of difference between compositional parts or between one image and another. High contrast tends to be eye-catching and is often used by graphic designers to create dynamic, highly readable images.

contrasting colors Colors that are substantially different in hue, value, intensity or temperature.

convergent thinking A problem-solving strategy in which a predetermined goal is pursued in a linear progression using a highly focused problem-solving process. Six steps are commonly used: (1) define the problem, (2) do research, (3) determine your objective, (4) devise a strategy, (5) execute the strategy, (6) evaluate the results.

critique Any means by which the strengths and weaknesses of designs are analyzed. Common strategies include comparision, description, formal analysis, and inventing alternatives.

cropping The manner in which a section of an image or a fragment of observed reality has been framed. For example, photographers select a fragment of reality every time they look through the viewfinder of the camera. Part of the scene is included, while the remainder is cut away. Photographs are often cropped further in the darkroom, leaving only the most significant information.

cross contour Multiple, curving, parallel lines running over the surface of an object horizontally and/or vertically that describe its surface configuration topographically, as in mapping. This process is much like wireframing in three-dimensional computer modeling. Cross contours can also be used in drawing to suggest three-dimensional form through tonal variation.

crosscut In film, an abrupt alternation between two or more lines of action.

cross-hatching A technique used in drawing and printmaking to shade an object using two or more networks of parallel lines. Darker values are created as the number of line networks increases.

curvilinear shape A shape whose contour is dominated by curves and flowing lines.

cut In film, the immediate change from one shot or frame to another

D

definition 1. The degree to which a shape is distinguished from both the ground area and from other shapes within the design. 2. The degree of resolution or focus of an entire image. Sharply focused shapes tend to advance while blurred shapes tend to recede.

denouement The outcome, solution, or point of clarification in a story.

density The extent to which compositional parts are spread out or crowded together. The visual connections that occur easily in a high-density composition are often less obvious in a low-density composition.

depth of field The range of focus in a photographic image, from foreground to background. In a photograph with great depth of field, an object that is 15 feet from the camera is in focus, as well as an object that is 5 feet from the camera.

descriptive critique A critique in which the viewer carefully describes what he or she sees when observing a design. Descriptive critiques are used to heighten awareness of visual relationships, for both the artist and the viewer.

descriptive shape A shape that is derived from specific subject matter and strongly based on perceptual reality.

diegesis The world created in a film or video.

dissolve A transition between two shots during which the first image gradually disappears while the second image gradually appears.

dissonance The absence of harmony in a composition; often created using disharmonious colors.

distribution The manner in which colors, shapes, or other visual elements are arranged within the format.

divergent thinking An open-ended, problem-solving strategy. Starting with a broad theme, the designer explores in all directions, expanding ideas in all directions.

duration 1. The length of time required for the completion of an event, as in the running time of a film, video, or performance; 2. the running time of events depicted in the story (plot duration); 3. and the overall span of time the story encompasses (story duration).

dynamic Energetic, vigorous, forceful; creating or suggesting change or motion.

E

earthwork An artwork that has been created through the transformation of a natural site into an aesthetic statement.

editing In film, selecting and sequencing the details of an event to create a comprehensive whole.

elevation In orthographic projection, the front, back, and side views of an object or architectural structure.

emotional advertising Use of emotion to sell a service, product, or idea. This strategy is often used when a product is neither unique nor demonstrably better than a competing product.

emphasis Special attention given to some aspect of a composition, which gives it prominence.

exaggerated advertising Pushing an idea to an extreme to make a point.

expansion The extending outward of a material to fill more space.

eye level In linear perspective, the eye level is determined by the physical position of the artist. Sitting on the floor creates a low eye level while standing at an easel creates a higher eye level. Also known as the horizon line. All vanishing points in one- and two-point perspective are positioned on the eye level.

F

fade A gradual transition used in film and video. 1. Fade-in: commonly, a dark screen that gradually brightens as a shot appears. 2. fade-out: a shot that gradually darkens until the screen goes black.

fidelity The degree of connection between a sound and its source. For example, when we hear the sound of a helicopter and see a helicopter on the screen, the sound matches with the image, creating close fidelity.

figure The primary or positive shape in a design; a shape that is noticeably separated from the background. The figure is the dominant, advancing shape in a figure-ground relationship.

figure/ground reversal An arrangement in which positive and negative shapes alternatively command attention. Also known as positive and negative interchange.

fill light In cinematic and theatrical lighting, a diffused light that is used to decrease contrast between light and dark areas.

filtration The process of separating a solid from a liquid by passing it through a porous substance such as cloth, charcoal, or sand.

flashback In film, an alternation in chronology in which events that occur later in a story are shown first.

floodlight A softly defined light with a broad beam.

form 1. The physical manifestation of a design as opposed to the content, or the idea behind a design. 2. The organization or arrangement of visual elements to create a unified art form.

format The type of shape used for the outer edge of a design.

frame A single static image in film or video.

freestanding sculpture Sculpture that is self-supporting and is designed to be viewed from all sides.

function The purpose of a design or the objective that motivates the designer. For an industrial designer, the primary purpose of a design is often utilitarian. For example, he or she may be required to design a more fuel-efficient automobile. For a sculptor, the primary purpose of a design is aesthetic: he or she seeks to create an artwork that engages the viewer emotionally and philosophically. However, a sculpture, like an automobile, must be physically well-constructed, and a car, like a sculpture, must have aesthetic appeal.

fusion The combination of shapes or volumes along a common edge.

G

geometric shape A shape derived from or suggestive of mathematics. Geometric shapes are characterized by crisp, precise edges and mathematically consistent curves.

gestalt A German word for "form." A complete configuration that we perceive through psychological closure. This configuration is more complete than the sum of its parts. In a gestalt, all elements operate in relation to the whole.

gesture drawing A vigorous drawing that captures movement and the overall orientation of an object, rather than describing specific detail. Often used as a basis for figure drawing.

gloss 1. In writing, words of explanation or translation inserted into a text. 2. A secondary text within a manuscript that provides comments on the main text.

gradation Any gradual transition from one color to another or from one shape or volume to another. In drawing, shading created through the gradation of grays can be used to suggest three-dimensional form.

graphic relationship In film, the juxtaposition of two or more separate images that are compositionally similar. For example, a graphic relationship can be created when a basketball is shown in the first panel, an aerial view of the round free-throw zone is shown in the second, and the hoop of the basket itself is shown in the third.

gravity The force that tends to pull all bodies toward the center of the Earth.

grid A visual or physical structure created from intersecting parallel lines. A grid can provide the compositional framework for a design.

grisaille A gray underpainting, often used by Renaissance artists, to increase the illusion of space.

group In sequential structure, a collection of images that are related by subject matter, composition, or source.

gutter In bookbinding, the center line of a book, where the two pages meet.

Happening An assemblage of improvised, spontaneous events performed by the artist and audience alike, based on a general theme. There is no rehearsal, and any location, from a parking lot to a factory interior, can be used. The Happening is most commonly associated with Allan Kaprow and is a precursor to performance art.

hard-sell advertising An advertising approach in which a major point is presented in a clear, direct manner. The narrative is usually linear, and the message is usually explicit.

harmony A pleasing or soothing relationship among colors, shapes, or other design elements.

hatching A technique used in drawing and printmaking to shade using a range of gray tones created from multiple parallel lines.

high definition Sharply focused visual information that is highly readable.

horizon line In linear perspective, the line on which all vanishing points are positioned. More accurately described as the eye line or eye level.

hue The name of a color, such as red or yellow, that distinguishes it from others and assigns it a position in the visual spectrum and on the color wheel.

humorous advertising Use of humor to sell a service, product, or idea. By entertaining the viewer, the designer can make the product memorable.

illusionary space The representation of an object or scene on a two-dimensional surface so as to give it the appearance of three-dimensionality.

implied line 1. A line that is suggested by movement or by a gesture rather than being physically drawn or constructed. 2. A line that is suggested by the positions of shapes or objects within a design. With either form of implied line, the viewer mentally connects the points.

installation art An artwork or a design that presents an ensemble of images and objects within a three-dimensional environment.

intensity 1. The purity, saturation, or chroma of a color. For example, fire engine red is a high-intensity color, while brick red is a low intensity color. 2. In theater, the power, concentration, and energy with which an action is performed or the quality of observation of an event.

interdisciplinary art The combination of two or more different disciplines to create a hybrid art form.

interdisciplinary thinking Use of skills and knowledge from more than one discipline.

in the round A three-dimensional object that is self-supporting and is designed to be viewed from all sides, as in freestanding sculpture.

joint A physical connection between elements or parts in a three-dimensional object. Some joints are fixed, such as ones that are bolted together, while others can be moved, as with a hinge or a ball-and-socket joint.

junction 1. A conceptual intersection between ideas or events. 2. A physical intersection between elements or parts in a three-dimensional object.

K

key light The primary source of illumination used by filmmakers and set designers.

kinesthetic Bodily perception of position, balance, movement, tension, and so on.

kinetic form A static form that suggests motion or a form that actually moves.

L

lap dissolve In film, a dissolve in which two shots are temporarily superimposed.

layers of space Separating compositional space into foreground, middle ground, and background to intensify expressive possibilities and spatial complexity.

line 1. A point in motion. 2. A series of adjacent points. 3. A connection between points. 4. An implied connection between points. Line is one of the basic elements of design.

linear perspective A mathematically based system for projecting the apparent dimensions of a three-dimensional object onto a two-dimensional surface called the picture plane. Developed by artists during the Renaissance, linear perspective is one strategy for creating the illusion of space.

long shot In film, a type of framing in which the scale of the subject shown is relatively small, as with an image of a human figure within a landscape.

loudness The amplitude of a sound wave; the strength of a sound.

low definition Blurred or ill-defined visual information that is difficult to read.

M

maquette A well-developed, three-dimensional model, comparable to a two-dimensional thumbnail sketch.

mass A volume that has weight, density, and bulk.

medium shot In film, a type of framing in which the scale of the subject shown is of moderate size, as in a view of an actor from the waist up.

metaphor A figure of speech in which one thing is directly linked to another dissimilar thing. Through this connection, the original word is given the qualities of the linked word. For example, when we say, "she's a diamond in the rough," we attribute to a woman the qualities of an unpolished gem.

meter The basic pattern of sound and silence in music or of positive and negative in design.

model In three-dimensional design, a model is a technical experiment or a small-scale version of a larger design.

modeling An additive sculptural process by which a plastic material is formed into an artwork or design.

moment-to-moment transition In comic books, a transition in which a character or situation is simply being observed over time. This transition is often used in Japanese comic books but rarely in American comic books.

monochromatic color system A color system based on variations in a single hue. For example, a light, pastel blue, a medium navy blue, and a dark blue-black may be used in a monochromatic design.

myth A traditional story collectively composed by many members of a society. The creation of the world, sources of evil, the power of knowledge, and even the nature of reality may be explained through these grand expressions of the imagination.

N

negative shape 1. Any clearly defined area around a positive shape; the receding shape or ground area in a figure-ground relationship. 2. A shape created through the absence of an object rather than through the presence of an object.

nonobjective shape Circles, squares, and other shapes that are not based on a specific perceptual source.

non-sequitur transition In comic books, the juxtaposition of two or more frames or shots that have no obvious conceptual relationship.

O

objective criticism The assessment of strengths and weaknesses in a design based on the visual information presented. Essentially, objective criticism focuses on the ways in which lines, shapes, textures, volumes, and so forth are combined to create a cohesive whole.

one-point perspective A form of linear perspective in which the lines receding into space converge at a single vanishing point on the eye level or horizon line.

opponent theory An explanation for the electric glow that occurs when two complementary colors are placed side by side.

organic shape A shape based on forms from the natural world or suggestive of living organisms. Also known as biomorphic shape.

orientation The angle at which a visual element is positioned.

orthographic projection A drawing system widely used by artists and designers to delineate the top, bottom, and four side views of a three-dimensional object. Orthographic means "true picture." Unlike perspective drawing, which is designed to create the illusion of space, an orthographic projection is constructed using parallel lines that accurately delineate the object.

overlap Placement of one shape in front of another to create the illusion of space.

oxidation A common form of chemical change used in creating a patina, or colored surface, on a metal sculpture.

panel A single frame in a comic book.

pattern A design composed of repeated elements that are usually varied to produce interconnections and implied movement.

pedestal A vertical support for a sculptural object.

performance art A live presentation which may combine elements from a variety of art forms, such as film, video, theater, and dance.

permanence The degree of durability, or resistance to decay, in a given material or design.

perspective A graphic system used to create the illusion of space on a two-dimensional surface.

picture plane The flat surface on which an artist creates a pictorial image.

pitch In music, the relative highness or lowness of a sound. Pitch is determined by wave frequency, as compression and expansion occur within the sound wave.

plane In three-dimensional design, an area with measurable width and height. Shapes that have been combined to create three-dimensional structures are called planes.

plan view The bottom view of a three-dimensional object or architectural structure, drawn orthographically or freehand.

plinth A horizontal support for a sculptural object.

polyhedra Multifaceted volumes, such as tetrahedrons.

positive shape The principal or foreground shape in a design; the dominant shape or figure in a figure-ground relationship.

primary colors Colors from which virtually all other colors can be mixed. The additive (or light) color primaries are red, green, and blue. The subtractive (or pigment) color primaries are yellow, magenta red, and cyan blue.

primary contour The outer edges of a physical object, such as the extremities of a carved sculpture.

principles of design The strategies most commonly used by artists and designers to unify disparate visual information into a cohesive whole, including balance, emphasis, rhythm, and proportion.

proportion A comparative relationship between the parts to a whole. For example, in figure drawing, the model's head is often compared to the overall height of the body.

prototype A well-developed model, as with the fully functional prototype cars developed by automobile companies.

proximity The distance between the parts of a structure or between an object and the audience.

radial symmetry A form of balance that is created when shapes or volumes are mirrored both vertically and horizontally, with the center of the composition acting as a focal point.

rational advertising A type of advertising in which logic and comparisons of quality are used to sell a service, product, or idea. A rational approach is most effective when the message is compelling in itself or the product is truly unique.

realistic advertising Use of a familiar setting or situation to involve the viewer and relate a product, service, or idea to use in everyday life.

rectilinear shape A shape whose edges are created by straight lines and angular corners.

relief Sculpture in which forms project out from a flat surface. The degree of projection ranges from low to high relief.

repetition The use of the same visual element or visual effect a number of times in the same composition. Can be used to increase unity in a

composition, produce a rhythmic movement, or emphasize the importance of a visual idea.

representation The lifelike depiction of persons or objects.

representational shape A shape that is derived from specific subject matter and strongly based on perceptual reality.

rhetorical form In filmmaking, a type of sequential organization in which the parts are used to create and support an argument. Often used in documentary films.

rhythm 1. The repetition of multiple parts in a composition to create a pattern of sound and silence, positive and negative, or other contrasting forces. 2. In filmmaking, the perceived rate and regularity of sounds, shots, and movement within the shots. Rhythm is determined by the beat (pulse), accent (stress), and tempo (pace).

rhythmic relationship The juxtaposition of multiple images to create a deliberate pulse or beat.

S

saturation The purity, chroma, or intensity of a color.

scale A size relationship between two separate objects, such as the relationship between the size of Mount Rushmore and a human visitor to the monument.

scene In film, continuous action in continuous time and continuous space.

scene-to-scene transition In comic books, the juxtaposition of two or more frames showing different scenes or settings.

scope Conceptually, the extent of our perception or the range of ideas our minds can grasp. Temporally, scope refers to the range of action within a given moment.

screenplay The written blueprint for the film; commonly constructed from multiple acts.

secondary colors Hues mixed from adjacent primaries. In paint, the secondary colors are violet, green, and orange.

secondary contour The inner edges of a physical object, such as the internal design and detailing of a carved sculpture.

section In orthographic projection, a slice of an object or architectural structure that reveals its internal structure and detail.

sequence 1. In filmmaking, a collection of related shots and scenes that comprise a major section of action or narration. 2. In narrative structure, any collection of images that have been organized by cause and effect. In a simple sequence, action number two is caused by action number one. In a complex sequence, there may be a considerable delay between the cause and the effect.

series In sequential structure, a collection of images that are simply linked together, as with cars in a train.

serious advertising Advertising that treats a topic in a somber or solemn manner. Often used for public service announcements, such as drunk driving commercials.

setting In time design, the physical and temporal location of a story, the props and costumes used in a story, and the use of sound.

shade A hue that has been mixed with black.

shading In drawing, a continuous series of grays that are used to suggest three-dimensionality and to create the illusion of light.

shape A flat, enclosed area created when 1. A line connects to enclose an area. 2. An area of color or texture is defined by a clear boundary. 3. An area is surrounded by other shapes.

shot In film, a continuous group of frames.

sidelight A light positioned to the side of a person or object. Can be used to increase the sense of dimensionality.

sight line 1. In perspective, a viewing line that is established by the arrangement of objects within one's field of vision. 2. A straight line of unimpeded vision.

simile A figure of speech in which one thing is linked to another dissimilar thing using the word *like* or *as*. Through this connection, the original word is given the qualities of the linked word. For example, when we say, "He's as strong as a lion," we attribute to a man the strength of an animal.

simultaneous contrast The optical alteration of a color by a surrounding color. For example, when a square of blue is placed on a yellow background, the blue appears dark and cool. The same blue will appear much lighter when it is placed on a black background.

soft-sell advertising An advertising approach that uses emotion, rather than reason, to sell a service, product, or idea. The narrative is often nonlinear, and ideas or actions may be implied.

space One of the basic elements of three-dimensional design. The distance between images or points in a design. The artist/designer physically contains and thus defines space when constructing a three-dimensional object.

spatial relationship In film making, the juxtaposition of two or more images that are spatially different, such as a close-up, a medium shot, and a long shot.

split complementary A complementary color plus the two colors on either side of its complement on the color wheel.

spotlight A light that produces a small, clearly defined beam.

static An equilibrium of forces. In design, a composition that is at rest or an object that appears stationary.

style The distinctive artistic treatment of an image or idea.

subject The person, object, event, or idea on which an artwork is based.

subjective criticism The assessment of strengths and weaknesses in a design based on nonobjective criteria, such as the narrative implications of an idea, the cultural ramifications of an action, or the personal meaning of an image.

subject-to-subject transition In comic books, the juxtaposition of two or more frames showing different subject matter.

subtractive color Color created when light is selectively reflected off a pigmented or dyed surface. For example, when an object is painted red, the molecular makeup of the red pigment absorbs (subtracts) all of the spectral light except the red wavelength, which is reflected back to the viewer's eyes. The subtractive primaries are yellow, magenta red, and cyan blue.

subtractive sculpture Any process by which an artist or designer removes materials from a larger mass, gradually revealing the form within.

symbolic color A color that has been assigned a particular meaning by the members of a society. For example, in the United States, the white color of a wedding gown symbolizes purity, while in Borneo it symbolizes death.

symmetrical balance A form of balance that is created when shapes are mirrored on either side of an axis, as in a composition that is vertically divided down the center.

tactile texture Texture that can be felt physically.

take In film or video, one version of an event.

tangibility The substantiality of an object or the degree to which an object or a force can be felt.

temperature The physical and psychological heat generated by a color.

tempo The pace at which music and time-based art occur. A fast tempo is generally used in action films while a slow tempo is usually used in a dramatic film.

temporal relationship How the shots in a film relate in time.

tension The distortion of an object through stretching or bending.

tertiary color A hue that is mixed from a primary color and an adjacent secondary color.

testimonial advertising Use of a trustworthy character or celebrity to provide endorsement for a product, service, or idea.

texture The surface quality of a two-dimensional shape or a three-dimensional volume. Texture can be created visually, using multiple marks; physically, through surface variation; or through the inherent property of a specific material, such as the texture of sand as opposed to the texture of polished glass.

three-point perspective A form of linear perspective in which the lines receding into space converge at two vanishing points of the eye level (one to the left of the object being drawn and one to the right of the object being drawn), plus a third vanishing point above or below the eye level. Used when the picture plane must be tilted to encompass an object placed above or below the eye level.

three-quarter work A physical object that is designed to be viewed from the front and sides only.

timbre The unique sound quality of each instrument. For example, a note of the same volume and pitch is quite different when it is generated by a trumpet rather than a violin.

tint A hue that has been mixed with white.

tone A hue that has been mixed with black and white.

torsion The distortion of an object through a twisting movement.

transition The process of changing from one state or form to another. For example, the surface of a metal sculpture as it shifts from a smooth to a rough surface or the manner in which a computer drawing morphs from one form to another.

triadic harmony A color scheme based on three colors that are equidistant on a color wheel.

tromp l'oeil A French term meaning "to fool the eye." A flat illusion that is so convincing the viewer believes the image is real.

two-point perspective A form of linear perspective in which the lines receding into space converge at two vanishing points of the eye level (or horizon line), one to the left of the object being drawn and one to the right of the object being drawn. Used when the object being drawn is placed at an angle to the picture plane.

typestyle The distinctive quality of the letterforms within a given font. For example, Helvetica type has a very different look than Palatino type.

unity The oneness, or wholeness, in a design that occurs when all parts work together to create a cohesive whole.

value 1. The lightness or darkness of a color. 2. The relative lightness or darkness of a surface.

value scale A range of grays that are presented in a mathematically consistent sequence.

vanishing point In linear perspective, the point or points on the eye level at which parallel lines appear to converge.

variety The differences that give a design visual and conceptual interest; notably, use of contrast, emphasis, differences in size, and so on.

visual book An experimental structure that conveys ideas, actions, and emotions using multiple images in an integrated and interdependent format. Also known as an artist's book.

visual texture 1. A surface treatment that simulates an actual physical texture. 2. Any covering of a surface with multiple marks.

visual weight 1. The inclination of shapes to float or sink based on their solidity and compositional location. 2. The relative importance of a visual element within a design.

vitalistic sculpture A sculpture that appears to embody life in an inanimate material, such as plastic, stone, or wood.

volume 1. In three-dimensional design, a volume is an enclosed area of three-dimensional space. 2. In two-dimensional design, basic volumes such as cubes, cones, and spheres are created through the illusion of space. 3. In time design, volume refers to the softness or loudness of a sound.

volume summary A drawing that communicates visual information reductively, using basic volumes, such as sphere, cubes. and cylinders to indicate the major components of a figure or object.

walk-through work An artwork or a design that presents an ensemble of images and objects within a three-dimensional environment. The viewer must walk through the space in order to experience the artwork fully.

weight The visual or physical heaviness of an object.

wipe In film, a transition in which the first shot seems to be pushed off the screen by the second. Wipes were used extensively in *Star Wars*.

Part Opening Images

Part One Opener, Solomon R. Guggenheim Museum, NY. Gift, Solomon R. Guggenheim, 1941 (41.283). © 2001 Artists Rights Society (ARS), NY/ADAGP, Paris. Photo: David Heald © The Solomon R. Guggenheim Foundation, NY.

Part Two Opener, Photo: David Browne.

Introduction

i.1, Video/Sound Installation of a 9 × 12 ft screen which slowly rotates on its axis in a darkened room. Collection: Edition 1, Museo Nacional Centro de Arte Reina Sofia, Madrid. Edition 2, Los Angeles County Museum of Art; Modern and Contemporary Art Council Fund.

i.2, Pendant. Found objects, text assembled. 2½ in. (6 cm). Collection Toni Greenbaum, NY. Photo Keith E. LoBue.

i.3, Designers: Bill Cannan, Tony Ortiz, H. Kurt Heinz. Design Firm: Bill Cannan & Co. Client/Mfr: NASA Public Affairs.

i.5, Mixed media with 6 found prints and 6 photographic enlargements on cotton scrim. Dimensions variable. Installation at the Chiesa di San Stae, Venice, Italy. Swiss contribution to the 1995 Venice Biennale.

i.6, By permission of the Estate of Alfred Hitchcock. Photo: Museum of Modern Art, Film Stills Archive.

i.7, Designers: James E. Grove, John Cook, Jim Holtorf, Fernando Pardo, Mike Botich. Design Firm: Designworks/USA. Client/Mfr: Corona Clipper Co.

i.8, Solving the Problems of Flight. Design firm: National Park Services, Intrepretive. Design Center: Harper's Ferry, WV. National Park Services, Division of Publications.

i.9, Oil on canvas, 34½ × 35¾ in. (87.6 × 90.8 cm). Denver Art Museum Collection, funds from the Helen Dill bequest, (1935.14). Photo © 2002 Denver Art Museum.

i.10, Acrylic on paper, 32¼ × 22⅞ in. (82 × 59 cm). © 2001 Estate of Sam Francis/Artists Rights Society (ARS), NY.

i.13, Painted steel, fiberglas and wood. 20 × 15 × 8 ft (6.1 × 4.6 × 2.4 m). Collection, University of Illinois at Urbana, Champaign. Photo courtesy of the artist © Alice Aycock 1994.

i.14, Aluminum and steel, hand 27 × 40 × 4 ft (8.2 × 12.2 × 1.2 m) , ball 20 ft (6 m) diameter. Overlooking the Straits of Gibraltar. Commissioned by the port city of Algeciras, Spain.

i.15, TM & © 2001 Marvel Characters, Inc. Used with permission.

Chapter 1

1.3, Stanford University Museum of Art, CA, gift of Dr. and Mrs. Louis J. Rattner (1968.13).

1.4, Reproduced by courtesy of the Trustees of the British Museum, London. Photo © Copyright The British Museum.

1.5, Collection of David Lebrun. Courtesy of Koplin Gallery, Los Angeles.

1.6, Nelson-Atkins Museum, Kansas City, MO, gift of Mrs. George H. Bunting, Jr. (73-27).

1.7, Spencer Museum of Art, University of Kansas, Lawrence.

1.8, U & Ic, International Typeface Corp. Used by permission of Agfa Monotype.

1.9, Reproduction courtesy the Minor White Archive, Princeton University. Copyright © 1982 by the Trustees of Princeton University. All rights reserved.

1.10, Courtesy of the artist.

1.11A, Vatican Museums, Vatican State. Scala/Art Resource, NY.

1.12, Museum of Modern Art, NY. Gift of Victor S. Riesenfeld. © 2001 Artists Rights Society (ARS), NY/ADAGP, Paris. Photo © 2002 Museum of Modern Art, NY.

1.13, © David Mach. Courtesy Galerie Jérôme de Noirmont, Paris.

1.14, Musée du Louvre, Paris. Reunion des Musees Nationaux/Art Resource, NY.

1.15, Collection, National Gallery of Art, Washington DC. Robert and Jane Meyerhoff Collection. © 2001 Barnett Newman Foundation/Artists Rights Society (ARS), NY.

1.19, Los Angeles County Museum of Art, Modern and Contemporary Art Council Fund. Photograph © 2002 Museum Associates/LACMA.

1.20, Courtesy Pentagram Design.

1.23, Art and Artifacts Division, Schomburg Center for Research in Black Culture. The New York Public Library, Astor, Lenox and Tilden Foundations.

1.24, The Detroit Institute of Arts, gift of Edsel B. Ford Fund. Photo © 1991 The Detroit Institute of Arts.

1.25, Random House Vintage Books. Art Director: Edith Loeser. Agency: Carin Goldberg.

Chapter 2

2.15, Courtesy of Nicora Gangi.

2.16, © David Hockney/Gemini G. E. L.

2.17, Statens Museum for Kunst, Rump Collection, Copenhagen, Denmark. © 2001 Succession H. Matisse, Paris/Artists Rights Society (ARS), NY.

2.18, Smithsonian American Art Museum, Washington, D.C./Art Resource, NY.

2.20, Collection of the National Trust for Historic Preservation, Pocantico Historic Area, NY.

2.21, Collection, Albright-Knox Art Gallery, Buffalo, NY. Gift of Seymour H. Knox, 1956. © 2001 Estate of Arshile Gorky/Artists Rights Society (ARS), NY.

2.22, Philadelphia Museum of Art: Gift of Mrs. Iwao Setsu, Tokyo. Photo: Graydon Wood.

2.23, Philadelphia Museum of Art: Gift of Hilda K. Watkins. Photo: Lynn Rosenthal , 1997.

2.25, Private collection. © Kenneth Noland/Licensed by VAGA, NY.

2.27, © Wolf Kahn/Licensed by VAGA, NY.

2.28, University Art Museum, University of California, Berkeley, gift of the artist.

2.31, School of Art, Ohio University. Courtesy of the artist.

2.33, National Gallery of Art, Washington, DC. Collection of Mr. and Mrs. Paul Mellon. Photo: Richard Carafelli.

2.35, Chester Dale Collection, National Gallery of Art, Washington, DC. Photo © 2001 Board of Trustees.

2.36A, Honolulu Academy of Arts, gift of the Honorable Clare Booth Luce, 1984 (5311.1). © 2002 Victor Vasarely/Artists Rights Society (ARS), NY/ADAGP, Paris. Photo: Tibor Franyo.

2.38, National Gallery of Art, Washington, D.C., Alfred Stieglitz Collection, Bequest of Georgia O'Keeffe. © 2001 Georgia O'Keeffe Foundation/Artists Rights Society (ARS), NY. Photo: Bob Grove.

2.40, Joel Katz Design Associates, Philadelphia, PA. Photos © Peter Olson, digital illustration © Joel Katz Design Associates.

2.41, Musée d'Orsay, Paris. Reunion des Musees Nationaux/Art Resource, NY. Photo: Herve Lewandowski.

2.42, South Australia Museum, Adelaide. © 2001 Artists Rights Society (ARS), NY/Viscopy, Sidney.

2.43, © 2001 Estate of Francis Bacon/Artists Rights Society (ARS), NY. Photo © Tate Gallery, London/Art Resource, NY.

2.44, Photo: J. Kevin Fitzsimons.

2.46, Astor, Lenox, and Tilden Foundation. Spencer Collection, The New York Public Library/Art Resource, NY. © 2001 Succession H. Matisse, Paris/Artists Rights Society (ARS), NY.

2.47, © Wolf Kahn/Licensed by VAGA, NY.

2.48, Design firm: Louis Nelson Associates, Inc., NY. Art Director: Louis Nelson, Graphic Designer: Jennifer Stoller, Client: Port Authority/Port Authority Trans Hudson.

2.50, Minneapolis Institute of Arts, Minneapolis, MN, gift of the P. D. McMillan Land Company (54.30) .

2.52, Art Institute of Chicago, The Alfred Stieglitz Collection (1949.706). Photo © 2001 Art Institute of Chicago.

2.53, An oiran is the highest ranking courtesan. Courtesy of the Trustees of the Victoria and Albert Museum, London.

2.54, Signed at upper right. © Andrew Wyeth. Lent by Professor and Mrs. Charles H. Morgan, Amherst, MA. Mead Art Museum, Amherst College, on extended loan to the Museum from the Estate of Charles H. Morgan (AC EL.1984.51).

2.55, Nelson-Atkins Museum of Art, Kansas City, MO, gift of the Friends of Art (F63-15). Photo: E. G. Schempf.

2.56, © Sandy Skoglund/Superstock.

2.57, Repainted by Jim Kewanwytewa. Oraibi. Museum of Northern Arizona.

2.58, Copyright Maya Lin. Photo: Mark Segal/Panoramic Stock Images, Chicago.

2.59, Unsigned. Staatliche Kunstsammlungen der DDR. Kupferstichkabinett Dresden.

2.60, Signed lower right: Kollwitz. Staatliche Kunstsammlungen der DDR. Kupferstichkabinett Dresden. © 2001 Artists Rights Society (ARS), NY/VG Bild-Kunst, Bonn.

2.61, Staatsgalerie Stuttgart. © 2001 Artists Rights Society (ARS), NY/VG Bild-Kunst, Bonn.

2.62, National Gallery of Art, Washington DC. Gift of Robert and Chris Petteys. © 2001 Artists Rights Society (ARS), NY/VG Bild-Kunst, Bonn. Photo © 2001 Board of Trustees, National Gallery of Art.

Chapter 3

3.1, Courtesy Scott Hull Associates, Dayton, OH.

3.69, © David Hockney. Photo: Steve Oliver.

3.71, Collection, AXA Financial, Inc. through its subsidiary The Equitable Life Assurance Society of the U.S. © AXA Financial, Inc.

3.72A–J, © Disney Enterprises, Inc.

3.73, Albright-Knox Art Gallery, Buffalo, James S. Ely Fund, 1980.

3.74, Museo Nazionale Romano delle Terme, Rome, Italy. Scala/ Art Resource, NY.

3.75, Black Star, NY.

3.76, © 1984 by Chris van Allsburg. Reprinted by permission of Houghton Mifflin Co.

3.77, The Historical and Interpretive Collections of The Franklin Institute, Philadelphia, PA.

3.79, Carlo Ponti. © 2001 Estate of Francis Bacon/Artists Rights Society (ARS), NY.

3.80, TM & © 2001 Marvel Characters, Inc. Used with permission.

3.81, Metropolitan Museum of Art, NY, George A. Hearn Fund, 1956 (56.78). Photo © 1984 Metropolitan Museum of Art.

3.82, Albright-Knox Art Gallery, NY, gift of Seymour H. Knox, 1967.

3.83, Photo: David Caras.

3.84, Philadelphia Museum of Art, PA, Bridgeman Art Library. © 2001 Artists Rights Society (ARS), NY/ADAGP, Paris/Estate of Marcel Duchamp.

3.85, Museum of Modern Art, NY, gift of the photographer. Reprinted with permission of Joanna T. Steichen. Copy Print © 2002 Museum of Modern Art, NY.

3.86, Collection, Whitney Museum of American Art, Gift of Mr. and Mrs. B.H. Friedman (75.1). Photograph © 2000: Whitney Museum of American Art. © 2001 Pollock-Krasner Foundation/Artists Rights Society (ARS), NY.

3.87, Museum of Modern Art, Purchase. Photo © 2002 Museum of Modern Art, NY.

3.88, Syracuse University Library, Department of Special Collections. Syracuse, NY.

3.89, Photofest.

Profile, Walton Arts Center, Fayetteville, AR, permission of the artist.

Chapter 4

Page 4-9, Georgiana Nehl © 1996. Photo: David Browne.

4.2, 2002 Cordon Art B. V. Baarn, Holland. All rights reserved.

Profile, © Nancy Callahan and Diane Gallo.

Chapter 5

5.1, Cooper-Hewitt, National Design Museum, Smithsonian Institution/Art Resource, NY, gift of Gary Laredo, 1956-10-1. Photo: Dave King.

5.2, Museum of Modern Art, NY. Gift of Edgar Kaufman, Jr. Photo © 2002 Museum of Modern Art, NY.

5.5, Museum of Modern Art, NY. Gift of Herman Miller Furniture Company. Photo © 2002 Museum of Modern Art, NY.

5.6, Photo courtesy of Knoll, Inc.

5.8, Photo: Peter Colville.

5.9, Corning Museum of Glass, gift of Vera Lisková.

5.10, Chronicle Books, San Francisco, 1995.

5.11, Museum of Modern Art, NY, Mrs. Simon Guggenheim Fund. © 2001 Yves Tanguy/Artists Rights Society (ARS), NY. Photo © 2002 Museum of Modern Art, NY.

5.12, Private Collection. © 2001 Artists Rights Society (ARS), NY/SIAE, Rome.

5.15A, Photo: Kate Gollings.

5.15B, Photo: John Gollings.

5.17A, Honolulu Academy of Arts, gift of James A. Michener, 1991 (21.971). Photo © Honolulu Academy of Arts.

5.17B, Honolulu Academy of Arts, gift of James A. Michener, 1955 (13,695). Photo © Honolulu Academy of Arts.

5.17C, Honolulu Academy of Arts, gift of James A. Michener, 1991 (21.968). Photo © Honolulu Academy of Arts.

5.18, Photo: Leslie Leupp.

5.19, Left to right, Private collection; Collection Stedelijk Museum, Amsterdam; Private collection. Photo: George Erml.

5.20, Copyright 1999 Iomega Corporation.

5.21, Museo Nacional Centro de Arte Reina Sofia, Madrid/Bridgeman Art Library. © 2001 Estate of Pablo Picasso/Artists Rights Society (ARS), NY.

Chapter 6

6.1, Art Institute of Chicago, Charles H. and Mary F. S. Worcester Collection. Photo © 2001 Art Institute of Chicago. All rights reserved.

6.2, Stanza della Segnatura, Vatican, Rome. Photo: Copyright Scala/Art Resource, NY.

6.10, South facade of the Nelson-Atkins Museum of Art and the Kansas City Sculpture Park. Aluminum, fiberglass-reinforced plastic, urethane paint, approx. 19.2 ft h × 16 ft diameter (5.9 × 4.8 m). Nelson-Atkins Museum of Art, Purchase, acquired through the

generosity of the Sosland Family (F94-1/2-4) © Claes Oldenburg and Coosje van Bruggen. Photo: E. G. Schempf.

6.15, Collection: Moderna Museet, Stockholm. © Robert Rauschenberg/Licensed by VAGA, NY.

6.16, © Robert Rauschenberg/Licensed by VAGA, NY. Photo: Harry Shunk.

6.17, © Robert Rauschenberg/Licensed by VAGA, NY. Photo: Rudolph Burckhardt.

Profile, Scholastic Press, a division of Scholastic Inc. Illustration © 1998 by Bob Dacey. Used by permission.